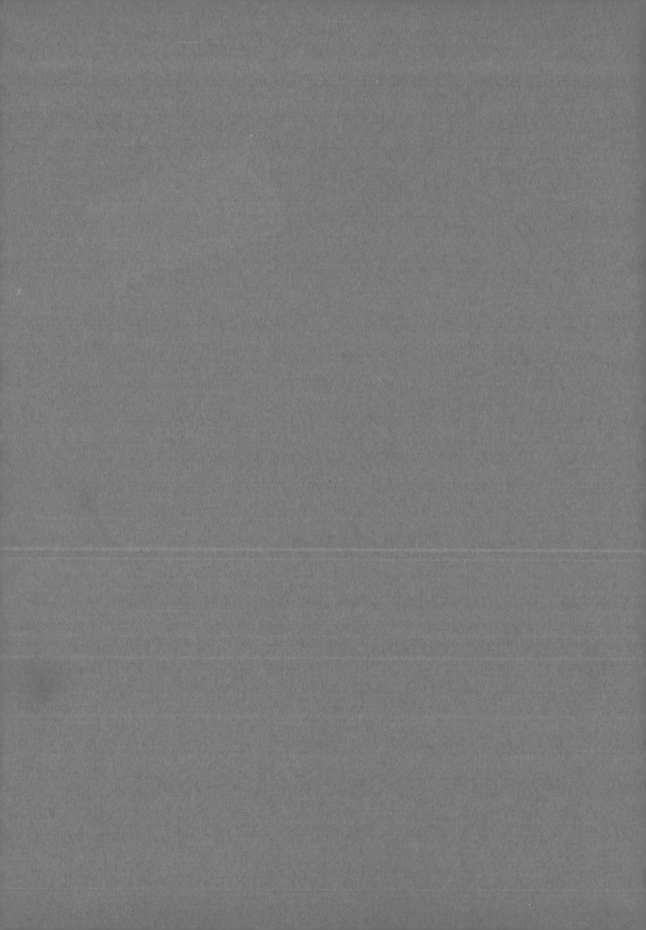

Creative Techniques in Studio Photography

Creative Techniques in Studio Photography

Bruce Pinkard

J. B. Lippincott Company
Philadelphia and New York

To my father who began it all

Acknowledgment

The author wishes to thank the following individuals and companies who have given special assistance on this project: Dick Hamblin of De Vere (Kensington) Ltd; Mr Dutton – May & Baker Ltd; Max Oschwald of Arca Swiss, Zurich; Nigel McNaught, Polaroid (UK) Ltd; Peter Sutherst – Kodak Ltd; David Shaw – Photopia International Ltd; Tom Walker, Rollei International (UK) Ltd; Ray Williamson – Photax Ltd; De Beers International for permission to print the pictures on pages 117 and 170; Maggi GmbH for permission to use pictures on pages 125 and 181; Weidenfeld and Nicholson for permission to quote from The Hidden Order of Art by Anton Ehrensweig on page 128; friends Wolfgang Schon for kind help and advice and Rotraud Degner for her extensive help on all matters relating to food photography and for preparing dishes on pages 166, 167, 175, 179, 181, 183; The Carrier Restaurant, London, for preparing food for the picture on page 140; Minox GmbH for permission to use the pictures on pages 123 and 168; and especially to my wife Didi, without whose help and encouragement this project could not have been completed.

U.S. Library of Congress Cataloging in Publication Data

Pinkard, Bruce
 Creative techniques in studio photography.

 Bibliography: p.
 Includes index.
 1. Photography, Commercial. 2. Photography,
Advertising. J. Title.
TR690.P49 770'.28 78-26109
ISBN-0-397-01353-1

Contents

Author's Note

It should be noted by all students and professionals engaged in the pursuit of photographic knowledge that technical matters are largely a question of suiting personal styles and making very subjective judgments.

The best way to success is *to read the manufacturers' data sheet* and follow their basic information. Each manufacturer maintains highly competent technical people who are only too willing to answer intelligent questions. Use their services to discuss any queries and extend your own research.

Almost all the monochrome photographs in this book have been taken from colour transparencies, many of them 35 mm. The quality is therefore somewhat degraded but study should be made of form and content, as well as lighting styles. Most of the design does however depend on the use of colour, as comparisons with those case histories which are reproduced in colour in earlier chapters will show.

With the exception of the pictures in Chapters 1, 2 and 8, all photographs are by the author.

Introduction

The camera is, undoubtedly, an honest witness ... it offers a blunt account of precise moments in time and is a tireless reporter of history, forever turning its one bleak eye on the world about us. But there is something dissatisfying about an *image* of reality, which at best is an interception and encapsulation of a temporal experience. The greatest challenge, I believe, is to *recreate* reality and therefore offer reality itself.

There is, in photography, a very satisfying chemical presence, most suited to the twentieth century, which can provide a perfect volatility of images with which to translate and hold every evanescent experience.

Not to be tied to easel painting or formal drawing, not to be curtailed by the elegant old world craftsmanship of other art forms means that the photographer can exploit the virtue of mobility and make *field* contact with all the elements of the final image.

Rapidly made latent images are exciting to make and difficult to control, while the cold unblinking optics can be an unnerving obstacle. Creating in this medium can produce all the problems and intellectual pain which are part of any creative statement. With no more than incidental craftsmanship, the modern image maker can present a reliable narrative of today's affairs.

Ordinary photographic 'drawing' can be rather sterile, however well crafted, and once basic control of the process is mastered, new areas of communications should be sought.

At this point in his experience the photographer should seek to construct visible memories of the visible world and let these become shared images with at least one other person. If, finally, a large number of people find that they can accept the same point of view as the photographer and his image, successful communication will arise.

Shared images are, of course, highly introspective and depend for their power on the suppression of unnecessary detail. Apparently, perception is not a wholly physical operation, but in fact is highly subjective, depending largely on grasping concepts, rather in the manner that the brain achieves understanding. The character and 'being' of the subject in view can also reactivate subconscious experiences in the viewer, greatly modifying the ultimate understanding of the statement made. Elementary perception begins with basic structures, passing on and on to other visible clues as they reach the viewer. The more obscurity in the clues, the more the viewer must supply solutions inspired by his own imagination.

Building these images of lower recognition characteristics which appeal to emotional perception, also brings into play an interaction of the temperaments of the artist and the beholder, rather in the same way that Sumi-ye painting inspires co-operation with the Zen artists who create such beautiful and fragile images.

By actively exploring ways of slowing down the *immediate* reading of his visual statement, the photographer is consciously trying to destroy the normal optical image and replace it with a highly subjective one, manipulated intensively in order to encourage participation in the whole statement by all those who are confronted by it.

In this evasion of the ordinary mechanics of photography, the photographer destroys the forbidding mirror characteristics of the lens and attempts to restructure the photograph in the manner of his own choosing.

Western civilisations now have a highly developed sense of interpretation of even minimal photographic clues and it is becoming increasingly easy to evoke memories of the original circumstances by the use of this medium, especially with regard to abstract and intangible factors such as mood, ideas or motives.

Einstein has said that the experience of mystery is essential to man and I believe the photographic image to be inherently mysterious. There is still an element of magic about this curious machine which produces such deeply satisfying statements about the reality near us and leads us step by step, on an emotional path, to truth. Photography has become a most persuasive dialect in the world of communication and knows no territorial boundaries once the basic vocabulary is mastered.

The exploring of this challenging, expressive art form, which can reach such an immense audience, fills one with pain as well as pleasure, yet I am convinced that photography still contains the greatest unused potential of any art medium in the modern world.

1 Practical Matters

To begin this book with a fairly serious statement about photography emphasises my belief that advanced photography is a fairly serious matter.

We all know that with the help of low cost, automated cameras, sophisticated machine processing and the immense technical resources of the photographic industry, anyone can, and will, produce reliable, readable images with no effort or skill. However, of the millions and millions of camera images made each year, few are durable communicative statements. It is possible to use minimal equipment and produce satisfying images but normally this stage is reached only by those who have experienced the craftsmanship of photography widely, then forsaken it for the stronger impact of conceptual images. Very few photographers can eliminate the basic study and craftsmanship which must be the first steps to advanced photography. This is a considerable undertaking, involving extensive applications of time and money.

The photographer who wishes to acquire special skill in his field must think carefully and deeply about his motives and objectives, as these will totally alter the nature of his approach to the basics and the equipment he uses. For example, if it is a matter of art, he will need to obtain only fairly simple equipment such as camera, tripod and darkroom. If the photographer wants to apply himself to commercial work his investment in equipment and organisation will be much greater. If it is an extension of existing skills in order to have a more satisfying hobby, then this will give rise to another set of circumstances. Therefore, give the question of motivation very careful thought and, if possible, discuss it at length with a photographer who has established himself at an advanced level in the special area that is of interest to you.

The first consideration in equipping any photographer will be his camera. This can be one of three types: view camera, reflex camera or rangefinder camera; each one commands respect in its own field. The *view camera* (Fig. 1) is ideal for still life, landscapes or architecture, as it controls perspective easily and permits correction of many inherent optical faults in the image, but it is expensive, the film especially so, and bulky to move around. It always requires a large, heavy tripod.

The *reflex* camera usually accepts 120 roll film or 35 mm roll film and can be sub-divided into a grouping of twin lens reflex and single lens reflex.

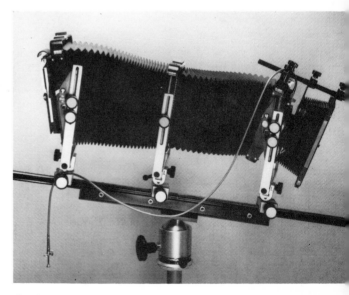

Fig. 1 Most professionals will need a camera such as this ARCA-SWISS 13 × 18 cm monorail view camera. It is the most flexible of camera systems, except for action photography, that can be obtained. Lenses, such as Rodenstock Sironars will need to be bought in several lens lengths and the whole outfit will weigh more than 25 kilos.

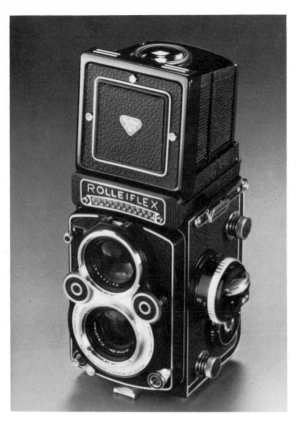

Fig. 2 The original twin lens reflex was built by Rollei, W. Germany, and up-dated models are still very much a professional tool. Probably the most reliable camera available today, but optically, not as flexible as other systems.

The twin lens reflex (Fig. 2) (of which the Rolleiflex is probably the most well known and the most reliable) has a taking lens and a separate viewing lens. This allows for a brilliant focusing image even in dull light, plus constant supervision of the subject, right up to the moment of exposure. It is exceptionally quiet and ultra reliable and is a good choice for portraiture, theatre photography or travel. This kind of camera has been basic equipment for great photographers such as Richard Avedon for many years and is an outstanding camera with which to begin serious work. One drawback is in the question of parallax. This is usually corrected by a device which is built into the camera's focusing mechanics but in situations where precise information on reflections is important, errors can be made. For example, in a close up portrait of someone wearing glasses it is important to avoid catching a mirror reflection of the light source in the subject's eye glasses. These problems can be very difficult to avoid with some twin lens reflex cameras. Another problem is that it is unlikely that such cameras will have interchangeable lenses and instead they rely on objectives added on to both the viewing and taking lens. These supplementary lenses, such as Zeiss Proxars are easily obtainable from the camera manufacturer in wide angle, telephoto and macro lengths. They offer, again, the advantage of light weight and portability but if your intention is to use super-wide angles, or very long telephoto lenses, then this camera will eventually cease to satisfy you. It is, however, a camera to consider deeply for serious, advanced work.

The rangefinder camera (Fig. 3) can be a large or medium format, such as the Linhof Technika, but is most likely to be a 35 mm format or smaller. Various half frame cameras, taking half a normal 35 mm format, could be considered for advanced work and even the minute 110 size, but usually these formats are too tiny for serious exploitation of the image, particularly in respect of big scale enlargements. The most well known example of the 35 mm rangefinder camera is probably the Leica series, the chief advantage of these cameras being their compact nature, quiet operation, superb fast lenses and reliability. It should be mentioned in passing that the Rollei 35s does not have interchangeable lenses or a rangefinder but is probably the smallest full frame 35 mm camera

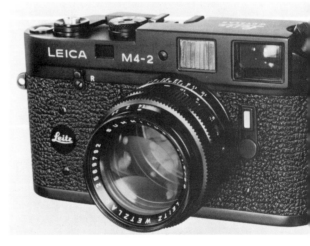

Fig. 3 The Leica M42, the latest from the famous camera makers E. Leitz of W. Germany. Ideal for unobtrusive, fast documentary photography and produces images of incredible sharpness.

with unquestionably good optics. This could be very suited to photo journalism of street subjects, especially where people were not to be aware of the camera's presence.

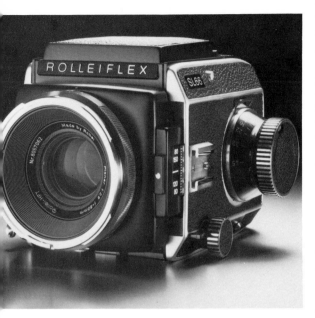

Fig. 4 Typical of the bulky 6 × 6 cm roll film cameras used by the majority of professionals, the Rollei SL 66 is very expensive and fairly heavy, but it is the most practical support camera available for studio use. Hasselblad make a somewhat similar camera that is famous as a professional tool, especially for location photography.

The choice of many photo journalists would be the Leica system even though it is costly. Consideration to the parallax problem should be given, but it hardly ever arises in the kind of work for which those cameras are used. By far the most well known family of modern cameras is the single lens reflex. The SLR camera usually accepts either a 120 film (Fig. 4) or 35 mm film. The larger formats give excellent results, especially where maximum definition on black and white film is needed, but are bulky, very expensive and often limited in the choice of lenses. With modern scanner reproduction these larger formats seem almost unnecessary but they do produce the most superb quality on black and white materials. They are normally very noisy in operation so should not be used in theatre situations or where noise is an adverse consideration.

Hasselblad make a camera of this type, taking 6 × 6 cm (2¼ × 2¼ in) square pictures on 120 film and many professionals use them constantly. Rolleiflex make two such cameras, the SL 66, which has the important advantage of a built-in bellows extension of the lens for normal close up work and a unique basic lens which is reversed in its housing for close macro focusing. This camera is probably the ideal studio-type camera where perspective correction is not needed and is especially suited to studio advertising assignments. It is bulky however and should be used on a tripod. For this reason it is not a good location camera. Rollei also make a new electric camera, the SLX, which has less flexibility on close up techniques but is very compact, fully electric both in film transport and exposure automation and can shoot a picture every 0.7 of a second. If automation is important to your needs, this is a superb camera and as it can be totally enclosed in protective cladding and then operated remotely by radio pulse, this camera would work well in hostile environments such as are to be found in some scientific and industrial applications.

Another highly regarded 120 SLR is the Pentax 67. This is a bulky but beautifully balanced camera, with no magazine provision or Polaroid capability but is an excellent choice for advanced work where these shortcomings are not important.

A much smaller camera, but a good one, is the Mamiya 645 using a format of 6 cm × 4.5 cm (2¼ × 1¾ in) on a 120 film. Very compact, excellent handling and less expensive than most of its type.

The primary advantage of the large format SLR is that it has interchangeable magazine backs which can be preloaded with the same or different emulsions and with varying lengths of film. At any point in a photographic session, magazines may be changed. This permits an uninterrupted flow of work, important when photographing people or action and also allows alternative film types to be used in the same situation. A further valuable consideration is that most of these cameras have Polaroid capability. A special back is supplied with the camera which accepts the Polaroid 100 series of film packs and in serious professional work, this can be most advantageous.

In considering the 35 mm SLR cameras (Fig. 5), there are so many from which to choose but as professionals demand certain ultimate criteria, it is only those cameras which come up to that standard which are included in this discussion. All are 'systems' cameras, so called because they have an

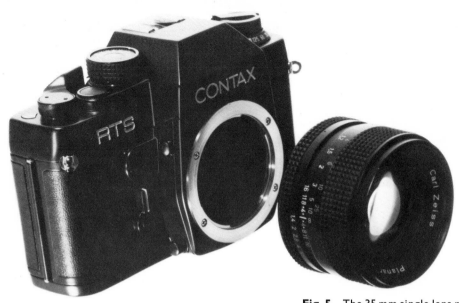

Fig. 5 The 35 mm single lens reflex, with easily detachable lens, is essential to most location situations and is the lightest in weight of all the professional systems.

almost unlimited supply of additional lenses and accessories for almost every conceivable purpose. International professionals, who often need to travel extensively but limit their camera systems because of weight, usually choose a camera for which most systems can be found in rental offices in all big cities. The popular choice is Nikon. These are rugged cameras, handle very well and it is possible to rent additional Nikon equipment almost anywhere. Their back-up service to professionals is legendary.

Canon make an excellent SLR system with special attention to lens quality, but it is less easy to rent extra lenses on a world wide basis. Minolta have a very sophisticated system, the camera handles physically well and on automation and exposure measurement is especially good. An added advantage is the compatibility of some of the Minolta cameras with Leitz lenses and for the discerning professional who wants access to Leitz lenses, this will be the choice. Minolta are also leaders in special purpose lenses such as variable curvature optics and perspective control systems.

Many European professionals prefer the Leica SLR, which is a beautiful camera, but a little bulkier than some of its Japanese competitors. Its optics are superb.

A very complete systems camera is to be found in the Contax RTS (Fig. 6). Capable of full automation and remote control, it is one of the new breed of camera designs where the best of Europe joins with the best of Japan to make a superb camera capable of extending the experience of the most advanced photographer. It is fully equipped, notably with Zeiss lenses.

Olympus are famous for their compact OM cameras and if size and weight are important, this camera must be considered. Personally, I find it too small for easy handling unless equipped with bulky accessories. By itself, I find that the highly desirable attribute of compactness does not offset the inhibition of working speed that this produces. However, this is definitely a camera for the advanced amateur who travels.

Probably the most expensive and interesting 35 mm SLR is the prototype Rollei SL 2000. Unconventionally box shaped, fully automated (including electric rewinding) and equipped with superb Zeiss lenses, this is a compact camera which handles well. It has the tremendous advantage (very rare in this type of camera) of having interchangeable magazines. In a long working life with 35 mm systems cameras, this is the capability I have found of most use in a roll film camera. This camera is a magic box indeed, with all information being screened in the viewfinder, while shutter or aperture preference is selected at will. There is a built-in waist level viewfinder.

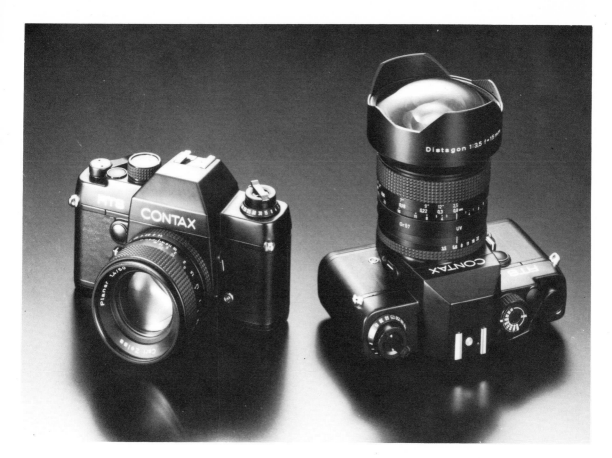

Fig. 6 The professional working mostly with 35 mm will need at least two bodies and a battery of lenses. This is the Contax RTS systems camera, one fitted with a normal length f. 1.4 lens and the one on the right with the super wide 15 mm Distagon lens from Zeiss. A very comfortable and creative systems camera, the Contax RTS is an excellent combination of Japanese electronics and German body design, coupled with superb optics from Zeiss of W. Germany.

Most photographers hope for a camera that is merely an extension of their eye and mind and this camera comes very close to that ideal.

Returning to the view camera, this type of camera must be seriously considered by all advanced photographers. The 'old fashioned' kind of camera, placed on a sturdy tripod, with black cloth to cover both the photographer and most of his machine, has been a curious object in our landscape ever since photography was invented. Apart from the practical advantages mentioned above, of perspective correction, etc., it should also be noted that this camera has contributed to the advancement of the art of photography in the hands of such twentieth-century people as Steichen, Stieglitz, Weston, Atget, Avedon, etc. Many modern masters of photography have found that it is not necessary to have the machine gun capabilities of sophisticated systems cameras. Photography at a very high level is often quite a contemplative matter, needing much pre-planning, but in the end needing only minimal amounts of material. So the few sheets of film available before reloading is required are sufficient and there is an added concentration of thought brought about by the need to complete the assignment with only those few sheets. All the best photographic schools will limit the student in his first semesters to the use of this type of camera and advanced photographers can well take note of this practice.

View cameras are available in formats ranging from 18×24 cm (8×10 in) down to 6×7 cm ($2\frac{1}{4} \times 2\frac{3}{4}$ in) and the choice is governed by what the photographer plans to do with the results of his efforts. Obviously the large 18×24 cm camera

produces exceptional quality and renders texture superbly, while the small 6 × 7 format uses roll film and is nearly as flexible as similar portable cameras. The largest cameras are very bulky (perhaps with the exception of the Deardorff view camera) and this requires added weight in tripods and lenses. My own choice has been to use a 13 × 18 cm (5 × 7 in) format, with reducing attachments for 9 × 12 cm (4 × 5 in) and 6 × 7 cm. This is a monorail camera built on the optical bench principle and fits in a large 66 cm (26 in) suitcase. It is built by Arca–Swiss of Zurich and is ultra strong but very light in weight. With four or five lenses from Rodenstock of Munich, this is a highly sophisticated camera capable of almost any professional assignment which does not require rapid, repetitive exposures. Other highly respected makers of this type of camera are Linhof, Sinar (a frequent choice for professionals) and Calumet. The Deardorff camera, mentioned above, is made in the USA from wood and brass and although it does lack some useful capabilities, it is such a compact camera that this very often makes it a desirable choice.

Another source of these view cameras is the auction rooms and second hand shops who handle photographica. Prices are still not excessive and modern lenses can easily be fitted. This is probably the least expensive way in which a serious photographer can obtain very advanced equipment.

Having chosen the basic camera system, the photographer *must* acquire a tripod. Stories are told of legendary photographers who can hold telephoto lenses at $\frac{1}{5}$ second, etc., but it is a basic fact that if you use a small 35 mm SLR you risk unsharpness if you hand hold normal length lens at 1/30 second or longer. Medium telephoto lens require minimum shutter speeds of 1/125 or 1/250 and longer lenses require 1/500 or less. Many, many situations will require that you put your camera firmly on a tripod and at times, even with 35 mm formats, use a cable release, to achieve the sharpness that is essential for professional acceptance of small formats. It is definitely not an inhibiting factor once the practice is routine. Excellent tripods are made by Gitzo of France, Bilora and Linhof of Germany, Foder of Switzerland, Velbo of Japan, and Davis, Quickset, Suzmann and Majestic of the USA.

Preferably, a tripod should have the capability of rising to about 2 metres (78 in) and also to be used as low as 25 cm (10 in) from the floor, and have a geared centrepost to make final adjustments of camera height. There is also need for a rapid mounting of the camera onto a universal joint that sits on top of the tripod. Tripods sometimes have this built in, but the better ones require a separate device. For larger cameras, the Arca–Swiss Monoball (Fig. 7) is ideal, while lightweight SLRs may be solidly locked into any position by using the Leitz universal ball joint. A cable release, lens hoods for the chosen lenses, and an exposure meter, should complete basic taking equipment.

Even if the camera of your choice has fully automatic exposure calculation it may be necessary to have also a suitable separate meter. Gossen make several and Minolta make an especially good professional meter called the Autometer. They also have a very expensive but superb spot meter (Fig. 8) which professionals would do well to consider. My own choice has been the Pentax spot meter which reads at a 1° angle area with great

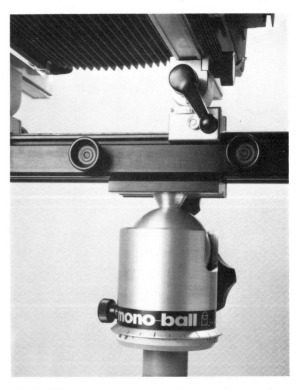

Fig. 7 Heavy view cameras need heavy tripods and a suitable universal head to tilt in all directions. This is the ARCA-SWISS Monoball, massive yet very quick adjusting and will hold the heaviest equipment solidly in place. This can be the weakest part of a photographer's equipment, so selection of the best is advised.

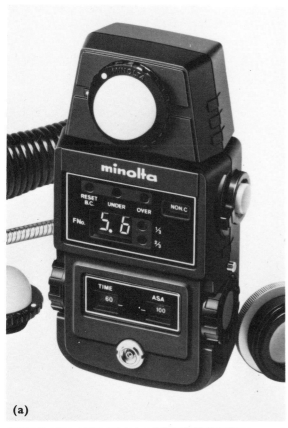

(a)

(b)

accuracy. General meters such as Norwood and Calumet are also excellent. Minolta also make a very good colour temperature meter, to check the colour balance of light in the picture and these are really useful tools for the professional who shoots on location.

The photographer must also provide for himself darkroom facilities, even if he works only in colour. If his chosen work involves mainly transparency material, his darkroom can consist of a large lightproof cupboard to load film, if he is using sheet film and view cameras, or for occasional emergencies in other formats. If, however, he wishes to find fullest benefit from the photographic process, he will need to provide a wet darkroom (Fig. 9) for processing and somewhere dust free to dry film and prints. This normally could not be adequately housed in a total area of less than 2 metres × 3 metres (6 ft 6 in × 10 ft).

In deciding upon processing equipment, the photographer should be guided by the camera he has chosen. View camera negatives require large tanks such as the Kodak 3F series which hold

Fig. 8a For the professional who must work to very exacting briefs with electronic flash it is usual to calculate exposure and lighting with the help of both Polaroid and a flash meter. These meters should be battery operated and give a direct reading of f. stop values. In the lower price bracket Bowens and Courtenay produce effective instruments, but probably the most efficient (and probably the most expensive) is shown here. This is the Minolta flash meter which gives a direct f. stop value as a constantly held digital read out and is certainly ideal equipment for any serious studio professional and one of the most flexible exposure calculators available on the market.

Fig. 8b Measuring exposure in daylight or by constant emission lamps of any kind will need a critically accurate meter which is easy to use. There are some benefits in using generalised information obtained from a meter with a wide angle of acceptance and these are suitable for most work, but the professional will need to consider the pinpoint accuracy of a spot meter. This type of meter reads only a 1° angle of the field of view and can assess the reflectance value of tiny highlights or obscure shadows from considerable distances.

An extremely accurate one, from Minolta, who are specialists in supplying equipment for measuring photographic data, is shown here. Other less expensive but highly regarded spot meters are available from Pentax, Goosens and Spiratone.

15

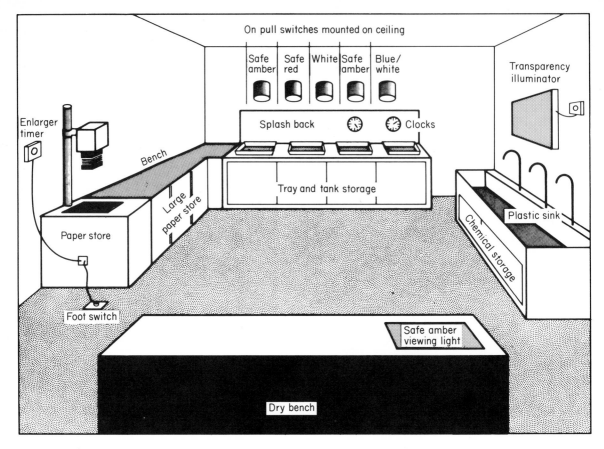

On pull switches mounted on ceiling

Safe amber | Safe red | White | Safe amber | Blue/ white

Transparency illuminator

Enlarger timer

Splash back Clocks

Bench

Paper store

Large paper store

Tray and tank storage

Plastic sink

Chemical storage

Foot switch

Safe amber viewing light

Dry bench

Fig. 9 An effective darkroom needs meticulous planning, especially in confined space. Be especially careful about the electric wiring and have a competent professional do this.

about 13 litres (US 3½ galls) of solution, together with stainless steel frames to hold the film in the solutions. Roll film is developed on reels such as those made by Nikkor, Paterson or Brooks and every manufacturer has a suitable tank to house his own reels. It is also essential to have a close meshed filter on taps connected to final wash water to avoid dust and mineral particles causing contamination of the final rinse before drying.

A suitable enlarger must be found and, for the largest formats, De Vere and Besseler are excellent. Omega make a rugged professional 9 × 12 cm (4 × 5 in) enlarger which, with extra lenses, can accept formats all the way down to 16 mm, while Rollei have an excellent 6 × 7 cm (2¼ × 2¾ in) machine with automatic focus by remote control, which occupies a small space and is also suitable for 6 × 6 cm and 35 mm format.

Great consideration should be given to the enlarger lens and it is *not* a good idea to use the lens from your camera. Special enlarging lenses with flat field characteristics and good contrast are made by Rodenstock, Nikon, Schneider and Leitz, while recently Omega have introduced a range for their own enlarger which is giving very fine results.

Six dishes measuring at least 30 × 40 cm (12 × 15 in) should be bought for print processing and some means should be provided for drying prints. At least twelve film clips will be necessary and the best I have found are the plastic variety from Paterson.

From looking at the above advice, those who wish to become closely involved with advanced photography will realise that costly purchases must be made, a certain minimal space is required which is permanently allocated to photography and considerable detailed planning is necessary.

If the photographer intends to open his own studio as a full, or part-time venture, he has other obligations to consider. He will need professional advice on financial matters, especially tax matters

and usually will need to obtain local authority permission if the business involves the public in any way. In closely settled areas, he would need to consider that his business venture might affect his neighbours in some detrimental way and should come to satisfactory *written* arrangements with them. He should carefully consider, also, what his involvement in photography would mean to his own household, especially where considerable capital must be set aside at the beginning and put at fairly high risk for long periods of time. The artist-photographer will be driven by deep motivations that he cannot control but he should, at the very beginning, understand that modern photography, practised at any deep level, will be a costly operation.

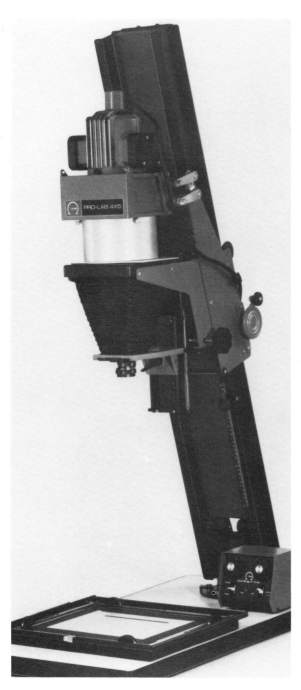

Fig. 10 Systems enlargers are needed by the professional, especially if he owns several camera formats. The Omega is a most reliable instrument and the one shown here is capable of accepting lenses and negative carriers for 4 × 5 down to 16 mm. Locate it away from the wet areas in the darkroom.

Check list for setting up a studio

- Think carefully of your aims in photography.
- Talk to a professional photographer.
- Talk to business professionals about money.
- Read photography magazines for equipment analysis.
- Visit several camera dealers and discuss needs.
- Compare prices, advice and service.
- Test the camera of your choice, both in black and white and colour, against spectrum and lens charts and with people.
- Do not buy a camera without testing.
- Buy a tripod.
- Arrange adequate finance to cover *all* equipment needed.
- Buy and fit secure cases for all equipment.
- Allocate space for darkroom and/or studio.
- Arrange all risks insurance.
- Buy a large notebook for notes on all technical matters.
- File safely all equipment registration numbers.

On important assignments, it will be necessary to have *back-up equipment* for at least the camera body, if it is a complex one, and the most significant lens and an element of lighting equipment, plus spare batteries, lamps and other expendables. Professionals normally need two camera bodies at least, if they are using SLR equipment, but with view cameras do not need to do more than duplicate one lens length and possibly a spare tripod. It is important to consider the weaknesses in your camera system and make provision for whatever back-up equipment would be needed if the weak link fails while on assignment. This expense should be met, if possible, at the time of purchasing the basic outfit.

Two other major items will be essential to the practising of advanced photography and must be included in the budget. Once the chosen equipment is assembled it must be housed in a suitable, secure case and all equipment *must* be insured on an *all risks* policy.

The cases for camera equipment can be almost as expensive as a medium priced lens but it is foolish to obtain delicate and costly equipment without making sure of its adequate protection. Generally speaking, the attractive leather cases, even the large compendium type, are not suitable, unless they are custom built and have provision for easy access to all equipment and accessories. Professionals rightly favour a suitcase style container, one large enough to hold all the basic cameras and accessories in a single layer. The case should be very strong and have suitable locks. Well known makers like Haliburton supply excellent aluminium cases and many professionals use them. However, one drawback to the aluminium camera case is that, throughout the world, at most major travel points, thieves are seeking to part unwary travellers from their baggage and it is just these silver cases, known invariably to contain cameras, which are stolen first. A better solution is to obtain a more commonplace item of luggage, such as a Samsonite case, buy dense plastic foam sheets, 5 cm (2 in) thick, and fill it. Then with a sharp knife, heated in a flame, cut pockets to contain all equipment, including lens caps, filters, flash guns etc. As an essential security, an extra lock should be fitted, preferably a padlock with a combination.

It should be a matter of the deepest concern to every photographer on any assignment for a third party (whether paid or not) to bring back usable images. Very often, enormous sums of money are dependent on such images and if the photographer fails to deliver by deadline time, he can be excluded from ever again working for that company or their contacts.

Take every possible precaution against loss of equipment. The question of insurance is a formality, but seek out a company experienced in photographic insurance and take out an *all risks policy*. Discuss with the insurers and obtain confirmation in writing, about the nature of their service in the event of a claim. Can they service claims by telephone? Do they offer cash or equipment? Do they protect your earnings while you wait for equipment? Do they have a representative in those foreign areas you may visit on assignments? Remember too to revise the schedule of values, upwards to new replacement prices, on an annual basis.

Finally, the guiding factor in purchasing equipment should be to keep it to the absolute minimum, buy the best (not always the most expensive) and only buy equipment that is comfortable for you personally to operate and that will assist you to reach those objectives in photography which you desire.

2 Chemistry and Optics

The craftsmanship of photography has a magic attraction for us all. The unique attribute that permits man to select a subject, or the mood of a subject, record it by means of a 'latent' image and then, at will, reconstitute that image or any part of it in the darkroom, this is an intriguing and mysterious human activity that has only been possible for a relatively recent part of our history. It never seems to lose its magnetic ability to hold our attention and, in fact, this hand crafting of a mechanically constructed image is in itself very therapeutic and relaxing for people beset with twentieth-century tensions.

Millions of words of advice have been written about the actual way photographic chemistry should be used to produce images, but in the beginning, certainly, the professional or advanced photographer should seek only basic and very certain techniques. He must not fail to produce a usable image or all his investment in time, money and commercial contact will be wasted.

The photographer should begin with attempts to make superlative black and white negatives and should explore a very narrow area within the vast field of black and white chemistry until he has an absolutely routine, foolproof technique to serve him under almost any conditions.

In selecting film for his undertaking he must be able to work well with a slow fine grain film and also a fast film suitable for low level existing light conditions. A single film or any compensating chemistry cannot solve both of these problems so competence in the use of two kinds of film must be gained. Fundamentally, a fine grain film will be of slow speed, have a thin emulsion with very little latitude and will produce very sharp images suitable for big magnification. From 35 mm fine grain films, good processing should produce acceptable enlargements of 50 × 60 cm (20 × 24 in) and should give, therefore, beautiful reproduction in magazine or book formats which normally are one third of that area.

Film Speed Equivalents	
ASA	DIN
1	1/10
1.2	2/10
1.5	3/10
2	4/10
2.5	5/10
3	6/10
4	7/10
5	8/10
6	9/10
8	10/10
10	11/10
12	12/10
16	13/10
20	14/10
24	15/10
32	16/10
40	17/10
50	18/10
64	19/10
80	20/10
100	21/10
125	22/10
160	23/10
200	24/10
250	25/10
320	26/10
400	27/10
500	28/10
640	29/10
800	30/10
1000	31/10

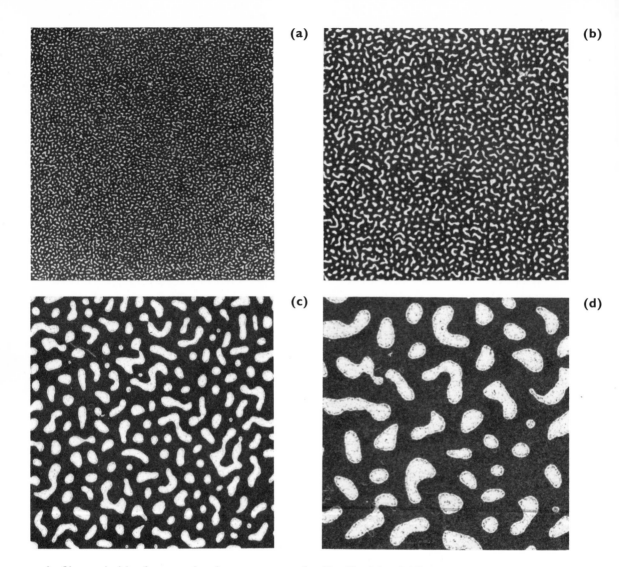

A film suitable for use in the extremes of available light must have low contrast and great latitude, be intrinsically very fast, but be capable of considerable chemically induced speed increases and have a good grain pattern that when enlarged does not diffuse or destroy the basic concept of the image. Acutance will be considerably lower than fine grain emulsions.

Most photographers will choose from one of the big three manufacturers: Ilford, Agfa and Kodak. Ilford have a fine slow emulsion in their Pan F roll film and FP4 sheet film and an excellent fast roll film, HP5. Agfa has a superb slow Agfa 25 emulsion in roll film and Agfa 100 sheet film, while Kodak have Panatomic X as a slow roll film emulsion, Plus X for fine grain sheet film and Tri

Fig. II Film of different speed will, even when developed in the same developer, give varying contrast, different grain size and different grain pattern.
(a) Large format film gives brilliance and very small grain structure even at great magnification.
(b) Medium speed 120 film, such as Ilford FP4 or Kodak Plus X gives moderate, sharp-edged grain and brilliance in high light areas.
(c) High speed 120 film such as Kodak Tri X, gives noticeable grain at normal enlargements and medium to low contrast.
(d) High speed 35 mm film such as Kodak recording film 2475 gives very large grain patterns and medium to high contrast. Excessive grain is often used to strengthen the impact of documentary photography.

20

X as a fast emulsion in all formats. My own choice after much experiment is to use Ilford Pan F for fine detailed 35 mm work, Agfa 100 for view cameras, Ilford FP4 for 120 cameras and Kodak Tri X for all available light situations where moderate definition and graininess are acceptable enhancements to the picture. Other photographers will produce superb pictures with entirely different combinations. It is very much a personal idiosyncrasy.

For the beginner in advanced photography it is a good exercise to explore these different film types but these should be processed in a single basic developer to eliminate some of the variables. The standard chemistry by which most results have come to be judged is that of development in Kodak D76, with a stop bath of acetic acid diluted to a working strength of about 2% and a hardening fixing bath mixed from either proprietary liquid concentrates or organic powder obtained from photographic suppliers. D76 at standard strength gives good general acutance to most emulsions, provides generous shadow detail, does not decrease film speed excessively and is in no way temperamental. Most professionals have a long acquaintance with this developer and for many it has become a basic tool, especially when diluted 1 to 1 to improve shadow detail and definition. When used this way it must be discarded after each batch of film is processed. Ilford's ID11 developer is substantially the same in its character and composition.

Paterson's Acutol is also a very fine standard developer for films up to 200 ASA and can safely be used with Tri X at 400 ASA or even one stop above. Diluted at 1 + 15 or 1 + 20 it performs as an excellent 'compensating' developer in which a full tonal scale is obtained with excellent edge sharpness, together with increased exposure latitude.

A unique contribution to photography has been made by May & Baker of England who many years ago produced a powder developer called Promicrol. After many experiments with many developers this has become my standard developer but is never used at normal strength. Dilutions of 1 + 3 and 1 + 7 produce superlative results on all films (especially FP4 from Ilford) but I have found it desirable to lift working temperature to 24°C (75°F) to reduce processing times. For best results uprate the film by $\frac{3}{4}$ to 1 stop above normal exposure times.

May & Baker also produce an intriguing paper developer, Suprol, which besides delivering good

Check list for negative processing

- Find a slow film and a fast film and learn to process them.
- Use one basic tested developer.
- Record all data in permanent notebook.
- Be precise with dilutions, times and temperatures.
- Use large thermometers.
- Use two clocks to check development times.
- Maintain all solutions at correct temperature for entire time.
- Agitate correctly.
- Always wash hands and equipment in running hot water before using them in next solution.
- Wash all equipment thoroughly *before* and after use.
- Use liquid concentrates where possible.
- Use a stop bath.
- Use a hardening-fixing bath.
- Wash thoroughly for correct time.
- Use a wetting agent.
- Dry in dust free environment.
- *Always read manufacturer's instructions* on film and chemistry.
- Code and file every usable negative, clearly.
- Contact print every usable negative and code contact sheet.

printing quality can be diluted 1 + 19 to 1 + 30 to give excellent negatives in incredible times of 1½ to 3 minutes at 20°C (68°F). Results are better than D76, with finer grain and very much improved acutance. Film speed in the initial exposure should be −20% of normal but caution should be shown in actual processing.

With such brief development, careful agitation technique should be used. The manufacturers suggest (and I endorse) a 20 second period of agitation on immersion followed by a 5 second agitation every 30 seconds thereafter. Do not use a 'still bath' technique with this developer or

streakiness will result. It will be noted that shadow areas drop away quickly in Suprol, so if detail in this respect is of major interest, take care to give any dark areas sufficient exposure, or add supplementary lighting or reflectors.

Correct agitation is extremely important on all negative processing. When loaded film spirals or film hangers are first put into a developer they should be sharply tapped on the bottom or sides of the tank to dislodge any bubbles and then rapidly agitated up and down for 10 to 20 seconds. They should then rest 30 seconds and milder agitation should then be given on the basis of 5 seconds at 30 second intervals thereafter. Closed tanks of roll film may be inverted 4 times in 5 seconds and sheet film gently raised and lowered back into the tank over the same period. Avoid patterns of agitation that are constant, as streaking may take place.

Kodak HC110 is a very universal developer and can be used selectively on many occasions to produce fine quality negatives. Because this concentrated developer has a very viscous consistency it is difficult to dilute accurately. The entire bottle should be emptied into a suitable container and then water added to make a working strength of stock solution to the manufacturer's instructions. This stock solution can then be diluted accurately to provide the normal working strengths of 1 + 30.

One other film/developer combination will bear examination, particularly by the photographer who prefers existing light situations. Kodak produce an ultra fast recording film, Type 2475, coarser in grain than most others on the market but capable of producing beautiful images in impossible lighting conditions. Test this film by rating at 2400 ASA and processing in DK50 at 50% longer than the recommended Tri X times. Promicrol will be useful here also, diluted at 1 + 3 and developed at 21°C (70°F) for 15 to 20 minutes. Open shadows will have excellent detail but highlights may tend to block up a little. This film when dry is difficult to handle because it curls excessively, but patience in its processing can give phenomenal opportunities to the photo journalist or documentary photographer. It can be rated to 5000 ASA, but shadow detail may be lost, at this speed.

No effort should be spared to make superlative negatives, as these are fundamental to the communication the photographer wishes to have with his audience. Get to know selected basic film types, use entirely routine and repeatable film developing

technique (Fig. 12) and maintain fanatical standards of cleanliness when working. Two main enemies of negative processing exist, chemical contamination and dust, and they are preventable by sensible, routine cleanliness in the darkroom.

Contamination can occur if carry over of chemical residues takes place in the initial mixing of solutions or if the processing solutions are in touch with contaminated equipment. Hands, film clips or processing equipment should be thoroughly washed in running hot water before being placed in any solution. Spilled chemicals must be cleaned up immediately. Floors should be washed with hot water after each day's work and sinks and bench tops should be scrubbed clean.

Dust can be minimised by filtering incoming water supplies and air supplies, by shrouding all equipment with dust covers of cotton when not in

Fig. 12 To find the working characteristics of any unfamiliar film and developer combination expose nine negatives of a test subject containing a full range of colours in daylight conditions. Three negatives each should be given normal exposure, 30% over exposure and 50% under exposure and then each set of three should be developed singly – one at normal development, one at 30% under development and one at 50% over development. The accompanying scale indicates the probable tones that will result. Notice how some blacks are lost and some highlights blocked.
(a) Normal development, normal exposure.
(b) Normal development, under exposure.
(c) Normal development, over exposure.
(d) Under development, normal exposure.
(e) Under development, under exposure.
(f) Under development, over exposure.
(g) Over development, normal exposure.
(h) Over development, under exposure.
(i) Over development, over exposure.
Notes relating to printing from these negatives.
(a) Gives good average of tones.
(b) Causes blacks to clog but separates highlights.
(c) Gives better separation in blacks but highlights begin blocking up.
(d) Weak blacks, low contrast.
(e) Low contrast, low density.
(f) Improved rendering of scale, slightly lower in contrast. Excellent prints from this negative.
(g) Low contrast in shadows, highlights blocked up.
(h) Extension of printing scale with good separation in highlights but difficulty arises if shadow detail is needed as well.
(i) Low contrast condensed scale of tones into mid range of greys. Effective for producing high key prints.

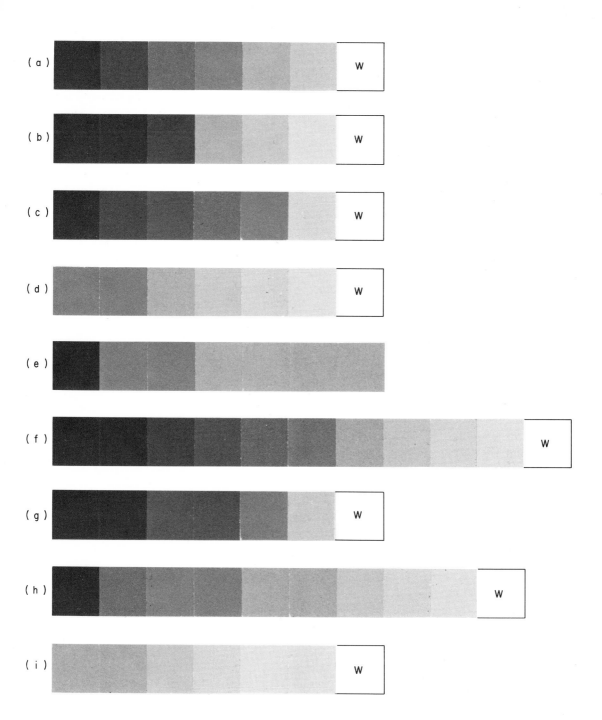

use and by washing squeegees, cloths and film sponges in hot, but detergent free, water and keeping them in closed cupboards or plastic bags. Film *must* be dried in a dust-free atmosphere and such a place can be a cupboard (with a close fitting door) lined with thick plastic film or a specially purchased drying cabinet. Dust settling on the soft surface of wet film can be enormously costly in terms of retouching, and sometimes re-shooting is necessary. To provide heat for drying, I prefer to generate it from two or three 100 watt lamps, suitably protected from water splashes. This gentle heat speeds drying without introducing hazards of dust which might arise if forced air was used.

In obtaining repeatable results, it will be necessary to measure time and temperature accurately. It is advisable for professionals to time their processing of negatives by two clocks with alarms. It has been useful to me to have one very large timer with a sweep second hand (luminous) to time agitation and short development times plus one small minute timer that can time lengthy processes. On all vital negative processing, *both* are used to time the same operation.

Temperatures must be measured by very accurate thermometers and the large mercury type – at least 25 cm (10 in) in length – or the dial type with metal probe are both very suitable. Be very, very accurate in estimating developer temperature. Measuring solutions is best done by a good collection of plastic graduated cylinders such as those with Paterson make. Glass is possibly more accurate, but in total darkness, these graduates may often be knocked off benches or sinks and plastic will survive these accidents. Graduates of 100, 300, 600, 1200 cc are essential and a $2\frac{1}{2}$ litre ($\frac{2}{3}$ US gallon) measure is useful. A large mixing bucket is also useful but it must be kept for photographic chemicals and nothing else.

Negative developing of most films should be carried out in total darkness but certain orthochromatic emulsions can be processed in suitable red safelights. Time and temperature are entirely interlocked and it will be necessary to keep developers at correct temperature for the whole time of negative processing. This can be done by a water bath where a large volume of water at correct temperature is used to surround the tank. A commercial thermostatically controlled heating tray is an expensive but very helpful device and room temperatures should be equal to the desired developer temperature.

Ideally, a common temperature between all solutions should be maintained, as this minimises grain to some degree.

In the quest for fine grain, the photographer should use the slowest film possible and a suitable fine grain developer as a matter of course, but should not over expose film and not over develop negatives. Density should be the minimum needed to produce full tonal rendition of every value required in the final print. This is generally a considerably 'thinner' negative than most people regard as normal and in the case of 35 mm negatives, even moderate density can crucially affect graininess, in an adverse manner.

At the other extreme of 35 mm photography, that taken by available light, where photography is often made with wide apertures, a good grain pattern can beautifully enhance the feeling of immediacy and give the eye an overall structure on which to rest while it is decoding the soft edges that result from low contrast, high speed film, taken with marginal depth of field. Developers that are of excellent acutance will assist the production of this structure. Also it is wise to include many large areas of open grey tone if possible, as these can become essential and powerful elements of design when broken up with grain pattern.

Processing must always be made with the original photography in mind and every film should be coded to indicate its contents. A 'clip test' should be made of each roll shot in differing light conditions and processing of the whole roll should not continue until this test or successive tests are found to give desired negatives. In altering development after making clip tests, it is wiser to produce radical adjustments to time for new tests. For example, if a test is made at a normal 6 minutes and is found to be seriously under exposed, double the development time to 12 minutes and review the result. This will of course increase contrast overall and there may be loss of shadow detail. Most professionals shooting in available and difficult lighting conditions will bracket the exposures into one frame over and one frame under exposed, making sure that sufficient leading frames are exposed at 'normal' to allow for testing.

With automatic cameras like the Contax RTS, which reads difficult light conditions with considerable success, it is usually not necessary to bracket and many more usable negatives will result.

If the subject has very heavy shadows or

considerable black areas that must retain detail it will be necessary to supplement the light with reflectors or by artificial light or alter processing, or all three. In these circumstances film should be *over exposed* by at least ½ a stop and under developed by 15 to 20%. This will considerably increase structure in the dark areas and the loss of contrast which this technique produces can be compensated for by moving to a higher printing grade of enlarging paper.

Of course, if the beauty of the subject depends on high light surface texture such as skin tones or organic surfaces in landscapes and shadow areas are of small importance in the overall image, it is possible to *under expose* by 1 stop (or even more) and compensate by *increased* development. This may give added grain, but usually not enough to be of great concern, because highlight density can be kept at its minimum.

Very contrasting lighting conditions or accidental over exposure of film may be treated by shortened developing times or the use of a compensating developer. A simple, effective compensating formula could be made as follows:

Metol Softworking Developer

Water 50°C (125°F)	(24 ozs)	750 cc
Metol	(¼ oz)	7.5 gm
Sodium Sulphite	(3 ozs)	100 gm
Water, cold to make	(32 ozs)	1000 gm

Develop 12 minutes at 22°C (72°F) and discard after each batch.

Develop TRI-X at 21°C (70°F) for about 14 minutes for the purpose of the first test. Revise development accordingly, when you see the result of testing.

The question of negative processing equipment is one of personal choice. Most professionals favour stainless steel because it is hard wearing and easily cleaned, but heavy duty plastic is also most suitable; Brookes, Nikkor, Paterson are good names to begin with, while Kodak supplies excellent, if expensive, professional equipment for those processing large formats or quantities of roll film.

It has been my practice to process important films in large volumes of developer, usually in Kodak 13 litre (3½ gallon) tanks and always with the 'one-shot' technique. This maintains exceptional brilliance in the negative and, although expensive on raw material, can be justified in all fee-paying photography or at any time superlative prints must be made.

After development and in the dark, films should be immersed in an acetic acid stop bath for the correct time (100 to 120 secs) and then transferred to a hardening-fixing bath. Light should not be turned on for at least 2 minutes after the film enters the fixer. Correct fixing time will be stated on the manufacturer's technical sheet but usually is taken to be twice the time the negative takes to clear. It is important to discard the fixer well before exhaustion of the bath takes place, but fixers will keep for a considerable time when not being used, provided they are protected from the air. Fixer tanks should have floats or lids to cap them, for this reason, or be covered with cling film.

Generally, in photographic chemistry, pre-mixed liquid concentrates have replaced the cheaper powdered kind and, in professional work, benefits are great. Speed of mixing, accuracy of dilution, and reliability are important plus factors. Now that extreme concentrations are on the market, the advanced, but non-professional user should also find this helpful, especially as regards storage space.

In my darkroom I have two exceptions: Promicrol from May & Baker for negatives, and Dektol print developer from Kodak. Both of these are powders and will keep indefinitely in this form. Tropical climates could also influence keeping properties of liquid concentrates and it is advisable in this case to keep basic chemicals as powder, protected from moisture by polythene bags.

After the image is fixed, a vital next stage is reached. Washing away residual chemicals will protect negatives from stains and fading and should be thorough. Fortunately film base will not absorb chemicals and washing is comparatively rapid. If a temperature of 20°C (68°F) can be maintained, 25 minutes should be sufficient if the washing tank disposes efficiently of its waste chemicals. Syphon washers will be found very effective and the incoming water supply should have a suitable filter trap to prevent grit from entering the tank.

After washing, it is wise to soak films in a wetting agent such as Kodak Photo-flo, for the recommended time, but I have found it better to use it at half the suggested strength. The wetting agent speeds drying and helps to prevent water marks. Note that a water mark is usually permanently damaging to a negative and on 35 mm frames quite disastrous.

To assist in prevention of this, it is wise to take a soft photographic sponge, dip it in the wetting

agent solution, wring it quite dry, then gently wipe it over the film, both sides, while the film is suspended at full length. A chamois leather, soaked and wrung out may also be used, but note that *any* particle of dust embedded in cloth or sponge will scratch *every* frame of film. All wiping accessories should be frequently washed in plain hot water and kept in sealed plastic bags or dust free cupboards.

Large format sheet film can be carefully cleaned of water droplets after immersion in wetting agent by lightly wiping over with a straight-bladed squeegee or windshield wiper while being held in a film clip suspended from a chrome screw in the darkroom wall. This technique is even more vulnerable to dust problems and should not be used on roll film.

Drying should take place in warm (28°C) (85°F) but dust free conditions. A special drying cupboard will be found essential for the highest quality work, particularly for 35 mm formats.

After drying is complete, ends of roll films are trimmed off and film is cut in even lengths and placed in negative envelopes. It is essential that this be done for every negative that will be kept for printing. Negatives must be coded in order that clients may order and in the case of sheet film, a waterproof ink is used with a fine pen to write the number in one corner. Write this on the back of the film; 120 roll film usually receives a job code at frame 1 and frame numbers at each frame. Some manufacturer's frame numbering may be dense enough to read in contact printing, but usually larger numbers are needed, put on with an India ink pen. 35 mm is best put in clear plastic sleeves which have been preformed into 18 × 24 cm (8 × 10 in) sheets. These can be contact printed without removal, as if it were a single large negative, and this reduces handling to a minimum. Each sheet must carry a code number and this can appear on the contact proof. Numbering on 35 mm is usually excellent and does not need extra attention. Photographic Products Co. from Redondo Beach, California, makes a suitable proof file and other excellent makes are obtainable from good camera stores.

All negatives should be contact printed before any further work is done on them and it has become fairly standard to do this on a sheet of 18 × 24 cm (8 × 10 in) single weight, glossy bromide paper. Commercial proof printers are made (Paterson has a good one) but I have found, in a professional darkroom, a 25 × 30 cm

(10 × 12 in) piece of 6 mm ($\frac{1}{4}$ in) plate glass which has had the edges polished is a good substitute. Be careful to keep this free from scratches and very clean. Keep it in an envelope.

Contact prints made this way are used by the client to assess the shooting session and help select those frames which are to be printed. Most art directors will ask for the entire frame to be enlarged without cropping, but if the photographer is permitted or demands this right to crop his own picture, a pair of cropping L's should be made from black paper and a very lengthy study of each frame and all possible cropping solutions should be undertaken before any enlargements are made. Check selected frames on the proof sheet by using a 5 × magnifier and also check the negative the same way. If no defects appear, note the code number on a sheet of paper and proceed to the next frame.

Enlarge only those frames which have been carefully studied in this way.

Printing from good negatives can be a very satisfying experience and the advanced photographer will normally be concerned with enlarging small negatives to much larger prints. Contact printing with slow print emulsions to achieve final pictures for exhibition is not generally used by modern photographers unless a very large format camera such as 18 × 24 cm (8 × 10 in) is the original taking size.

Enlarging prints will usually be made for two reasons, either for reproduction, in which case it is an *intermediate* stage in printing, or a final print for viewing. A reproduction print *must* be made with the anticipation of considerable loss of tonal quality. Only with exceptional and very costly engraving can the full tonal range of the picture be realised in anything approaching a facsimile of the original photographic print.

It must be remembered that the black and white image will be very seriously degraded by the newsprint process and many mass media print techniques. Brilliance is paramount and the picture must never depend on subtlety of tone for its power. Such pictures as are used in cheap print media must be somewhat raw in tone and be very direct in concept.

Fine art reproduction, such as in expensive books or quality wall prints can achieve, mechanically, very high standards, but discuss with the printer precisely what he prefers in the way of a reproduction print from which to make blocks.

Prints for *viewing only* are quite another matter

and allow for every possible subtlety, provided that the exhibition of such prints will be carried out in suitably high levels of lighting.

So, the quality printer of photographs must first discover for what purpose his print will be used. For reproduction, he will often go to a more contrasting paper, looking for brilliance in the highlight areas and rich, but open, shadows. Absolutely black must appear black. Greys must fit precisely those tones which the print medium can accept.

Just as in negative making, printing is a matter of careful routine and cleanliness, with strict attention to time and temperature. First choose a quality print developer, such as Ilford P.Q. Universal, May & Baker Suprol, Kodak Dektol or Paterson Acuprint. Select a basic paper surface and as a general rule, keep away from exotic surfaces. Personally I have always wanted my prints on a glossy but unglazed double weight paper, as this seems to impart maximum brilliance

to the photograph if it is to be exhibited and is also perfectly acceptable for reproduction. As a matter of cost, also, the photographer should keep a very limited range of papers on his shelf. All enlarging paper loses brilliance as it ages and paper should only be bought in quantities that can be used within six months.

It has been my practice to use all print developers at $21\,^{\circ}$C ($70\,^{\circ}$F) rather than the usually recommended $20\,^{\circ}$C ($68\,^{\circ}$F). Developing times are shorter, but with slightly reduced exposure times in the enlarger, this is easily controlled and very crisp prints result from this technique.

It is important to use test strips and these should not be smaller than 20×5 cm (8×2 in). With a little skill, only two such strips will be needed to indicate exposure on even really difficult negatives. Assess all tests in diffuse daylight, if possible, and allow for the fact that dried prints will be a little darker and lose some highlight value in comparison to wet prints.

Having assessed test prints, in diffused daylight conditions (or diffuse fluorescents), make a first total print and develop it for precisely 2 minutes at $21\,^{\circ}$C ($70\,^{\circ}$F). If it goes dark and past acceptable standards, make a new print and cut exposure time 50%, developing again for 2 minutes precisely. Assess these results and if very close to standard, but needing more over-all density, allow 1 minute more in the developer. In darkrooms with tested safe-lights, up to $4\frac{1}{2}$ minutes in the print developer can be permitted, usually with the result that the tonal range is greatly extended, but under these conditions care must be taken that highlights do not lose their brilliance during this extra time.

Never work with exhausted developer, read the manufacturer's printed instructions for correct dilution and throughput and avoid any contamination. The least drop of fixer in most developers will degrade the quality of blacks on print paper. Wash your hands in running hot water after touching the fixing bath.

A 2% acetic acid stop bath will be needed and a fresh hardening-fixing bath which is large enough to contain reasonable quantities of prints, when they are agitated. It has been my practice to use a rapid liquid fixer such as Amfix from May & Baker, as the extra expense is quickly offset by the efficiency of the bath and the reduction of fixing times.

Washing prints correctly is a laborious business. The paper base absorbs large quantities of chemicals and is reluctant to release them. Time

Check list for good enlarging

- Accept only perfect negatives.
- If substandard, re-shoot negative.
- Clean negative gently with lens tissue on backing side only.
- Using a Staticmaster or camel hair brush, *slowly* wipe both sides of negative before putting into negative carrier.
- After placing in negative carrier, use anti-static brush once more.
- While using enlarger check for dust by turning on enlarger lamp.
- Use canned air to dislodge dust while placing in carrier.
- Focus with no safelights on, use easel magnifier.
- Use at least 20 × 5 cm (8 × 2 in) test strips of paper.
- Maintain developer and room temperature at 21°C (70°F).
- Develop test 2 minutes at 21°C (70°F) *precisely*, in basic P.Q. developer.
- Use stop bath 30 seconds.
- Use fast fixer 1 minute.
- Turn on diffuse daylight colour light.
- If test incorrect alter enlarging time 30% either way.
- Test again, process and assess in white light.
- Re-focus enlarger.
- Make final print.
- Leave final print in fixer minimum 2 minutes before white light.
- Wash 1 hour in rapidly changed water for permanence.
- Air dry in blotting paper or on plastic racks.
- Spot each print under daylight illumination.
- Reprint any seriously damaged work.
- Danger points are: dust on negative, dirty lenses and glasses, vibration during exposure.
- Cleanliness is paramount, precision indispensable and contamination of solutions a constant possibility.
- Always wash your hands in hot running water and use print tongs where possible.

each batch of prints and do not add further fixer-contaminated prints to such batches without resetting the timing to zero. Prints must be able to move gently within the wash tank, and water should be piped into the bottom of the tank if possible. Rapid dumping of water, either by simply emptying the tank or by a dump-gate device, enormously improves washing effectiveness. Warm temperatures of about 20 to 24°C (68–75°F) also assist. Under these conditions, single weight paper can be thoroughly washed in 20 minutes while double weight paper will take at least 1 hour. Double weight paper is helpful in improving both wet and dry handling characteristics and for exhibition printing should always be used. Where a photograph is to be cut out and used in a paste-up for commercial work, single weight paper is often essential, but ask the art director for his preference.

After washing, prints should be drained for 5 to 10 minutes to remove excess water and dried, preferably in warm air, on absorbent blotter rolls or glass sheets. Heated drums are used for professional finishing, because of speed, but it should be noted that excessive heat will 'burn-out' a print, giving a stained look to highlights and a bronzing to the shadows all of which can be most destructive in terms of quality. The canvas belts of such drums become easily contaminated with chemical residues from rush printing jobs and must be changed frequently to avoid contamination and staining. Never dry archival prints on rotary drums with a belt feed.

Second-rate prints should be ruthlessly destroyed but final judgments are better left until all are dry.

Dry prints should be carefully inspected for dust marks or abrasion. Reprint any photograph

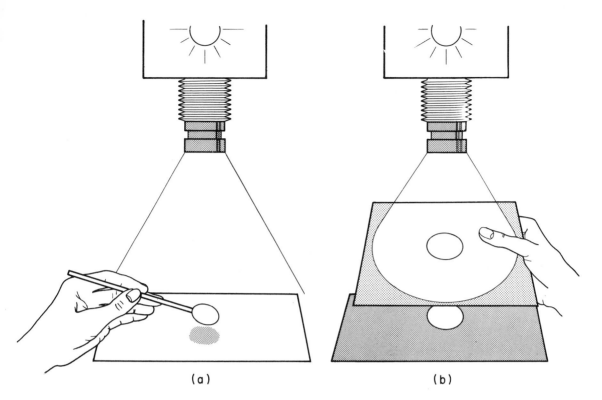

(a) (b)

Fig. 13 By interrupting the enlarger beam with these simple tools, light can be controlled to fall in more or less quantities where desired.

that has been damaged in processing by stains, cracks or other surface problems.

Spotting is a special skill, but must be undertaken in every case where dust marks, hair lines or negative abrasions have caused problems. No good photographer will allow substandard work to leave his hands and the most basic remedial work (and possibly, the most tiresome) is spotting. Daylight is the best illuminant, but diffused fluorescent is effective. Do not spot prints under tungsten light as colour matching is almost impossible.

Use a .000 brush or any fine pointed sable and use a good spotting medium such as Spotone liquid dye. The brush should be kept in a plastic tube and should be capable of being made into a needle sharp point. The liquid dye should be a cool black for all work on standard prints but for direct toned prints and chlorobromides, warmer dyes are suggested. White watercolour can be used to cover dark spots and it is often necessary to spot these

Check list for archival protection of photographs

- Use fresh photographic stock.
- Mix all solutions accurately.
- Maintain correct temperatures.
- Use one shot technique for negatives.
- Fixation should be precisely timed and never excessive.
- Never switch white light on prematurely.
- Washing should be temperature controlled and prolonged.
- Material should be air dried at room temperature.
- Use fibre based print paper.
- Protect all images from excess ultra violet light.
- Store processed colour film at 0°C (32°F) in sealed containers.

'Lining' large areas to be filled

Random 'pointing' for small spots

Fig. 14 Spotting needs a sharp brush, daylight conditions and patience. 'Lining' large areas and spotting small areas will bring results.

whitened areas again with black, in order to achieve a final invisible grey.

Mix a small amount of wetting agent, say 2 drops per 100 millilitres (4 ounces) in the water which is to be used for mixing the spotting dye, but on very slick glossy print surfaces, saliva is often the best mixer as it is a little stickier and clings well to this kind of paper.

Even small spots should be touched many times with the almost dry point of the brush and only minimal amounts of dye deposited, in a series of infinite dots that gradually fill the whole blemish.

Larger areas need to be wetted slightly, then blotted dry. Cheeseborough-Ponds Ltd Q-tips are helpful here. 'Lining' of larger areas (Fig. 14) helps break up massive spots and then regular dots can be produced with a carefully rolled brush point.

Spotting of resin-coated prints is not always easy owing to the low rate of absorption by this emulsion but a water mixture that is made of 100 millilitres (4 ounces) of water, 2 drops of acetic acid (2% strength) and one tiny drop of wetting agent, can help in getting dyes to take.

Take great care to finish your print perfectly and *never* let a client take away an unspotted print nor submit such a print for public inspection.

Fig. 15 Flow chart of the photographic process.

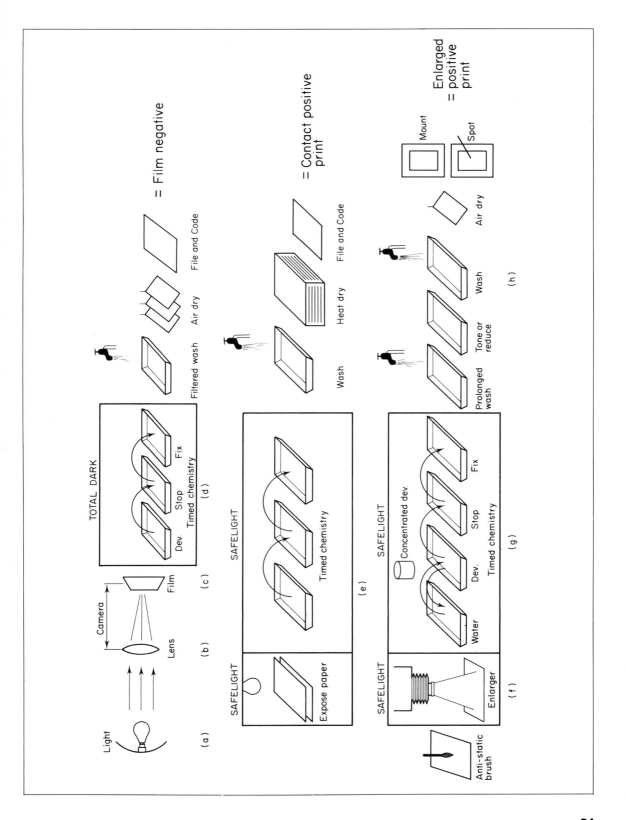

(a) Light

(b) Camera — Lens — Film

(c) SAFELIGHT | TOTAL DARK — Dev. Stop Fix / Timed chemistry — (d) Filtered wash — Air dry — File and Code = Film negative

(e) SAFELIGHT | Expose paper — Timed chemistry — (f) Wash — Heat dry — File and Code = Contact positive print

(g) SAFELIGHT | Anti-static brush — Enlarger — Water Dev. Stop Fix / Timed chemistry / Concentrated dev. — (h) Prolonged wash — Tone or reduce — Wash — Air dry — Mount / Spot = Enlarged = positive print

3 Creative Controls

The subject in front of the camera has only the significance the photographer cares to give it. The photographer can and must control the many variables which will appear at every part of the photographic process.

Apart from the elementary controls of standard chemistry, sharp focus and usual care, the advanced photographer will find that he can in many ways alter the photographic image to suit his own purpose and intensify the communication he wishes to make.

The purpose of all controls is just that: to direct the eye of the beholder so that he will accept what it is the photographer wishes to say. This controlling of the optical and chemical aspects of photography is a simplified form of coding and should never, therefore, be so mysterious or impenetrable that it exceeds the familiar experiences of the target audience. It should be clearly understood that the camera image need not be left pure and untouched but can legitimately be manipulated by the photographer to suit his own purpose. The cold optical stare of our twentieth-century, one-eyed witness, can be made to disclose as much or as little of what passes before it, as the photographer desires. The control factors in photography can largely be categorised as follows:

A great number of these controls will interact, sometimes the interchange will be directly proportional to the exercising of the initiating control factor (Fig. 16). Thus if a certain fast film type is loaded, the camera, in bright light conditions, must be stopped down, or the shutter speed increased, or a neutral density filter added, or development decreased, etc. This in turn will determine whether the resulting picture is deeply focused or whether the subject is isolated by selective focus, whether moving objects are blurred or sharp, whether heavy grain structure is used to enhance documentary effect, etc.

Always be aware that compensating factors will generally be required whenever *mechanical* controls are used but rarely need be considered when *conceptual* controls are initiated.

Mechanical Controls	**Conceptual Controls**
Film controls	Research
Camera controls	Pre-visualisation
Optical controls	Viewpoint
Chemical controls	Environmental control
Printing controls	Lighting control
	Separation
	Editing
	Cropping
	Scale
	Presentation

Neutral Density Filter Chart and f. Stop Increases

Density	Transmission by factor	Increase in %		f. Stop
0.10	80.0	1.2	×	$\frac{1}{4}$
0.20	65.0	1.5	×	$\frac{1}{2}$
0.301	50.0	2.0	×	1
0.40	40.0	2.5	×	1.1/3
0.50	32.0	3.1	×	1.2/3
0.604	25.0	4.0	×	2
0.70	20.0	5.0	×	2.1/3
0.80	16.0	6.2	×	$2\frac{1}{2}$
0.91	13.0	7.7	×	3
1.00	10.0	10.0	×	3.1/3
1.20	6.3	15.8	×	4
1.50	3.2	31.2	×	5

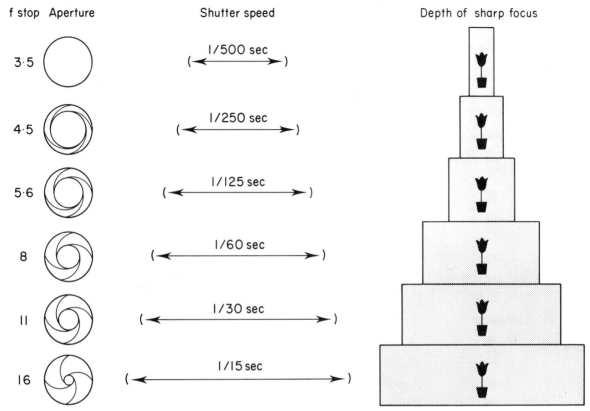

f stop	Aperture	Shutter speed	Depth of sharp focus

3·5 1/500 sec (⟵⟶)

4·5 1/250 sec (⟵⟶)

5·6 1/125 sec (⟵⟶)

8 1/60 sec (⟵⟶)

11 1/30 sec (⟵⟶)

16 1/15 sec (⟵⟶)

Fig. 16 Physical controls on the camera generally require compensatory factors, e.g. when a short depth of focus is needed a fast shutter speed is used to compensate for the large amount of light passing through the widened lens aperture. To secure an extended depth of field, it is necessary to select a small aperture and then compensate for the lack of light by leaving the shutter open for a considerable time. This aspect of control is quite fundamental to photography and is proportional. Thus at the top of the graph, an exposure of 1/500 at f. 3.5 will give approximately the same amount of light to the film as the sequence at the bottom, 1/15 at f.16, but the optical nature of the image will be radically different.

FILM CONTROLS

Control will begin first with the selection of film. Fine grain film will deliver sharp-edged images with no grain and a brilliant, long scale of tones. Exposure must be *exact* and development precise. Speed of such a film will be slow and usually a tripod must be used. This slow speed can advantageously be used as a control to permit slow moving objects to blur and thus look much more believable. Cyclists, walkers, mountain streams, waves, trees and fashion models can often be suitable subjects for the slightly blurred movement which enhances the naturalness and immediacy of the movements which the photographer is trying to portray. Very pronounced blurring, such as is produced by time exposures of 1 to 10 seconds (Fig. 17) can only be attempted in normal light by using 25 ASA film or faster film with Neutral Density filters. Normal or fast film can be slowed down by adding these N.D. filters, but inherent grain remains and most movement which carries an exaggerated blur will benefit by being grainless.

Medium or particularly fast films have enormous attraction as documentary tools. However, in this photography, mood is paramount and the sense of human involvement is essential. Clear-cut grain and low contrast silver greys such as arise when Tri X is exposed at 1000 ASA and developed in Promicrol, diluted 1 + 4, can be a beautiful way of suggesting mood. Fast film exposed under existing light conditions needs most careful processing, but the absence of flash light in such pictures immediately relaxes the viewer and suggests normal experience.

33

Fig. 17 An example of extreme blurring by making the camera keep pace with the subject and the use of a slow speed.

Learn to use *grain, sharpness* and *unsharpness* to help your photographs communicate. Slow films are obviously helpful to suggest impressionistic moments by the use of blurred edges or action. It is no accident that the Impressionists were fascinated by the camera in its early development. Had chemistry been at the advanced level that optics and camera design had then reached, many painters of the time would probably have become deeply involved with photography as their major means of expression.

Selective focus (Fig. 18) is an elementary design control and usually requires the use of slow film, about ASA 25. The blurred edges which result

Shutter speeds to stop movement past the lens at 3 to 5 metres (10–16 ft) distance

Subject	Approx. speed mph	Speed of Shutter
Swimming	2	1/60
Walking	2½	1/100
Running	10	1/300
Cycling	12	1/500
Horse galloping	20	1/1000
Heavy surf breaking	40	1/500
Speed boats	30	1/1000
Car	50	1/1000
Train	80	1/2000

Fig. 18 Areas behind the subject can be reduced in importance by using wide apertures and focusing the camera only on the eyes.

when cameras are moved over reasonably static scenes, or when fast moving subjects are exposed with slow shutter speeds, also usually depend on the use of slow film. The grainless, sweeping effects which result from such film add enormous beauty to relatively dull subjects.

CAMERA CONTROLS

The first basic choice of control in this direction, is that of the camera itself. If your wish is to communicate line, form and texture, producing sensitive, tactile reminders of organic subjects it will be wise to use the larger format cameras. Some leading professionals will use an 18 × 24 cm (8 × 10 in) format but this greatly complicates ancillary equipment. A 13 × 18 cm (5 × 7 in) film size is possibly the largest needed and is certainly the ideal format for most professional use, both in colour and black and white. This is a saving compared with 18 × 24 cm in film cost for the client, a saving in effort for the photographer and a saving in silver for Mother Earth, yet a breathtaking rendition of natural objects and their environment is still possible. The size of these larger cameras and the cost·and weight of supportive equipment, plus the expense of film, generally limit this kind of camera to professionals or photographers with generous private means. All still life photographers must aspire to ownership of such equipment. My own choice has been the Arca-Swiss monorail system, made in Switzerland. This is a light weight, rigid, but

entirely flexible system which is highly portable, yet capable of totally controlled operation.

Such cameras have a distinct advantage in that corrections may be made to parallels, depth of field and perspective (Fig. 19). Their disadvantages are that they must always be used on a tripod and can rarely be used to capture fast moving subjects, especially where there is any notable interaction with their environment. Absolutely everything which appears in the final photograph, with this type of camera, can be pre-visualised and placed in precisely the position desired and then enhanced

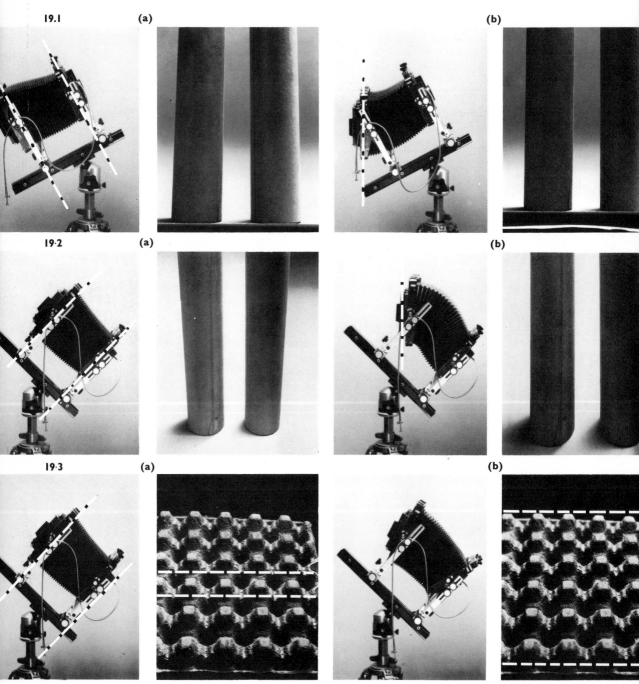

19.1 (a) (b)

19·2 (a) (b)

19·3 (a) (b)

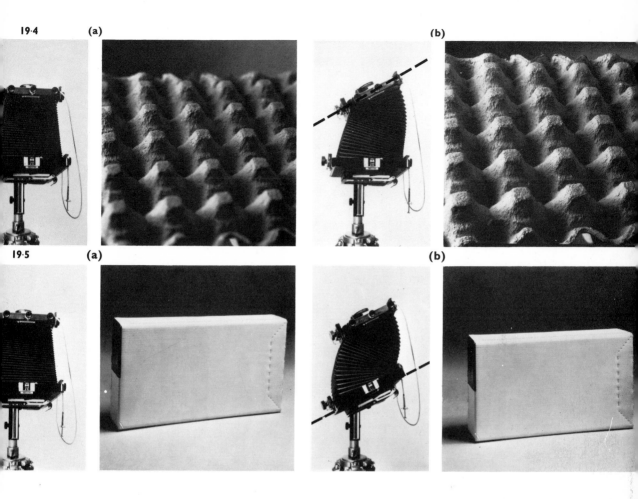

Fig. 19 The view camera is capable of extreme flexibility in its optical system and this produces effects essential to the production of many professional photographs.

(1) With the camera looking up at parallel lines, use the *swing back*.
 (a) normal view.
 (b) corrected view.

(2) With the camera looking down at parallel lines use the *swing back*.
 (a) normal view.
 (b) corrected view.

(3) To improve depth of field and make selected planes of the picture sharp, use the vertical *swing front*.
 (a) normal view.
 (b) corrected view.

(4) To increase sharpness in a plane of the picture which is at an angle to the negative, turn the *swing front* in the direction of the plane of interest to more nearly parallel to that plane.
 (a) normal view.
 (b) corrected view.

(5) To control perspective in horizontals that are at an angle to the negative plane, use the *lateral swing back*. Diminishing lines can be restored to normal by swinging the back almost parallel with the subject. Swinging the lens standard also parallel with the subject increases sharpness over the inclined plane.
 (a) normal view.
 (b) corrected view.

with exactly the light which the photographer considers best: almost the ultimate control in fact.

At the other end of the scale, the SLR owner has a small format with usually only moderate control of perspective. But such a camera should not be used to explore deeply tactile experiences. This camera makes exciting statements about human activity, feelings, mood. The controlling factor in capturing these elusive elements is fast operation, continuous supply of new frames of film

and selective focus. With such a volume of photographs, literally machine made, editing becomes a primary control. First 'edit' the scene before actual use of the camera. Quickly walk around the whole environment in which picture-taking will take place. Watch the fall of natural light, mentally note where advantages may be gained by amplifying these sources with added tungsten or flash light.

If this kind of photograph is taken, with a person, in a studio, *list on paper* actions that the model may perform, together with colour combinations, backgrounds, props, etc. Assemble all of these ready for the time photography is planned to begin.

While actually shooting with 35 mm format, continually modify and edit while the interaction of subject and environment takes place. Change angle, change aperture, change lenses, change lighting. This kind of photography needs a progression of changes, but always every change must be under the control of the photographer. Discard every uncomfortable picture immediately you see it in the view finder and *before* you press the release button. Even a passing, impressionistic shot must have a controlled and intended structure, otherwise the session will degenerate into an expensive, snap shooting situation, that will never produce successful communication.

This type of photography revels in fast shooting, giving immediacy and mood. Grain can be an additional graphic plus factor. Except in exceptional circumstances, such as crowded environments or sports activity, all 35 mm shooting should be conducted from a tripod, preferably also with a cable release. The danger of knowing that 36 frames can rapidly be exposed, cannot be over emphasised. Shoot each tiny frame as if it were of maximum value and importance. Think *before* you press the button. Excessively fast shooting can, in the hands of a highly competent professional, be a

Order of perception

Movement or apparent movement is seen first.

The colours yellow and blue are seen second.

The colours red and green are seen third.

Outline is seen fourth.

Form is seen fifth.

There can be no perception without separation of form from form.

Fig. 20
(a) If a wide angle lens is used, distance between objects in the foreground and those in the background are exaggerated.
(b) When a normal lens is used, reasonably normal relationships between the scale of objects, near and far, result.
(c) When a long focal length lens is used, backgrounds are considerably enlarged in relation to foreground objects, aerial perspective is condensed dramatically.

(a)

(b)

(c)

deepening contact with a subject and its changing mood, producing momentous pictures. The beginning photographer and even the young professional can produce a mindless waste of photographic opportunities through lack of control in this matter.

Select shutter speeds that will enhance the activity of the subject and use compensating aperture or film speeds, or select apertures that will define the image ideally and compensate with suitable shutter openings or film types. Remember over exposure and under exposure can also be useful factors in controlling graphic effects.

OPTICAL CONTROLS
These must begin with the selection of the proper focal length of the taking lens. Both in view cameras and with smaller, structurally fixed

Filters for black and white film

Subject	Effect	Filter
Cloudy sky	Normal	Yellow or pale green
Clear sky and white clouds	Darker than natural	Orange
Normal blue skies with clouds	Theatrical effect	Red
Plain sky, deep blue	Black sky	Polariser
Fabric	Darker than normal	Complementary colour to subject
	Lighter than normal	The same colour as subject
Flowers	Lighter foliage	Light green
	Separate flowers from leaves	Colour of flowers
Pottery and ceramics	Increase contrast of pattern	Complementary to main colour in subject
Landscapes	Natural	Medium yellow
	Improved rendering of contours	Orange
	Theatrical effect	Red
Seascapes	Natural look	Light green
	Dark water	Dark yellow
Portraits with landscape	Natural skin and natural landscape	Light green
Indoor portraits	Improve blemished skin	Medium yellow or light red
	Deepen skin colour or texture	Light green
Snow scenes	Improved contrast	Orange
Fog or haze	To exaggerate	Blue
	To decrease	Ultra-violet
Wood	To improve texture	Red orange
	To improve light yellow woods	Dark yellow
	To improve dark woods	Pale green

Fig. 21a This picture may not please an engineer because of the distortion, but it does include a vast amount of information about the job of loading special railway wagons. The photograph was made on a Rollei SL66 fitted with an ultra wide Zeiss Distagon 30 mm lens. Notice that care has been taken to keep the chimneys vertical in the centre of the picture in order to help stabilise the image.

cameras, the choice of correct lens length, plus camera viewpoint can vitally alter the design of an image.

A 'normal' lens does not usually deliver a normal impression of the subject unless the print viewing distance is highly controlled. In most cases, a focal length of about double the normal will give enough latitude in viewing to produce a pleasing effect for most people in most situations of viewing.

Normal lenses usually work at very wide apertures and focus at close and even macro distances. They are usually moderately wide angle and compact to carry. One should be bought for every camera or format to be used. The longer focus lenses will give opportunities for selective focus at even quite small apertures and because of their narrow angle of acceptance can easily isolate subjects from complex backgrounds.

These long lenses are of immense value for shy or inaccessible subjects and are essential for most sports. Distortion of aerial perspective, a 'compacting' of depth, will take place with this type of lens and haze will be greatly increased. These attributes may be deliberately used in adding impact to an image and will alter in direct proportion to increases in focal length. Lenses over 200 mm on 35/SLRs and 300 on 6 × 6 cm (2¼ sq in) cameras, will magnify haze, while very long lenses, say 1000 mm or more, must often not be used in hot or hazy conditions. All lens lengths above 'normal' tend to increase apparent weight in

Fig. 21b The use of the 30 mm Distagon for portraiture creates dynamic tensions within the image and many professionals find the wide and ultra wide lenses most useful for dramatic editorial pictures. Where no verticals are present, distortion is usually more acceptable.

attention to specific elements of the image. Their most usual role in strictly commercial terms is probably to photograph architecture or in confined spaces where the camera cannot be located far from the subject or tilt up or down would produce unwanted divergence of parallels in the subject.

Wide angle lenses tend to produce graphic images, quite bewitching at times and with great emphasis on pattern and edges. Close objects come forward from their background and when ultra short lenses are used, a substantial flattening of the three dimensional planes will occur, until finally the image takes on almost a two dimensional appearance which brings the image/illusion almost parallel to the surface of the print.

Lenses should be equipped with lens hoods, which shield the lens from stray reflections and this is very necessary for studio photography with flash light. A compendium hood such as made for the better view cameras and 6×6 cm ($2\frac{1}{4}$ sq in) cameras will be found useful. Lens hoods usually have provision for filters to be placed against the lens and filters are a vital *optical control*. Tiffen in the USA, BDB in the UK and Hoya in Japan are valuable names to remember when filters are being obtained. Adding even the thinnest filter to a beautifully constructed lens will degrade the image to some degree and this effect can of course be exaggerated to create special effects. Soft focus filters with clear, centre sharp areas, are fine for portraiture and the effect is accelerated by using wider apertures. Desaturation filters to modify colour or fog filters to give hazy highlights, dichroic filters to give spectral bands of colour to highlights, prisms to produce multi-images – the list is endless in the special effects area.

Much more precise, and often overlooked, is the use of colour compensating filters for colour photographers and coloured filters for monochromatic films. The cc filters gently compensate for light which is in some way out of balance with the film. In bluish shade a warming filter such as a Wratten 81 A or even an 81 EF could be used, while to cool the hot light of late sun on flesh tones the Wratten 82 series may be used. Delicate changes in film balance can also be obtained by using Cyan, Yellow, Red, Magenta, Green or Blue filters. These grade gently from density peaks of 0.05 to 0.50 and are much used by professionals to counter the effect of film faults or processing errors. Tests must first be made and if the results show that minor colour correction will be helpful, actual photography takes place with that selected filter

human subjects. Very thin people may be photographed with long lenses to give them flattering body proportions in the picture. In the very long lenses for 35 mm, the Questar is almost unmatched for quality and compactness and gives superb definition at very large magnification.

Modern cameras, especially the 35 mm SLR type, can easily be fitted with lenses which are of very short focal length and consequently very wide angle. The wide angle lens distorts real proportions dramatically (Fig. 21a) and is used most effectively by the illustrative photographer to draw

held very closely to the front lens surface. No more than three such filters should be used in one pack, or serious degradation of the image will result. View cameras often have provision for these thin gelatin filters to be held behind the lens and this can assist in holding optimum sharpness.

Filters for monochromatic film are most useful. In general, a good rule is to use the filter complementary to the colour you wish to darken, but if your wish is to lighten a subject, use a filter of the same colour. For example, to darken green foliage against the sky, use a red filter. To lighten such foliage use a green filter. Ruddy complexions can be given attractive creamy appearance if a red filter is chosen. Yellow filters darken blue sky and blue filters increase the effect of fog by lightening the bluish cast in the vapour.

Important also is the ultra violet filter. It should be left in place on all small camera lenses which are constantly handled on location. It does not increase exposure, gives good tone to skies, especially at higher altitudes and is a constant protection for expensive lens surfaces.

Filters for use with infra red film will be found essential, if this material is used, particularly the deep yellow No. 12 for colour infra red film. However, most interesting results can be obtained with this film by using filters of oranges, reds and pinks and this is a matter of testing.

Neutral density filters cut down the transmission of light through the lens and can be used to prevent over exposure in sand and snow scenes, allowing very wide apertures in ordinary lighting conditions or permitting super-slow shutter speeds for special effect.

Polarising filters in *rotating* mounts are most useful. As the front section of the filter revolves the polarising effect becomes more intense and the exposure must also be increased. This filter reduces reflection when light strikes shiny surfaces at about $30°$ to $35°$ angles and is a most practical help in photographing shop windows or cellophane wrapped packages. It also intensifies blue skies when the sun is at right angles to the lens axis and enhances the colour saturation of most colour film.

All filters will have a filter factor, this being the factor by which it is necessary to increase exposure to compensate for its density. For the cc filters it is usually minor for colour films and negligible for black and white films, but with polarisers, the factor can be as high as $8 \times$, which demands the use of very fast film and wide apertures. All filters

degrade the image and this is especially true of inexpensive ones. Buy the very best, particularly with polarisers, from reputable makers. On automatic cameras, no mathematics are involved with filter factors, as the camera will compensate. Hand held exposure meters, particularly spot meters, need only have the filter held in place over the cell while the exposure is read. Otherwise it is necessary to calculate from makers' own charts. Serious under exposure can result if these are not followed closely. Do not use filters at all in macro situations if it can be avoided and using cheap filters in this work can be disastrous to sharp focus.

Filters of course can be used over the light source itself in controlled lighting plans and the use of polarisers over lights *and* lens can give striking effects to, for example, organic crystal forms or can reduce reflections on surfaces to nil. Coloured filters over lamps must be non combustible, such as those made by Cinemoid, and these can introduce a magic dimension to mundane objects, especially where metal plays a large part in their construction. For example, colour photography of chrome motor parts can be treated in a very exciting way by this means but the effect should be delicately controlled.

Diffusion filters can be placed over the light source and these often subtly change the colour of the light towards yellow, apart from altering the quality. Inaccessible light sources can be filtered with diffusers by constructing silk or fibre glass tents to intervene with the direct light fall. Even large smoke bombs can be placed in buckets and fired, to give temporary diffusion to the fierce light of a summer sun, but make sure the local fire department knows about this activity well in advance.

CHEMICAL CONTROLS

Photography is highly susceptible to effects due to altering the normal chemistry or by adding or subtracting chemistry when the processes are complete. In situations where over exposure is suspected, with harsh blocked up shadows a 'compensating' developer can be used to save film. One is given in the preceding chapter. Super speed developers can compensate for under exposures, as can greatly increased development times. Colour balances can be changed during development by adding miniscule amounts of acid, but in every case it will be found that normal exposure, normal development and straight photo-finishing will produce excellent results. Many B & W photo-

graphers over expose their film by 10 to 25% and compensate for this by reduced development. This increases tonal scale considerably with good realisation of any black objects and excellent highlight detail. This treatment seems to work best with broad source-diffused light. On the other hand, contrast may be increased by under exposure and forced development. This is very useful to the professional whose photographs must end up in newsprint or other publications with highly absorbent paper. Any low contrast areas which must undergo reproduction on this kind of material will not separate and will smudge in printing unless given a full tonal scale of values, all of which separate clearly.

Fine art photographers may indulge in every chemical control necessary without suffering the hazards of reproduction. The most commonplace is to alter the construction of the print developer to give richer blacks, print the image darker and develop for 3 to 5 minutes. This almost black print may be 'reduced' in a highlight reducer to give very striking print quality.

Without this total approach, it is possible to achieve fine prints by allowing very moderate over development and then a brief immersion in a simple 'Farmer's reducer'. This same reducer can be applied to local areas with a soft brush or cotton wool, but the action must be watched closely as excessive reduction is irreversible.

In the development of prints, it can be helpful to use swabs loaded with warm developer (24°C) (75°F) at double strength to improve highlight areas, but fogging of these highlights can easily take place when using this technique.

A further chemical control is the use of toning solutions to tone the shadow areas of prints to rich browns, blues, greens and reds. Many commercial toners may be bought and the selenium toner from Kodak is excellent, as are the Tetenal toners from Germany. The plus factor of sulphur sepia toning, which is a very old technique, is that images become absolutely permanent. Such prints which have been made for toning must be fully developed, fixed well in fresh fixer and washed totally beforehand, otherwise stains will result. Vigorous and brilliant prints will produce ideal results. Always use toning solutions in very well ventilated rooms and keep them away from unexposed photographic film and papers.

It should be noted that in chemical control, water is a useful factor in its own right. Of course, dilution of developers can be used to reduce grain size and increase acutance, while improving overall tonal range. But a plain water bath, at the same temperature as the developer, can be used to cut contrast and improve gradation. Pre-soaking before development will help, but it can be used as an interruption to normal development by placing films into such a bath for one minute before returning them to the developer and so on. This also works very well with enlarging paper and can often give the effect of going to a $\frac{1}{2}$ grade softer in paper. The water in this case can be about 24°C (75°F) and the print should be a little over exposed.

PRINTING CONTROLS

These usually take place in the enlarging process (Fig. 22) and basically consist of 'dodging', that is applying light to the print by using a large black card with a hole in it or taking out light by using small black masks (Fig. 13) on the end of fine wire, to hold back areas of the print that tend towards over exposure. Many printers use their hands to interrupt the enlarger light beam and this can be successful except in applying the technique to very small areas. Precision counting is essential and an automatic timer is a wise investment.

CONCEPTUAL CONTROLS

These are easily the most important for the photographer to learn and definitely the most difficult. Mechanical control is largely a matter of discovering technical references and then practising easily acquired skills. The mechanics of photography should become only the means to improve communication and never the goal of photography itself. Learn these controls and then try to establish very sound, routine habits which employ them. On the other hand the conceptual controls are infinite and will never be fully mastered.

RESEARCH

Research is a fundamental tool, especially to the professional photographer. Know your subject as thoroughly as possible before photography commences. Talk to experts, not about how to do it, but about the subject itself. If recreating a difficult room set, or a believable, but unfamiliar, environment in the studio, visit the real thing if possible, search libraries for visual references, talk to those who know. The photograph made of any subject is largely the sum of the photographer's knowledge of that subject, plus a little mechanical skill.

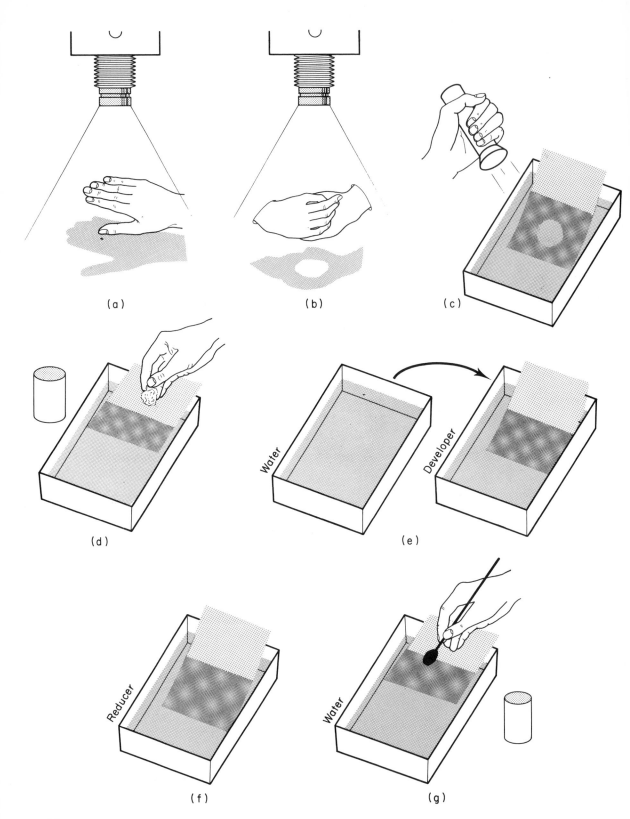

(a)　　(b)　　(c)

(d)　　(e)

(f)　　(g)

Fig. 22 Enlarging controls.
(a) I hand in beam.
(b) 2 hands in beam.
(c) Torch, working with light.
(d) Hot developer swab.
(e) Water bath.
(f) All over reducer.
(g) Local reducer.

Research all locations very thoroughly before committing expensive photographic operations to the field. Remember, a location photographer *must* come back with usable images if he is being paid a fee.

PRE-VISUALISATION

This is a meditative exercise where the photographer will attempt actually to visualise the final photograph long before he takes it. This cannot be done on snap shooting assignments, press assignments, etc., except by the most skilful and swift thinking master photographers, but always should be done by the photographer involved in deliberate, controlled studio work. Research is a key aid to pre-visualisation, knowing how the subject might look when photographed by a particular lens in a particular quality of light etc.

It has been my practice to draw tiny stamp-size layout sketches (Fig. 23) to help fix visualised situations in my mind and if one of these is found especially promising it can be redrawn a larger size on the sketch pad. This technique is an acquired skill and can save hours of wasteful shooting. It encourages the photographer to think clearly about his subject and closely to define the structure of the final image. This positive point of view will impart greater authority to the photograph and give it distinction and life.

To assist in this exercise, sit in a quiet comfortable room and project in the mind a possible camera image when taken from a selected viewpoint in relation to the subject. Try and re-visualise the effect, but with a shorter lens. Change the imaginary viewpoint, add a suitable accessory or prop to the subject, visualise the colours of the background. Note these down on plain paper in small, almost involuntary, sketches.

VIEWPOINT

This is again a very basic control. From the choice of angle and distance, many images will make

Fig. 23 Pre-visualisation sketch for lobster picture in Case History Number 56.

unconscious, but penetrating, statements to a beholder. Look up at a subject with your camera and you suggest dignity, power. Look down and you enter design, pattern and intellectual areas of the mind. Choose a distant view and emotional connection is lost. Take the camera in close and organic designs are revealed while strong emotional contact is made with the image. The same viewpoint but with differing focal lengths of lenses can drastically alter the communication. Camera position can often give logistical problems. Wild life photography, underwater or aerial photography need very careful arrangements to bring about correct and powerful viewpoints.

ENVIRONMENTAL CONTROL

Sometimes this will arise from the establishing of ideal viewpoints, but the best photography takes place where the outer perimeter of the immediate environment is under strict control while the centre, involving subject and photographer, is left open to find an interaction with each other and with the environment. Await the happy accident. Probe any insecurity until a reaction takes place. The camera is at its best in recording volatile situations, but the *subject* must be stabilised and the *viewpoint* must be stabilised, even for a fraction of a second, while the camera records the image of the photographer's choice.

This means that a studio should be closed to wandering visitors, all potential dangers such as overhead gear, electric cables, ladders, etc., should be properly and safely controlled. No person in a studio should ever be placed at risk from anything under the photographer's control. Thus the outer shell of the environment should be totally controlled. Locations must be checked for danger areas, animals which may be used in photography should be safely in charge of skilled handlers. Vehicles should be radio controlled if possible and thorough safety routines practised at all times. Within this cocoon of controlled activity, the photographer and subject must find a meeting point without stress, or weak images will result.

LIGHTING CONTROL

The fall of light and the quality of that light which strikes the subject will unconsciously arouse feelings in every beholder of the photographic record of such situations. Man has an uncanny ability to derive information from photographs and it is the skill of the advanced or professional photographer to disclose only the information of his choice in any image he makes. Lighting, of course, is a primary tool and is dealt with in a later chapter.

SEPARATION

Again this is a very basic control. Within an image, form must separate from form, edge from edge. If any important part of the image does not stand away from its surroundings, the eye of the beholder will scan it and lose interest. The subject and all its intrinsic properties must stand out strongly enough to be quickly perceived by the eye. If the image is to be reproduced, separation must be exaggerated. The worse the reproduction quality is, the more must be the exaggeration of separation. This separation will be a culmination of precise controls over almost every part of the photographic process and largely will be a summation of the photographer's entire skill.

EDITING

Good photographers edit possible images long before they pick up a camera, by rejecting situations, environments and concepts at an early stage. Less skilled photographers will use much more film, shoot many alternatives and become entangled in wasteful and expensive exercises. Restraint is vital with small cameras and highly desirable even with large formats, particularly from a fee paying client's point of view. Be miserly with your material during shooting, but never endanger an expensive session of photography by not shooting enough film. An extra sheet of film at the right moment may save expensive re-shooting. In editing final images, be ultra critical of technique. Watch for every image that is substandard and reject it. Never show clients work which is uncertain with regard to quality. Edit all 35 mm work with the aid of a 5 × magnifier and discard out of focus or inferior work.

CROPPING

Cropping is a subtle form of editing (Fig. 24). Extraneous matter in a frame is removed, edited out, by simplifying the image. All final selections for any important assignment or competition should be studied relentlessly for any possibility of simplification. Cut two large L pieces of black cardboard at least 5 cm (2 in) wide and form a rectangle around a print or transparency. Close the rectangle, tilt it, change its shape, etc. Close cropping has the effect of enlarging a section of an image and usually strengthens the communication. Only those things which are pertinent to the story which the image conveys should be left in the picture. Ruthlessly eliminate all others, to the point of re-shooting if necessary. Many good photographers using 35 mm SLR cameras will crop heavily in the viewfinder and this of course gives a larger area of usable negative, reducing enlarging magnification. This technique wonderfully concentrates the contact with the subject and gives much more memorable images. Many photographers will not permit art directors or editors to interfere further with their choice of cropping and this is to be encouraged wherever possible.

Fig. 24 Always crop the image in camera if possible, but for important pictures make a test print of the whole negative and carefully study how cropping improves the structure of the image and also discards unwanted details.

SCALE

Scale is vitally important as a controlling factor. If the final usage of a picture will be at a very large scale, much detail can be built into the image, with sophisticated use of colours and forms. Tiny pictures are generally best when ultra simple with large strong forms. Book images are usually scanned by the average eye right to left from about 25 to 35 cm (10 to 12 in) away, so wide angle photography is acceptable and interest can be concentrated into relevant areas. Large scale, however, diffuses tones, colours and edges and alters spacing between objects unless viewed at a correct distance. Posters and bill boards must be readable in fractions of seconds so, while large, must also be simple and strong in image structure. Packages which carry photographs of their contents must have very sharp pictures and details must be easily discerned. The best photographers will consider final scale as an important part of designing the image and will insist on obtaining precise information on this subject before beginning the assignment.

PRESENTATION

This is a controlling factor, especially for photographers working in the fine art areas. Mounting, framing, lacquering, placing on site, etc. are part of the whole control system and must be carefully considered before the image is made. Tape/slide shows are very much a useful presentation technique for photographers but need even more consideration before photography begins than any standard technique requires.

4 Lighting

Light ... is the most spectacular experience of the senses. It remains for the artist to preserve the access to wisdom that can be gained from the contemplation of light.

(from *Art and Visual Perception* by Rudolf Arnheim)

The contemplation of light ... truly a summation of the advanced photographer's most essential technique and Nature is the supreme teacher. Those who wish to acquire a flawless lighting technique can do no better than to stay long hours in any landscape, watching the position of the sun as it moves through its daily path. Spend every possible moment in this study. Watch the shape and character of shadows as the sun changes position and draws out different forms and characteristics from the same object. Observe how clouds diffuse the bright light and dissolve the hard edge from the cast shadows, giving a gentle mood to particular areas, allowing a relaxed reading of the entire subject. See the rich beauty in the surface gleam of water when it is lit solely by reflected light after the sun has left the sky. The contemplation of light ...

From a constant and careful contact with light in its natural environment can come a total understanding of how to control lighting conditions creatively for the camera. A primary lesson is that in nature there is no second source of light, no 'fill-in'. Also, the key light, even in greatly diffused conditions such as rain, always has a definite direction. There is always a light and dark side to every object. It will be found that in all bright lights an object will have a highlight, an incident highlight, a core (where light and dark meet) a shadow and a cast shadow.

In translating this observation to practical use in photography, remember that the eye, perfect optic that it is, requires no 'fill' light, because of its scanning and dilation capabilities. The photographic emulsion, however, can only discover a limited scale of values and compensation must always be made for this fact. If the image is only a transition toward a final image produced by any means of mechanical reproduction, a much greater use of secondary lighting values must be made.

In changing the natural ratio of light to one which will be accepted and recorded by the film chosen, a photographer must not only master the placing of a key light and decide its size, shape and character, but he must also acquire a complementary supporting lighting technique which defines the secondary characteristics of an object. The light *and* dark areas of the subject must be so lit that all of the true nature of it at the moment of exposure, is disclosed. By the contemplation of light, the photographer will gradually learn to control and build lighting plans which distil the essence from his subjects and immensely strengthen the effective communication contained in his images.

Light is a law, not a chance phenomenon. It moves at incomprehensible speed and is the most constant of all the natural forces. Its rays may be turned, reflected, absorbed, coloured, collected or transmitted by the environment in which it moves. Properly reduced to photographic terms and coupled with a mastery of processing technique, it can endow each object, each expression, even the individual and collective *moods*, which confront the camera, with their true characteristics.

There is no formula for advanced lighting which may be learned, but it will help to formalise areas in which the key light is located (Fig. 25). These may be named as side-left, side-right, top-left, top-right, top-centre, top-front, top-back, back, front and grotesque. They are located on an imaginary hemisphere, with the subject at its central axis. These key light positions may be,

This began as an image 4 mm in length, taken on high speed Ektachrome and enlarged to this size on Agfa Duplichrome duping film through a yellowish filter.

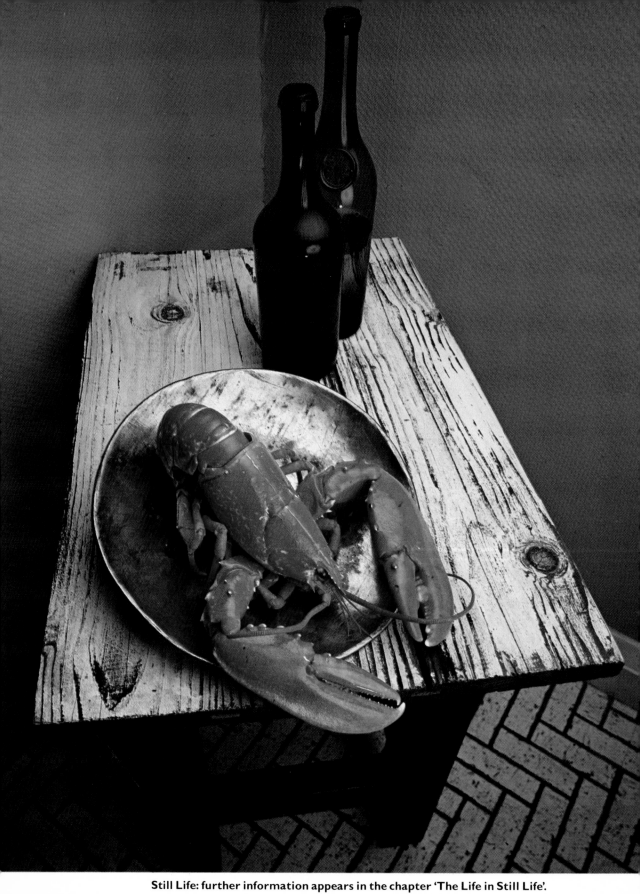

Still Life: further information appears in the chapter 'The Life in Still Life'.

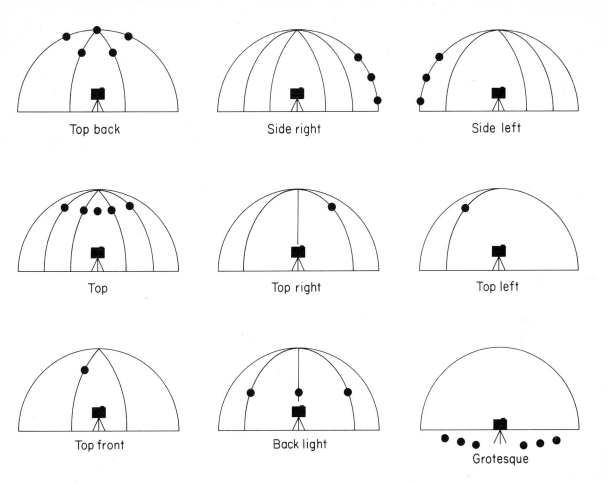

Fig. 25 These are zonal positions of the main key light.

always, related to the natural position of the sun as it moves around us.

The advanced photographer will need to understand and use two main conditions of light and, even occasionally, mix them. These are existing light and artificial light.

In artificial light the photographer has absolute control of every aspect of illumination and his lighting plans are normally built up in an additive manner. That is, the key light is set in place first, after careful consideration of what is required to be revealed about the subject, then areas of secondary importance in the image are given added 'fill' to render the whole image as the photographer desires.

In daylight however, it is mostly a question of *subtracting* light from the abundance supplied by nature and this is a very special skill indeed.

Artificial light may be further divided into two more parts, namely incandescent and flash lighting. Both require different lighting techniques and changes in film stock and negative processing but the 'character' of both types of light is largely brought about by the shape, size and optical behaviour of the reflector which surrounds the lamp.

It is normal to have, in a professional studio, the following types of reflector: a broad diffuser about 1 metre (39 in) square; a tall diffuser, about 2 metres by half a metre (72 × 20 in); 2 round diffuse reflectors of a diameter about $\frac{1}{2}$ metre (20 in); 2 round 'straight' (undiffused) reflectors, $\frac{1}{3}$ metre (1 ft) wide; 2 narrow or snooted reflectors, and an optical spot. Some of these reflectors can be made cheaply from lightweight wood with muslin or fibreglass-silk acting as a diffuser but as soon as it is financially possible the serious photographer should buy suitable lightweight reflectors, complete with lampholders, from reliable manufac-

49

(a)

(c)

Fig. 26 The Rollei Studio Flash System uses varying reflectors to achieve necessary differences in the fall of the light.
(a) Narrow, snooted reflector.
(b) Round, direct reflector.
(c) Round dish with lamp capped for extra diffusion.
(d) Soft box diffuser with extra diffusion sheet for very soft light.

turers (Fig. 26). 'Barn doors' are an essential part of lighting control (Fig. 27) and are used to control the spread of light from the edges of reflectors. These can be made of thin aluminium, painted matt black, or even strong black cardboard. They should be fastened to the edge of the reflector in such a way that they can be moved like a hinge and stay in position at whatever angle the reflector is aimed.

For reducing light within the set, a 'flag' is used.

Fig. 27 Barn doors control the edges of light from a direct reflector and give more flexibility in a lighting plan.

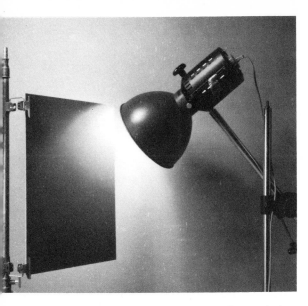

Fig. 28 A 'flag' is used on a separate stand to exclude larger areas of light from the set.

This is a thin piece of wood or cardboard (Fig. 28) mounted on a lightweight stand and is placed between the light source and the subject to create darker areas where desired, without altering the key light. A semi-transluscent flag which diffuses but does not totally interrupt the light beam may also be useful. Add to all this equipment some white reflectors about 1 metre (3 ft) square, made of heavy cardboard, a matt silver reflector of the same size and some small cosmetic type magnifying mirrors and this will provide the total equipment needed to undertake very ambitious lighting plans.

Lighting plans are best considered once the final image has largely been thought about for some time. Remember that the play of light throughout the image will increase the feeling of third dimension, change the emphasis in any given area, obscure unwanted detail and dramatise the 'hero' of the photograph. Every photograph must have a hero, a prime object of interest, with supporting arrangements of every other object within the frame. The fundamental way to identify the hero will be to place the key light so that its special character easily defines the form of the main object and, by the 'feeling' in the nature of the light itself, also discloses the actual mood of the particular moment which is caught on film, just as the photographer desires. Returning to the earlier suggestion of formalised names for key light positions, some special characteristics could be broadly stated (Fig. 29).

Side lighting, both left and right are excellent for drawing textures and in the high position, the side-right key light also has something of a heroic, optimistic mood, drawing form as well as texture. This is an excellent key light to use for single important objects with strong form, or in masculine portraiture. This light can often be used without secondary fill light in order to make a brilliant, emphatic image with unequivocal meaning.

Top-front light also can be used without fill light, but draws form with much less drama, and in portraits of women is the 'glamour light'. A broad diffuse light from the top-front position can be a most flattering light, especially for older women who are sensitive about character lines. This light is excellent for lighting spherical objects also.

The top-centre light, often used with heavy diffusion, is one of the most useful key light positions. It draws form in a very satisfying way and can simplify the lighting of very large sets. It can be used also as a general 'mood light' to give the entire subject a level of light where everything is totally lit, but at a low level of brightness, in order that a narrow definition key light can be used to distinguish the hero. The top light must be used with care on portraiture. It is still very useful as a key light for this speciality, but to prevent dark shadows under the eyes, it must have a satisfactory fill light close to the lens axis. The top light may be used also as a 'wrap around' light where a subject is moving continuously and unexpectedly, thus preventing the use of carefully placed key lights from precise points. Used in this manner it should be very large in area, say 2 to 3 metres (6 ft 6 in × 10 ft) square, and diffused, with two similar areas of fill light (at about one-third of the strength of the key light), located near the lens axis on *both* sides of the camera.

A primary function of creative lighting is to separate: separate form from form, colour from colour and mood from mood. The most important light in separating form in a still life is the top-back light. This light, when used in a broad diffuse reflector, is one of the most beautiful with which to work. When over-lapping forms are present and a moderately high camera angle is adopted, this key light position draws textures superbly. Great care must be taken in placing the fill light and flags are quite often needed to reduce the amount of light within the overall subject. A word of caution: in

51

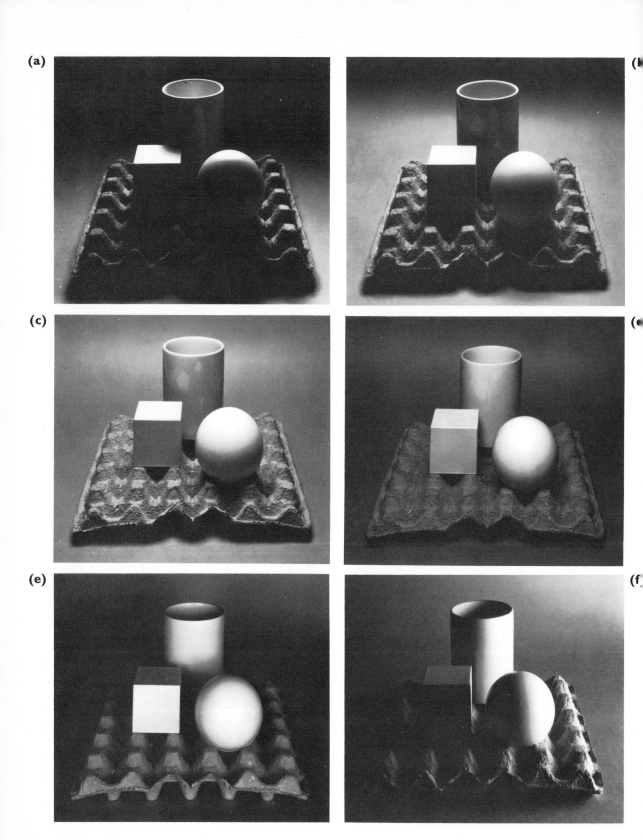

(h)

Fig. 29 Placing the key light in different zones (see Fig. 25) around the subject radically changes the information which can be obtained from an image. Supporting, secondary lights can help to separate different parts of the image but there must appear to be only *one* dominant source.

(a) *Back Light*. Placed very low, facing into the lens. Separates dark forms from dark backgrounds.

(b) *Top Back Light*. Lifting the back light gives almost equal separation of forms but needs only reflector fill light to complete a rich lighting plan which produces excellent mood in a picture.

(c) *Top Light*. Most useful general light for many products and still life pictures. Needs almost no fill unless people are included in the set.

(d) *Top Front Light*. Does not separate the highlight areas very well and reduces form except at edges of round objects. This is the 'glamour' light often used for cosmetic photography and portraiture.

(e) *Front Light*. From near the lens axis gives a characteristic dark edge to contours. Most used for fill light, as a key light it can, surprisingly, show amazing texture when slightly underexposed.

(f) *Side Right Light*. From a level about camera height gives very strong texture and form to objects near the light source. Very suitable for spherical objects.

(g) *Top Right*. Gives almost as much surface texture and form as (f) but with much more information in the overall image.

(h) *Side Left*. Is a reverse of (f) but is psychologically less interesting. Often used as a fill light to support (c) and (f).

(i) *Top Left*. Is again a very useful light in still life and is the exact reverse of (g).

(j) *Grotesque*. Light from below camera level is a theatrical light which usually overdramatises a subject and minimises detail. Only rarely used.

using this light on a still life which contains liquids or highly reflective surfaces, the surface can mirror the light itself, thus resulting in over-exposure of that particular area or, if colour is used, a desaturation of the colour of such surfaces. To avoid this, cut a small flag, about 25 × 15 cm (10 × 6 in) from black cardboard and hang it above and to the back of the bright surface. Watch this operation carefully in the ground glass of the camera as it must be placed absolutely precisely. A polariser can sometimes be a good solution for this problem also, as it removes almost all reflections from shiny surfaces when the angles are controllable between light, lens and subject.

The back light is usually a fairly theatrical light when used as a key light, producing semi-silhouettes even if correctly filled with supplementary lighting, but it is useful for drawing the outside perimeter of the subject in order to define graphically a dark form from a dark background. It has a use in beauty photographs where a rapid identification of complex form is needed, for example, where a hair style is to be shown, but generally this lighting position lacks subtlety as a key light and is much more often used as a supplementary accent light to bring the subject forward from its environment.

Grotesque lighting is usually only used where a totally theatrical result is needed and the key light is located well below the lens axis. Some still life photographers will use this light position beneath glasses and transparent objects to illuminate their internal structure, but in general, lighting from below eye level lacks coherence and even when expertly used, is often too unnatural to be believable.

An item of lighting furniture too often neglected is the stand by which the lamps are supported. They should be strong enough to carry the heaviest lamphead in the studio and have a stable, heavy base on wheels. Stands should have high rise capability to permit the lamp head to be lifted to a height of 3 metres (10 ft) or more. Telescopic stands are ideal. It will usually be necessary at these elevations to add heavy counterweights to the base and the most ideal is a waterweight. This is an inexpensive but strong plastic container with a metal clip which can be filled with the desired weight of water up to about 7 litres (14 US pints). When not in use it is emptied and collapsed. Four or five of these are most useful items in any studio.

The most significant of all lighting stands, and the most expensive too, is the boom stand (Fig.

Fig. 30 The boom stand for lighting allows lights to be positioned over the set without the stand intruding into the working area and is the most useful single piece of lighting equipment to be bought.

30). This is a stand with a cross bar mounted to the vertical stand and with a means of altering the angle between the two. On one end of the cross bar the lamp is fixed and the other carries a counterweight.

Although a handyman could make such a stand, the T-mount must be extremely strong and even commercially made boom stands are often inadequate. So valuable is this particular item in the studio, however, that it is worth searching and saving for. Its flexibility in fixing the key light, especially a top or top-back light, extends the range of lighting plans that may be attempted without stress and can, in fact, be the sole accessory for the only lamphead and stand that is necessary in many small studios.

The photographer who is deeply interested in lighting should remember that it can take as much as six months or one year of constant practice to learn a professional lighting technique and he must, quite seriously, undertake this practice.

First, obtain an item of single source lighting equipment, preferably with a tungsten halogen lamp and some means of concentrating the light beam. This must be on a stand, and ideally on a boom stand. Berkey Products Ltd make a 'mini-pro', Colortran, which is not expensive and is perfect for most work.

Next, create the following basic shapes, about

15 cm (6 to 8 in) in the longest dimension, in white polystyrene or any matt white material: cube, sphere, cone and cylinder. Add a cheap wig stand or shop window dummy head and you have all the forms which should be used.

Without setting up a camera, place all the objects on a table and place your key light in the various zones mentioned in the diagrams illustrated. Watch the changing nature of the form, highlight shadows and surface of all the objects.

Then take each single object and repeat this exercise. Note which key light position does most to reveal the *entire* object and establish most rapidly an easy recognition of all its characteristics.

Set up a camera on a tripod and light the group of objects as perfectly as you can with a single source of direct light. Record the result on a medium speed black and white film. Repeat the photography and lighting on each individual object. Process in a D 76 type developer and print on glossy paper, then analyse the results. Have you shown the primary form? Have you shown the surface structure? Have you captured an incident highlight? Have you established the true nature of the object, e.g. does the sphere look really *round*; does the cube have *volume*?

Repeat the photography but this time use large white reflectors to catch the beam from the key light and bounce it back into the deepest shadows (Fig. 31). Process and analyse the result. Repeat

Fig. 31 Light from broad or narrow sources will give quite different effects.
(a) From a very broad source, such as overcast sky or a soft box reflector.
(b) From a slightly harder light, such as hazy sun through clouds or a small but diffused reflector.
(c) From a direct source such as the sun or a narrow undiffused reflector.
(d) The same as (c), but with the correct amount of reflected light added to the shadow side.

(a) **(b)**

(c) **(d)**

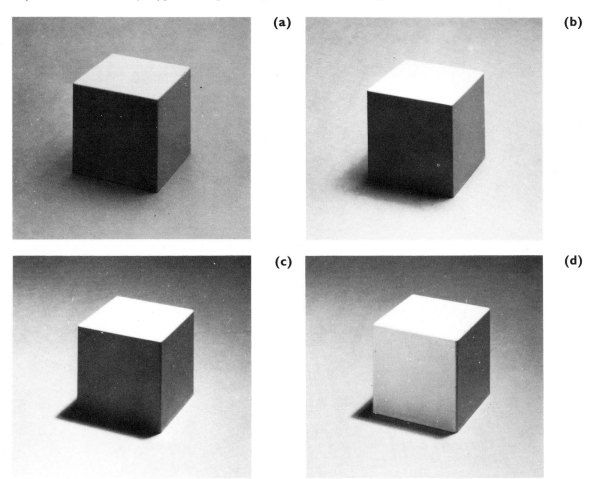

the photography of the objects, together, then singly, but this time with the lamp diffused by a screen of fibreglass or wire mesh. You will note that exposure is increased, but the 'mood' of the lighting is different. Process and analyse the result.

Repeat the total exercise, but bounce the light against white walls and ceilings. Process and analyse.

Gather all of these prints together and carefully look at all the differences you have created by your lighting plans.

Now repeat the exercise out of doors on a sunny and then an overcast day. Leave the camera and objects set up in one place while the day progresses and shoot a picture every two hours, using white reflectors to 'fill' the shadows. Process and analyse the result.

Keep the prints and notes you have made, especially information about exposure, developing and printing. They can be a refreshing visual notebook when your lighting technique becomes stale.

From lessons learned with a single source lighting plan, progress can be made toward those plans requiring several sources, such as fill light, accent light, rim light etc. Remember that a successful lighting plan will disclose only *one* apparent source and all shadows appear to arise from that source. Secondary or cross shadows must be eliminated.

After building confidence with the use of simple tungsten lighting heads, the very difficult lighting problems using electronic flash may be explored.

Electronic flash is a very expensive tool, necessary in some situations for the professional photographer whose business depends on absolute accuracy of colour, or in scheduled sessions involving moving objects indoors.

Very few manufacturers even now have offered really comprehensive electronic flash systems which permit the photographer totally flexible creative lighting. Such a system should have perfect colour balance in the flash tube, a modelling light which can reproduce the fall of light from the flash tube absolutely, complete safety checks to protect both the operator and the equipment and some measure of portability. Add to this desirable features like a single variable switch which alters the flash and model lamp output over a two or three stop range, plus interchangeable reflectors and high rise stands, and you have a very sophisticated and expensive piece of equipment. It should be noted by those who wish to open a

professional studio that this equipment is, for some particular areas of photography, absolutely basic to the proper execution of advertising assignments and that the initial cost is likely to be the same as a medium sized family car.

The Rollei Flash system was possibly the first to reach the market with all the above desirable specifications and in my opinion, it is still the best for still life and many studio assignments. Reliable systems are also being made by Balcar, Bowens, Ascor, Elinca, Broncolor, Strobe and Strobasol. In buying this type of equipment, always insist on a practical test of at least two hours in a situation that can be directly related to your own studio needs and always shoot test colour films with your own camera equipment before making a decision to buy.

SPECIAL LIGHTING SITUATIONS

There are some objects which require very special lighting plans in order to illustrate all their properties correctly.

LIGHTING OF SHINY OBJECTS

If bright metal is photographed in ordinary lighting, even with broad diffuse reflectors, distracting highlights and darks will result. This prevents good reproduction of the entire surface and character of the object.

Shiny objects are in effect mirrors, reflecting every source of light and its shape. First then, eliminate all specular light from the lighting plan (Fig. 32). Remember shiny black or shiny coloured objects need the same care in lighting as bright metal.

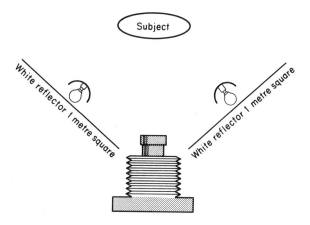

Fig. 32 How to place lights for the photography of metal objects.

Small matt silver objects can be photographed by two reflected light sources placed near the axis on either side of the camera or, more expensively, by a ring light which is a continuous, diffuse ring of light placed around the lens. Such a light is worth buying if much work is done with small metal objects.

Where the surface of an object is very highly polished it will be sometimes necessary to build an elaborate 'tent' of white material to diffuse all light reaching the subject (Fig. 33) or photograph in daylight under overcast skies in diffused light. For the studio, the tent technique is a valuable one and can be built in two ways. The translucent tent is made from matt acetate sheet film, obtainable from Kodak or graphic art suppliers. About .18 mm (.007 in) is a suitable thickness and it *must* have absolutely neutral colour characteristics. For small objects, a cone (Fig. 34) can be constructed from the lens toward and totally surrounding the subject. Lights are now thrown on the outside of the film to render the subject in a very diffuse light but with still a definite 'key' from one direction. Large objects simply require a larger tent, usually made in a box construction with a hole cut for just the lens to appear.

The other technique, using an opaque tent, is used on large sets and the lights are placed *inside* the tent and lamps in wide reflectors are turned *away* from the subject, causing very diffuse light to bounce back off the white walls of the tent (Fig.

Fig. 33 How to construct a large tent for big sets that contain shiny objects.

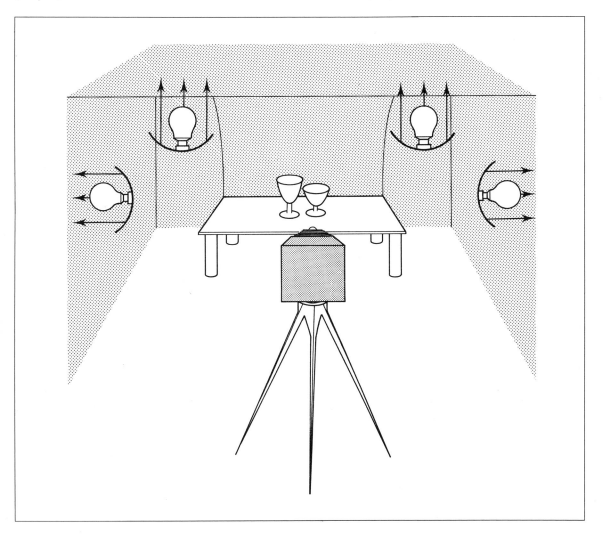

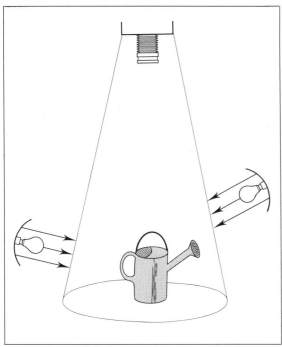

33). This opaque tent can be built of white paper for the occasional job or from hardboard flats painted white with some means of holding them safely in a box configuration if much work is to be done of this kind.

A further refinement, sometimes required for catalogue work, is to place the subject on a translucent glass or acrylic sheet and light it from underneath (Fig. 35). This gives a completely shadow free background but care must be taken that the main tent light is strong enough to overcome any tendency to give a silhouette effect.

SHADOWS

Under tent lighting, metal acquires a high key, somewhat unreal effect and it is often necessary to create dark areas of differing tone by using negative reflectors. These can be irregular strips of

Fig. 34 How to construct a diffuser cone for lighting small shiny objects.

Fig. 35. How to use a light box to eliminate shadows from top lit objects.

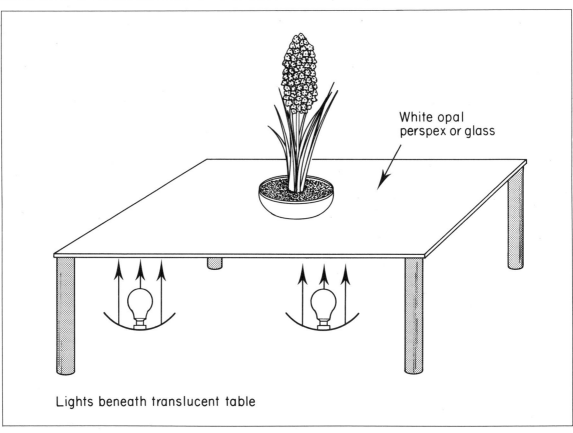

White opal perspex or glass

Lights beneath translucent table

grey or black paper hung near the lens to reflect in frontal surfaces or placed at the foot of the object just out of camera view. A partial tent can also give this effect but with very little control of delicate gradation. In using the light box, shadows are introduced by laying strips of black paper along the perimeter of the subject, as close as possible and then removing this by subsequent retouching.

Engravings, millings and shallow contours may be given contrast by rubbing lightly with black shoe polish and then a soft cloth. Make sure the shiny surface is completely free of every trace of polish before photography begins. Profiles on edges of tent-lighted glass objects tend to blend into light backgrounds and these forms can be given substance by a gentle application of powdered graphite to outside edges. Take care that none is carried into any frontal surface.

MATTING

Objects can be 'matted' by the use of dulling spray or fine translucent face powder brushed on with a soft brush. This gives the effect of tenting to selected shiny objects which can then appear in a lighting plan which has been designed to produce strong form in the rest of the set. Without such retouching, the shiny objects would burn out in the highlights and become eye-traps in the whole design. In an emergency, tiny highlights may be matted by dabbing putty or modelling clay directly on the area, but watch this operation carefully through the camera lens, as it can easily result in marred surface texture outside the highlights.

LIGHTING BLACK OBJECTS

Shiny black objects need tent lighting just as bright metal does, but very substantial increases in exposure are called for, say, 30 to 50% and where a black surface, such as a fabric, is important to the whole picture, a small, strong and heavily snooted light can be cast directly on this area alone. In subjects which contain a mixture of pure white and pure black areas, low contrast processing is essential if both are to be rendered correctly. Construct a lighting plan which is normal for the job, but over expose the film by at least 25%. In development, reduce processing time by about the same amount. A compensating developer such as Promicrol diluted 1+3 or Acutol 1+20 can assist.

LIGHTING GLASSWARE

Remember that glass both reflects, as a mirror, and transmits light. This requires a recognition of both properties by the photographer, but his chief concern will be with arranging a beautifully modulated background against which the glass can be seen in all its delicacy and beauty (Fig. 36).

The best possible beginning is, in my opinion, to provide a transparent film or sheet material and back-light this and the subject from outside the set (Fig. 37). The alternative, to bounce light from a white paper background, permits the possibility of stray specular highlights appearing at the edges of the glass and does not allow the flexibility that the translucent sheet provides.

Glassware usually needs a suggestion of the front surface to increase the feeling of volume within the glass and this is done by a very discreet use of frontal reflectors or even a very narrow barn door setting on a diffuse reflector. Seldom, if ever, is direct frontal light applied to glassware. Diffuse light from beneath the glassware can also be of use in increasing detail in stems and bases. Glassware partially filled with liquid will very often need amplified light behind the liquid to increase the transparency at this point. This is usually done by attaching small foil mirrors to the glass itself, out of camera view and below the level of the liquid. Great care must be taken that this increase in brightness does not receive an unreal emphasis in the total lighting plan and that the surface of the liquid does not appear with an unnatural highlight rim.

Correct exposure for glassware is quite difficult to estimate, because highly acceptable but different results will arise from over and under exposure. An average reading should be taken from the background and then a bracket of exposures made: one normal, one at a full stop over and one a full stop under. Increased highlight brilliance can be achieved by increasing development by about 20%.

POLARISED LIGHT

Many lighting plans which seek to reduce reflections will call for partial or full tenting, but it is also possible to avoid these very time consuming lighting problems by the use of polarised light. By placing a polarising filter on the lens and choosing a view point of a little more than 30° angle to the subject plane, most reflections will disappear, but the angle of view must remain close to this 30° for the best results. If however, polarising filters are placed on the light sources as well and the polariser on the lens rotated, great improvements are made

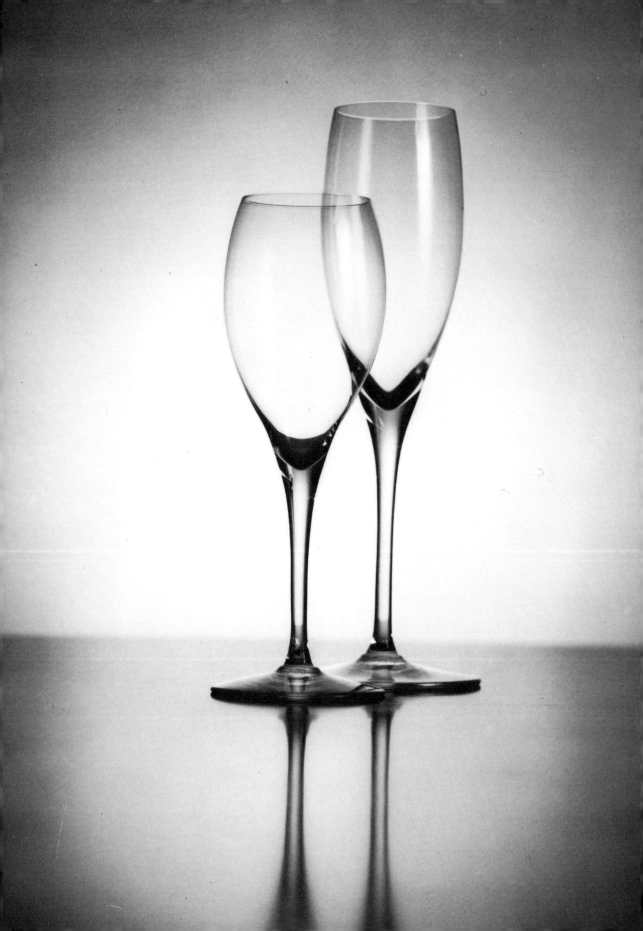

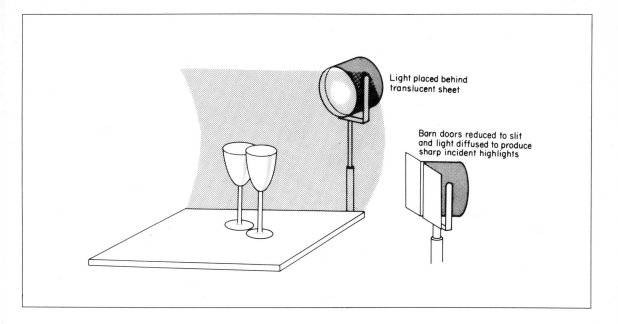

Light placed behind
translucent sheet

Barn doors reduced to slit
and light diffused to produce
sharp incident highlights

Fig. 36 An example of lighting glassware. Note highlights from secondary light sources.

Fig. 37. Sketch of lighting plan for glassware.

to surface texture of even highly reflective surfaces and in colour, saturation is much improved.

Polarisers tend to act partly as neutral density filters also and exposure must be increased by 2× to 8×. With polarising screens on lights as well, increases could run as high as 20×. This often means that tungsten halogen light sources are better as they permit longer exposure times without reciprocity problems or without altering f. stop values. Remember that if more than one polarised light source is used, polar screens on all lamps should be in matching positions.

PORTRAIT LIGHTING

Portraiture is a *description* of a person; his features, character and environment (Fig. 38) and special lighting to indicate these properties clearly to the photographer and his client will sometimes be found necessary.

Remember that basically the head is a sphere with projecting surface contours and the key light must reveal the primary contours and the surface structure of skin, hair, teeth, clothing etc.

There are three main key light positions (Fig. 39): top-front, top-left and top-right. These can be diffused or specular in character. Usually the diffused source renders the tactile properties of the

face sufficiently well and is kinder, but do not forget that a top-side light from a direct specular source can give heroic stature to the subject. With hard direct light care must be taken in exposure (do not over expose) and the sitter cannot move freely in this lighting plan unless the specular key light is handled by an assistant who constantly re-adjusts the beam as the subject moves. Where subject movement is an essential part of the session such as when children are photographed or a party must be illustrated, a 'wrap around' light is created. This is a broad, diffuse top light about 2 to 3 metres (6–10 ft) square with large diffuse fill lights placed on either side of the camera. The key light is the well defined top light, but the fill lights must create *very* open shadows. Another solution to the rapid movement of the subject is to use a continuous light source such as tungsten halogen and have an assistant direct it to various parts of the room on cue from the photographer as he follows the subject. In this case, the photographer is better advised to use an automatic camera, as the re-calculation of exposure is virtually impossible to maintain at a suitable speed to do justice to the subject.

In portraiture it is also common to divide lighting into high and low key characteristics. High key is a very diffuse but directional light used to create a feeling of outdoors. It is much used on cosmetic pictures and portraits of women or young children.

61

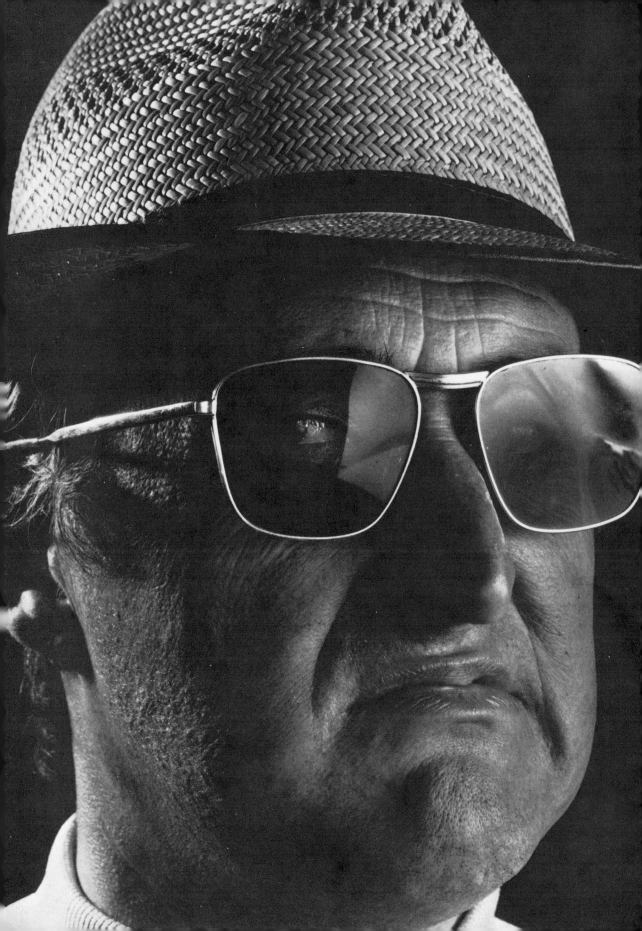

Low key is an introspective or masculine light and renders texture superbly. It often lights the side of the face turned away from camera and the key light can be harsh spectral light from a spot light or the sun, supported by diffuse, weak fill from the lens axis by the use of white card reflectors.

Accent or skid lights (Fig. 38) in portraiture are small snooted spot lights which add detail and interest to hair and skin. They often add volume to the figure and are very useful in separating dark areas of the face or head from dark backgrounds. Excessive use of these subsidiary lights can create an 'over-lit' atmosphere of artificiality. Never let them in any way compete with the main key light and be sure to use effective lens hoods while working with them.

BACKGROUND LIGHTS

These can sometimes be a very ugly addition to the studio portrait but carefully used can give a beautiful tonal transition to a plain background. It is usual to use a low power light with snoot or barn doors which throws a controlled but very diffuse edge.

To set the background light, leave the key light on, place the background light on a stand small enough to hide the whole assembly from camera view and aim it upward at the background toward the shadow side of the subject. The *lightest* part of the background light should appear behind the *darkest* part of the subject and a *delicate* transition must be achieved from light to dark by the use of diffusion scrims or using the edge of the light fall from the reflector. Turn off all other lights including the key light and calculate exposure for this background light alone, then adjust the rest of the lighting plan so that the film will barely discern the range of background tones.

THE BACK LIGHT

This is a light aimed at camera and it is extremely easy to make this light a disastrous addition to an otherwise good lighting plan. It can be used to separate a figure from a dark background or show the whole perimeter of a form. The light is usually a small specular spot placed above and well behind the subject. In nature it is rare to see a counterpart of this light and it is often an uncomfortable reminder that the picture was made in a studio. A rationale for such a light can be found if a light source actually appears in the environment of the subject and is included in camera view, but be careful of this light.

LIGHTING LARGE INTERIORS

This is usually impossible with normal portable lighting equipment, but where no life is included in the shot, a movable single source light with a long throw can be used to 'paint' the room with light. Planning on paper is often essential and Polaroids should be used to check the lighting effect before actual camera exposures begin. It is usually easier to use a tungsten source in a broad reflector and something like the Lowell soft light is ideal.

The camera is put on a tripod and the final image is decided upon. An assistant must set up the light to illuminate part of the interior and a reading is taken of the centre of the main area of light. It is important to note the width of the light fall that gives a constant exposure within the latitude of the film. An exposure of 10 or 20 seconds is desirable so stopping down of the lens or scrimming of the light, or both, might be necessary. The assistant will walk to the far left of camera with the light being constantly moved by a rotary action, then will begin a slow walk across camera to the extreme right of picture. The lens remains open throughout. The main subject plane is constantly 'washed' with moving light. If your light spread is say 3 metres (10 ft) then this is the distance the assistant should walk in the number of seconds indicated by the original reading. Remember that the edges of the image, especially if a wide angle lens is used, will need more exposure to compensate for transmission fall-off. Do not point the light at camera, make sure no stray light leaks from the back of the reflector and be aware of all other light sources, especially windows. Provided the assistant keeps fairly close to the lens and is *constantly moving*, no record will appear on film of the lamp or the assistant. If he stops at any time within camera view a ghost image will appear on the negative.

Allow considerable time to photograph a single large interior as many Polaroid tests should be made and on this alone several hours can be spent.

Where possible, windows can be covered with black felt from the outside and then after the main

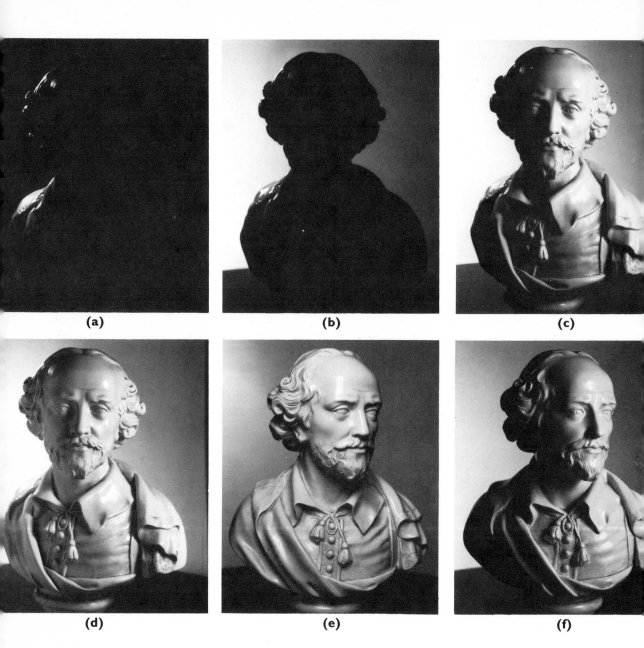

| (a) | (b) | (c) |
| (d) | (e) | (f) |

Fig. 39 Lighting for portraits needs careful positioning of as many as four separate light sources. Many variations are possible and constant notice must be taken of possible movement while the session progresses.

(a) The accent light will separate from dark backgrounds and accent hair texture.

(b) Background light is placed on darkest side of subject and adjusted to give transition of greys.

(c) Key light to reveal main forms.

(d) Fill light from a large white reflector, held near shadow side of the subject, completes total plan.

(e) Faces may be lit from the side turned toward camera and in this example the top front 'glamour' light is used. Note the dark edges around the perimeter of the contour.

(f) Faces may also be lit on the side turned away from camera and in this case a top right key light produces a 'heroic' mood, very suitable for strong masculine subjects. Do not use this lighting on any person susceptible to skin blemishes as it is the most revealing light possible.

64

exposure is completed, the lens is closed and the covering on the window removed while a short second exposure of just the windows is made. If using film balanced for artificial light, do not forget to add the correct filter to change the colour of daylight to 3200°K. In this case, a Kodak 85B would be necessary. The camera, of course, must be securely locked onto a tripod throughout the whole exercise, in order to obtain registration of each successive exposure.

Painting with light can be used also in lighting small objects where unwanted dark areas appear. Here, a small moving source of light (sometimes even a hand torch is enough) is washed over the dark area for a time sufficient to build up density in these parts of the image, while a time exposure is made.

EXPOSURE

On all lighting plans, correct exposure and processing is critical and most professionals make a final check by exposing Polaroid film (Fig. 40) in a special film holder that fits the taking camera or by a Polaroid camera placed close to the lens of the taking camera.

It is sometimes necessary to rationalise the Polaroid film speed against the speed of the film used in the actual take and this is done by dividing the ASA rating of the Polaroid by that of the final film used. Thus an exposure factor is obtained which is used to multiply the first exposure to find the correct use. For example, if a Polaroid film of 400 ASA is used to test lighting which is to be recorded on a colour film of 50 ASA,

$$\frac{400}{50} = 8$$

and 8 is the multiplying factor. If the exposure calculated by Polaroid is 2 seconds at f.32, then for the actual take it will be 16 seconds. If flash is used and f.32 is the Polaroid exposure the colour film will have to be exposed at f.11 or the flash intensity

Fig. 40 Polaroid can be used effectively to judge the exposure needed on colour film and black and white material is to be preferred. When all colours and forms can be clearly seen in the Polaroid print and the values are in the mid-greys, colour exposure is also likely to produce good results.
(a) Under exposure, colours do not separate.
(b) Correct exposure, good separation of all colours.
(c) Over exposure, colours do not separate especially in highlight areas.

(a)

(b)

(c)

increased by moving it closer to the subject. As Polaroid make a 50 ASA film to fit 4 × 5 cameras, it is convenient to use this when working with 50 ASA colour film.

A very accurate guide when using faster Polaroid emulsions can be found by placing a neutral density filter over the lens before exposing Polaroid film. The correct N.D. filter strength can be found in the table (Fig. 41).

It is necessary to time precisely the processing of Polaroid, by stop watch, with full allowance for cold temperatures, if this method is used to replace conventional meter reading. See Chapter 8 for more information on this subject.

Fig. 41 Neutral Density filters are most useful in reducing film speed in wide aperture 35 mm photography or when slow speeds are needed to enhance movement.

Neutral Density Filter Chart and f. Stop Increases

Density	Transmission by factor	Increase in %		f. Stop
0.10	80.0	1.2	×	$\frac{1}{4}$
0.20	65.0	1.5	×	$\frac{1}{2}$
0.301	50.0	2.0	×	1
0.40	40.0	2.5	×	$1\frac{1}{3}$
0.50	32.0	3.1	×	$1\frac{2}{3}$
0.604	25.0	4.0	×	2
0.70	20.0	5.0	×	$2\frac{1}{3}$
0.80	16.0	6.2	×	$2\frac{1}{2}$
0.91	13.0	7.7	×	3
1.00	10.0	10.0	×	$3\frac{1}{3}$
1.20	6.3	15.8	×	4
1.50	3.2	31.2	×	5

5 Colour

Colour is seen at the end of a physical and mental process, interpreted by each individual according to health, environment and circumstantial experience. It is a unique, *personal* sensation. Colour has always been identified with natural things ... sun, earth, sky, jungle, food, associating with yellow, brown, blue, green, red. Over centuries, it has acquired a mystique such as is always bestowed on unexplained forces, which are also restrained by unexplained harmonies and balances. Artists of the past were guided by instinct plus the choice of materials at hand and today they are offered many analytical methods of measuring and recreating colour harmonies, but still, even now, creative colour harmony is best achieved by a 'feeling' for the most satisfying combination, rather than devotion to any scientific plan. What looks right is right.

Many fascinating examples of colour control which are evident in primitive art can therefore be attributed to practical and individual experiences. For the photographer, very much the same path may be followed.

There are harmonic theories to be learned certainly, colour analyses are written by intellectuals and technicians, but a continuous and loving observation of colour in Nature, together with wilful priorities established by the photographer, plus a sensitive understanding of the total concept of the final result ... these still seem to produce the most memorable images in colour photography.

Colour of course is a language and, like all forms of communication, has geographic and aesthetic variations. The searing primaries, beloved of primitives, would alarm the Japanese whose sophisticated modulation of warm and cool greys would not contain a sufficiently emphatic vocabulary for, say, the packaging designer.

Because it *is* a language, colour does have a basic vocabulary and 'grammar' which can be used in a general way to design images for certain purposes. The photographer must be aware of the environment in which his image will stand and what duties that image will have to perform.

A photographer is probably never called upon to design a road sign, which would need a clear knowledge of scientific information about perception of saturated primary colours at road speeds, retention of colour information at certain distances and behaviour of colours in changing light, etc.

If he makes a living by producing images for roadside posters, however, he is competing with all

Seeing

Electro-magnetic waves enter the cornea of the eye	Light / Camera lens
in amounts controlled by the pupil	Lens aperture
and focus on the retina,	Film
stimulating rods and cones which transfer sensations to the optic nerve and then the brain;	Negative
this sensation is then interpreted by each individual according to his personal psychology.	Print
Seeing is a translation.	

Approximate colour temperature of common light in degrees Kelvin

Fire light	1000°
Candle flame	1500
House lamps	2500–3000
100 watt, tungsten-filament lamp	2850
500 watt, tungsten-filament lamp	3000
500 watt projection lamp	3200
3200° Kelvin floodlamp	3200
White, No. 2 Photo flood, reflector flood	3400
Reflector floods (except R 32)	3400
Warm, white, fluorescent lamp	3500
Foil filled flash lamp	3800
Cool, white fluorescent lamp	4500
White-flame carbon arc	5000
Noon sunlight temperate zone	5200
High-intensity sun arc	5500
Direct sunlight between 10 am to 3 pm (average)	6000
Blue expendable flash lamp	6000
Daylight fluorescent lamp	6500
Sunlight plus light from blue sky at noon	6500
Light from overcast sky	6800–7000
High speed electronic flash tubes	5800–7000
Light from hazy sky	7500–8400
Light from clear blue sky in afternoon	10,000–27,000

these road signs for attention and should know this basic scientific behaviour of colour in that particular environment, plus the factors related to the message carried on the poster, plus a great deal about the parties connected with this particular communication.

By acquiring an acceptable structure of basic generalisations about colour, he can then add his own sensitive interpretation to the colour language demanded in the final design. This interpretation, because it is based on very variable, subjective forces within the photographer himself, will change infinitely, even if the same client's work is done over many years. It will still, however, produce a *style* which is as identifiable with the photographer as his own fingerprints.

To acquire this style in colour photography takes many years of concentrated effort. Reading widely (especially useful are the writings of Faber Birren), watching Nature in changing moods, visiting museums and art galleries to see how others have reached solutions to past problems, these will help the photographer deepen his skills with colour materials.

Experiment with colour wheels and paper swatches, know about the science of seeing colour (Fig. 42) but do not get too deeply involved with intellectual theories of colour.

Many men have tried to explain the extraordinary powers of colour by the use of charts and diagrams, to the accompaniment of analytical strictures on harmonic theory, but usually the final result of such work is a delineation of what was personally right for them, the theorists, at that particular time and place in their own life. The measurement of colour, yes, and also to some extent, the understanding of perception, can be acquired by objective approaches to colour, but

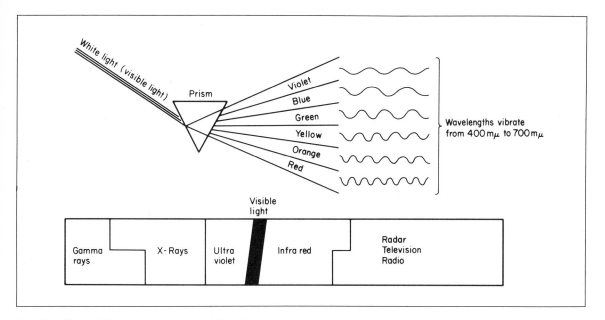

Fig. 42 The visible spectrum is part of the electromagnetic spectrum.

the harmonic 'feeling' of the right balance of a colour scheme, this is very much a personal matter belonging to the photographer.

Some generalisations about colour are useful to know. For instance, it has been shown that colour is sensual, emotional, somewhat feminine. It expresses mood, much more effectively than is done by shape. Shape dominance in a picture is introvert, classical, masculine. Colour dominance is extrovert, exciting, especially in the long wave length colours. Colour is highly unstable when scaled up or down; it not only *looks* different in changed scale it *is* measurably different and will stimulate the unconscious in a different way.

Strong colour interaction tends to soften sharp lines, because true involvement with this interaction requires a scanning of the whole image, focusing the total field of vision upon it. Strong local colours within this encompassing field will tend to isolate and specify those areas, as will strong, heavily accentuated form. Form affects colour and the reverse is true, also. Weakly outlined form, for example, increases colour saturation in an image. Very strongly rendered forms on weak backgrounds will immensely increase the interaction of colours and so on. Too vibrant interaction of colour must be counteracted by the inhibiting factors of strong forms and carefully designated space between those forms. It

is good to separate vivid colours such as complementaries, by neutrals. The bright colours will move to influence these grey areas and interaction begins. Robust use of colour will have to be joined with skilful rendition of form, space and surface texture. Goethe has said that complementary colours demand each other and this intense attraction can produce a noisy, irritating harmony that is very suited to brief acquaintance but needs neutrals to aid lengthy contemplation.

Neutrals are not found within a colour wheel and are not much used in their own right by easel painters but are most important to the photographer. Almost one entire hemisphere of photography and seven tenths of photography's total history is concerned with the manipulation of neutral, monochromatic greys. Such a collection of greys produces a 'black and white' photograph and may or may not be produced on colour-blind film. Absolutely neutral greys on colour film do have a life of their own and although requiring very careful technique, can provide very striking images.

The total absence of colour in an image abstracts that image to a considerable degree and draws attention to form within the subject. Therefore in such cases, where neutrals are used as dominant key colours, or even as the entire harmony, lighting must be arranged to emphasise that form,

69

in the correct proportions of incident highlight, highlight, core and shadow.

Colour schemes that are totally black or totally white raise great difficulties in reproduction, but if the photographer can be confident that the image which is finally printed is itself the result of superlative technique by the printer, then even these may be attempted.

Neutral values in a colour photograph will act as a screen upon which brightly coloured objects are perceived, thus drawing attention quickly to key subject matter and drawing them together as a design. Neutrals can also act as space between coloured forms thus separating those forms and giving them distinction.

When using greys or whites for their own sake, the photographer should organise these values into simple, decisive groups. If the image is littered with small areas of neutrals, these become confusing and busy areas which weaken the total design. The *pattern* of neutral values can greatly define the basic structure of the picture and can in fact produce a desirable, cohesive simplicity within the format.

Neutrals will, in fact, rarely be entirely neutral and particularly in colour photography usually show some colour cast acquired from neighbouring coloured objects. If the neutral object must

retain a completely balanced character, it will be necessary to eliminate these colour casts by rearranging the set or masking the coloured reflection with white or black paper brought as near as possible to that side of the object which is gaining any excessive colour of an undesirable kind. Small sets may be placed on glass, with the background paper hung some distance underneath.

Neutrals will require skilled lighting and care must be taken to bring out the texture of these surfaces. White and greys must never be over exposed and, in every neutral, *full surface contour must be visible*. This is particularly true when reproduction will be made from the photograph and in this case it is usual to *under expose* the film by a $\frac{1}{4}$ to $\frac{1}{2}$ stop. Modern scanners used in lithographic reproduction will easily reproduce this somewhat darkened image and indeed cannot cope with 'washed out' highlight areas. *Never* over expose colour photographs which will be duped or reproduced by any means.

Photographing pure white on colour film presents many problems, but chiefly becomes a matter of eliminating residual colour casts which affect the purity of the neutral white. This could be a question of correcting the colour balance of the film, lighting or processing with the use of colour compensating filters, or preventing reflections from nearby objects. Whites should be photographed in an environment which is itself devoid of any strong colours, as these will surely reflect. Whites need 'happy' light, a yellowish light rather than a bluish light. Colour film will often render whites as greyish green if exposed to cold light sources.

Blacks are also modified by nearby colour sources and, in a more vital way than white, act as cohesive elements in a design. The fact that black is often the shadow area of the photograph also enhances mood, by disclosing to the bystander the nature and direction of the light source. Shadows should not be entirely black, except in cases of intentional dramatisation and sufficient fill light should be added in order to disclose some hint of the subject's true colour.

Blacks also increase the apparent intensity of neighbouring areas of colour and, carefully used, can create deeply saturated colour designs. Black and to a lesser degree, white, can easily dominate a colour design, so the placing of neutrals is always a matter of skill. Luminosity of colours is greatly increased by placing an area of black or dark grey

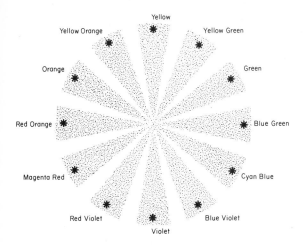

Fig. 43 Typical points on a colour wheel giving usual names to the visible colours.

deep within the area of their appearance or by surrounding these colours with black.

From designs with an absence of colour which eliminate considerable opportunities for emotive communication, the photographer can produce harmonious shifts of coloured images within a narrow band of colours which are found together on the colour wheel. Using these 'adjacents' to perform as almost monochromatic harmonies permits the photographer to develop a key, dominating, colour theme which can be used as a background to contrasting coloured typed faces or as a subtle emotional communication of quiet

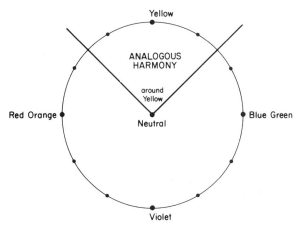

Fig. 44 An example of analogous harmony.

colour, or an attention getting statement of blazing, overall primaries.

This 'analogous' harmony (Fig. 44) needs very subtle changes of light and shade within the image, otherwise it becomes boring. There must be a very strong emphasis on form, requiring careful lighting.

Monochromatic analogies using one of the primaries can be a little naive if used at pure saturation, but even when only slightly modified by light or dark tones can be capable of sophisticated communication.

Analogous colour schemes may also be broadly sub-divided into two sections: warm and cool. Warm colours produce a feeling of pleasure and anticipation. Cool colours produce uneasiness, detachment. Warm colours are sensual, cool colours intellectual. These tested classifications can be used in analogous colour schemes to promote key moods to assist communication, for example, in food advertising.

The second and very important harmonic colour scheme to which most people will respond with pleasure, is the 'complementary' harmony. While the analogous colours lie adjacent to each other in a colour wheel, the complementaries lie exactly opposite each other (Fig. 45). They are extremely dissimilar and when placed together without modifiers, produce a vibrant, noisy activity that excites immediate attention and tires the whole body very rapidly. Place a red and green colour form adjacent to each other in the optical centre of a picture and the beholder's eye will never leave it. In fact red, blue and green are the colours most preferred by most people and it will be seen that these colours are always used for road signs, emergency exits and all visual areas where instant response is essential. Yellow is arguably the most perceptible of colours and is often used where long-range attention in bad light conditions is desired. Elegance and subtlety are usually more easily communicated by avoiding these colours at anything like pure saturation.

These extreme contrasting harmonies which result from using colours from the opposite sides of the colour wheel tend to create other things beside attention. Uneasiness on the part of viewers can often be a result of this kind of colour design. But it is not necessary to create such dangerous harmonies, by using absolute opposites.

Select the key colour to set the dominant mood and then look for a close complementary which is in a zone either side of the absolute opposite (Fig.

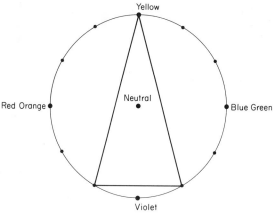

Fig. 45a An example of complementary harmony.

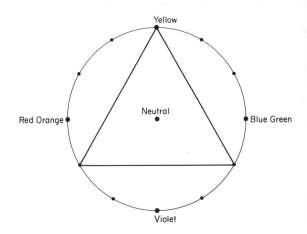

Fig. 45d An example of triadic harmony.

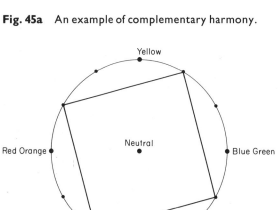

Fig. 45b An example of harmonic harmony.

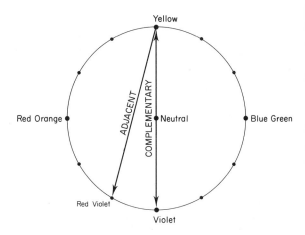

Fig. 45e Harmony using the adjacents of the complementary.

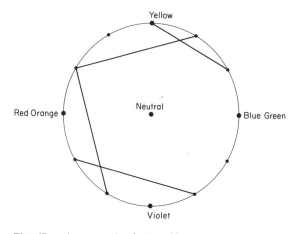

Fig. 45c An example of natural harmony.

45). This promotes the key colour to a dominant role yet attracts strong but acceptable attention by the use of a nearly complementary colour.

For additional interest, use a key colour, plus its complementary, plus one or more of that complementary's adjacent hues. This modification and support of the absolute complementaries will be found very effective in designing balanced colour schemes for photography.

There is no scientific way to select the correct harmonies, so be guided only partly by reason. Make your final solution as a matter of personal choice, but be aware, if possible, of the effect which that choice is creating.

The positioning of areas of colour and the

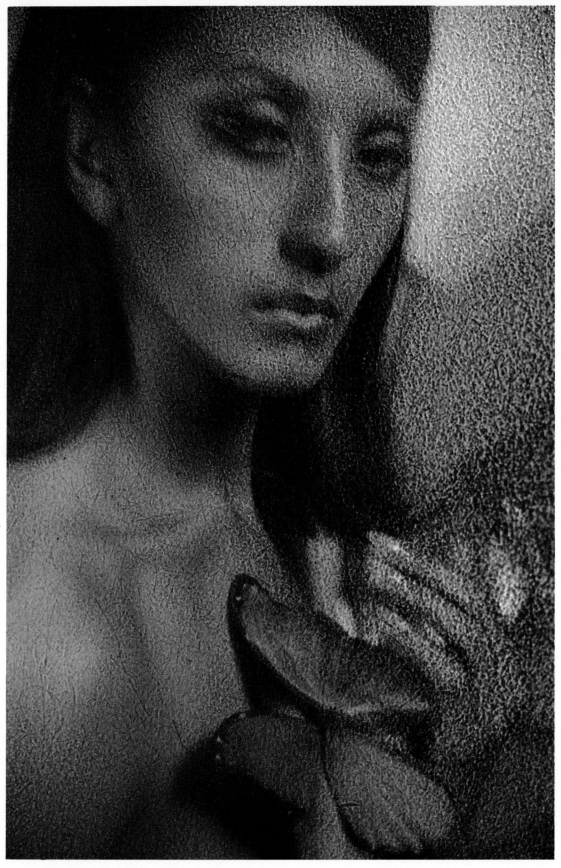

See Case History No. 12 for further details.

See Case History No. 50 for further details.

Colour psychology and symbolism

Blue
: Preferred by most people. Symbolises distance, reserve, wisdom, truth, holiness, eternity, disciplined love, loyalty, despondency, pessimism, tranquillity and introversion.

Red
: Aggressive and advancing colour, masculine. Symbolises deep emotion, sex, ardent love, extroversion, optimism, susceptibility, impulse, cruelty, anger, hatred.

Pink
: Pink is a dilute red and reflects the gentle side of red symbolism. Represents wealth, society, innocence and protection, caution and inflexibility.

Green
: Symbolises nature and refuge. Action with restful interludes. Rest, hope, prosperity, education, normality, morality, elements of warmth and introspection evenly balanced. Youthful colour, acceptable to most people. Masculine colour.

Yellow
: Preferred in the orient, misunderstood in western society. Visually, has more recall value than white, is very visible in poor light. Symbolises health, wealth, sunshine, noble love, enlightenment, treason, deceit. Advances strongly. Indicates imagination and goodwill with self expression.

Brown
: Autumnal, low key mood. Symbolises durability, responsibility, duty, peace, middle age, tranquillity, earthiness, wisdom, health.

Violet
: Symbolises mystic wisdom, wit and social expertise.

Purple
: Solemn, enigmatic colour, unconventional. Symbolises vanity, temperament, affectation, inconsistency, femininity in the male, exclusiveness, royalty, death.

Black
: Mysterious absence of light. Symbolises conflict, error, emptiness, heaviness, restfulness, despair, might, exciting passivity.

Grey
: Unspectacular good taste, femininity, faith, sophistication, intelligence, ambivalence, nobility, negation.

Turquoise
: Narcissistic colour, emotionally cool, confident, witty and discriminating with overtones of self indulgence.

White
: Visually tiring in large evenly lit areas. Symbolises divinity, power, triumphant innocence, cleanliness, happiness and vitality. Signifies lightness in weight, simplicity and decency.

outlining of those areas by lighting or by separation from neighbouring forms will alter the response of the viewer to the colour photograph. For immediate attention in short spaces of time, such as is demanded by posters and grocery packaging, use simple, well defined colour shapes of large area. Flat lighting from the lens position can increase saturation, as will the use of polarisers. Never over expose rich colours or the sumptuous effect will be lost.

Classification of hues

Psychological primaries	Red, yellow, green, blue. These colours are basic to the spectrum and the act of seeing. White and black are usually not included.
Additive primaries	Red, green, blue. These are the physicist's primaries and apply to coloured light. When mixed together, they make white light (Fig. 46a).
Subtractive primaries	Cyan (blue-green), yellow, magenta. These apply to colour photography. They are complementary to the additives and are formed by taking away one of these additive primaries from white light (Fig. 46b). Cyan is white light minus red. Magenta is white light minus green. Yellow is white light minus blue.
Artist's primaries	Red, yellow, blue. These apply to pigment and ink, and are used by painters and printers. When mixed correctly almost any other colour can be made.

Complementaries appearing in the same image can be considerably less in area and their form can be more subtly defined by lighting and placement in the set, but they must be easily identifiable.

Shapes of objects which are of complementary colours can be more complex, provided immediate recognition of these is not essentially a part of the main message. Use this approach for billboards, posters, magazine covers, where the eye has on average 0.5 of a second to perceive the salient points of the visual message. In constructing these colour images for rapid perception, it is wise to remember also all the basic rules of black and white photography and apply these soundly to the design and concept.

Complementary harmonies are often found in nature: yellow sun against blue sky, red flowers against green foliage, turquoise birds with orange flecks in their plumage. Spend time really *seeing* what exists in natural harmony and recreate these schemes in your own photography.

Complex harmonic designs involving the use of complementary colours also raise involvement of the viewer to a higher level. The precise, simple, analogous combinations, where only warmth or cooling of the mood must be accepted, are replaced by very complex schemes containing both warm and cool colours. The viewer is asked to react and decode a much more elaborate set of psychological factors.

Where the viewer has time to absorb the image in a favourable environment, with adequate lighting, such as when he opens an expertly printed book or looks at a picture hanging on the wall of his home, much subtler harmonies are possible.

The key colours can be smaller in area, more complex in shape and surrounded by complementaries and adjacents which are bigger and well muted by light and shade.

Personal choice, in this case, is much more the final factor in designing the image and great

delicacy can be used. The separation of half tones, by the use of basic photographic techniques of processing, lighting, etc., becomes vitally important.

It is absolutely essential in colour photography to remember that allowance must be made for the means of reproduction, if the photographer's image is not the final image. Often the photograph must have more saturation or density or use bolder colour schemes to compensate for losses when the final image becomes a second or third generation reproduction from the original.

Sometimes entire and beautiful harmonies must be discarded because the subtleties simply will not reproduce.

It is vitally important, therefore to know the final usage to which the image will be put and some of the viewing conditions in the final environment.
Always talk in colours at the level of the viewers' experience.

It is my belief that the best of colour photography arises from a fairly routine technique, together with a very deep understanding of the conceptual factors which bring about real communication in photography.

As a matter of practical technique, the advanced photographer using colour for the first time will need to know how this material differs from the 'colour-blind' film we all know as black and white film.

The storage and handling of colour film will need much more care than black and white emulsions. Professional colour film should be held at 10°C (50°F) or less, depending on the anticipated length of storage time. The film must be brought to about 20°C (68°F) before photography can begin. Film that is too cold will show unpleasant colour variance and the speed will be diminished.

More stable emulsions, particularly Kodachrome, need less care, but it is wise to keep all unopened colour film at recommended cool temperatures.

Colour film will begin to alter balance immediately light falls upon the film and if processing is delayed, undesirable colour shifts will occur.

The latitude of colour film, especially the professional type, is severely restricted and exposure variations of $\frac{1}{4}$ and $\frac{1}{2}$ stops can give rise to density or colour changes that are unacceptable. Again, Kodachrome is better in this respect and even one stop variations are often within printing range in commercial lithographic reproduction.

Professional films are always packed with precise data which applies to the specific emulsion number. Take careful note of this information and make it the basis of your exposure calculations.

Both film speed and colour shifts occur in Type B film (for tungsten light) with exposure increase or decrease and it is wise to adjust the quantity of

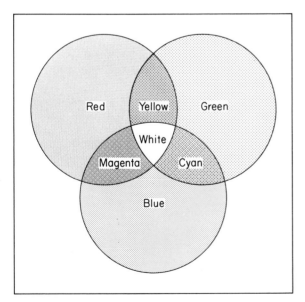

Fig. 46a The additive primaries.

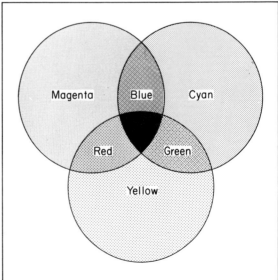

Fig. 46b The subtractive primaries.

(a) Draw in waterproof ink on acetate film each harmony system illustrated in book

(b) Cut circle out and pierce centre

(c) Make colour wheel with 12 colour points and same size to fit acetate overlay

(d) Place any selected acetate circle on colour wheel and rotate to find desired harmony.

Fig. 47 How to make a colour harmony wheel.

light to bring the exposure time to the ideal. For example most Type B material is at its best when exposed for 1 second, so light intensity or aperture must be altered accordingly.

If possible, expose a test sheet or roll of film to a colour spectrum held on the open hand. This will give a clear indication of any colour imbalance in the film, provided that standard, normal lighting is employed. Have this test processed before any further exposures are made and then continue.

If colour is less than perfect, a colour com-

pensating filter (or more than one) can be placed over the lens. This should be done for the exposure of all colour stock bearing the tested emulsion number when it is used in lighting conditions similar to those of the test.

Colour films cannot 'see' the same range of tones as black and white. Therefore light and shade must be brought closer together, with gradual intervals to give an acceptable tonal scale. In a studio this is done by increasing the strength of fill light so it comes much nearer the brightness value of the key

Causes affecting colour balance

Storage | temperature or humidity
variations | excesses
| out of date film stock

Processing variations

Exposure | length of exposure
variations | voltage drop to lamp
| colour of lamp
| age of lamp
| surrounding bounce light
| colour of daylight
| direction of skylight
| time of day

Near-natural colour photography results only when the colour of the exposing light is exactly the same as that for which the film is balanced, and when the film has been perfectly stored according to the manufacturer's specifications.

calculations, it is a standard practice to check all camera exposures with Polaroid.

After a little experience, it is possible to translate the information obtained from the Polaroid into a close guide to colour exposure. For this purpose it is best to use a black and white Polaroid film of the same speed as the colour film used. Colour Polaroid is not needed, except to guide art directors or clients for layout purposes and it is not so easily used for exposure evaluation. When using Polaroid to obtain exposure information it is more than ever essential to use a stop watch to time the development. It has become routine for many professionals not to begin shooting until a Polaroid of the camera's point of view has been seen by

How to expose colour film for perfect colour balance

- Buy bulk batches of film of the same emulsion number, correctly date stamped, from a reliable professional dealer who stores in good deep freeze conditions.
- Hold in deep freeze at 0°C (32°F).
- Warm up 2 hours to room temperature.
- Read manufacturer's data sheet.
- Test one sheet with spectrum held against flesh tones.
- Process immediately.
- Adjust exposure if required, test again with cc filters as necessary.
- Make a note of filtration and batch numbers.
- Begin to shoot and *list* exposure for *every* sheet or roll, together with subject matter.
- Bracket exposures.
- Always use the same processing routine or lab.
- Always hold in reserve at least half of all exposed material until the client sees results.
- Assess all transparencies on bright viewer with lamps at 5500 degrees K, with all excess light masked off.
- Modern scanners will need $\frac{1}{2}$ stop under exposure for good reproduction.
- Never store exposed film near heat or longer than one week even in cool conditions.

light. Outdoors, in sunlight, large reflectors, at least a metre square, are needed. Negative colour can accept a somewhat higher contrast than transparency film, but colour emulsions in general will look well and reproduce well at a highlight to shadow ratio of about 4:1.

Exposure, being so critical, must be very carefully evaluated. Automatic cameras, particularly those such as the Contax RTS and Minolta SLRs, which both have centre weighted metering, can usually be trusted to deliver excellent results, but it is wise on all important assignments to double-check their read-out against a hand held meter. Gossen, Minolta and Pentax make excellent spot meters and for colour work they will be found to be of great assistance.

When lighting by flash, the exposure may first be estimated by the use of a flash meter, preferably a battery operated type. In the use of the Rollei Studio Flash System, where the modelling lights are directly proportional to the flash output, it is possible to measure the flash by using a normal meter, rather than an expensive flash meter.

In professional photography, where a number of other people in the studio will also be vitally interested in the progress of the photographer's

those controlling the photography. It is an excellent habit to cultivate, wherever possible.

It is necessary to compensate also for the general overall tone of the subject matter, even after careful assessment of the scene by meters, etc. Dark brown sets with low key lighting will benefit by a plus factor of a $\frac{1}{2}$ stop increase exposure, while high key subjects, with a lot of whites, should be given a $\frac{1}{2}$ stop less than the information from Polaroid or meter suggests.

All shadows containing important detail must be given extra fill light when using colour, as the fall off from light to dark is much more abrupt than with black and white film. Usually broad soft fill lights, coming either from very diffuse lights or large white cards, will provide the necessary compensation. Colour film cannot capture lighting contrast in anything like the extended values which can be reproduced by, say, a slow panchromatic film.

6 Concept and Design

When ideas are present, the brush may be sparing in its performance

(From an ancient Chinese proverb)

A concept is a classification of things by the use of an idea or theme common to all those things and in photography it is a vast subject, encompassing all of the practical and philosophic answers to those eternal questions, Who? What? Where? Why? Who will see the image, what is the purpose of the image, where will it be displayed, how can the image be made, why am *I* making this picture?

Concept is also an editing process of the information being presented to the camera and in photography must have both optical cohesion and psychological unity, which are in every sense *designed* to fit the purpose of the image.

Such an image will first attract the passing viewer, then hold his attention, before finally taking command and will then subtly present the theme chosen by the photographer until the ideal of total participation of both creator and viewer is reached. How must this be done?

It must first be clearly understood that the only memorable images made in photography are those that make recognisable statements in terms of common humanity and those which also carry the creative convictions of the photographer. Each photographer must firmly state in all his work 'This I believe'.

Creativity can be limited strictly by the medium employed and photographers must first understand that they are involved in making images with the help of a machine. That machine has many flexible controls which modify its performance but, as in the case of all machines, limitations must be recognised. In considering concepts, do not cultivate ambitious ideas which the camera cannot present effectively. For example, do not accept a concept which depends on absolute detail and total clarity of focus for its success, but in fact must be photographed in a level of light which would make it impossible to use the equipment and film that could produce those ideal results.

This means of course that concepts can only arise from a certainty about all the practical matters that govern the medium of photography. This constant attention to technical skill is never an end in itself for, although picture content without technique is sometimes admissable, technique without content is a useless exercise. There will be no communication except on a very superficial level. Photography should be about what we are saying, not how we are saying it, but all of us must be aware of where the camera excels and where it does not. At one time it was thought that it was possible photographically to faithfully record reality, by using technique alone, but the result was not reality but an image of reality and this is of course a highly subjective thing to define and enjoy.

In consideration of a concept it must be said, that good images will generally need to make concessions of some kind to the viewer's knowledge and experience. This tends to make those things that are considered 'normal' more quickly communicative than those which are outside the viewer's experience. Therefore in cases where the image is to reach an audience of millions, say for advertising purposes, the concept must be carried by the *psychological* structure of the image instead of gaining attention by the use of unfamiliar photographic techniques. Naturally, if the audience is smaller, it is probably more discerning and techniques can be more adventuresome, while if it is a fine art image, the photographer himself may almost be the sole arbiter of technique. Consider carefully the photographic experience of those who will view your picture before establishing any guidelines for the concept.

79

> **Photography** is a visual language created as a statement of emotion, technique or design, by an individual. The beholder will interpret this image in the light of his experience of the technique or by intuitive involvement with the subliminal structure within this image. All images that conform to established rules of perception are easily accepted, unfamiliar images will be reclassified by time and economics. An element of timelessness should be inherent in the photographer's statement.

Whatever the photographic experience of the viewer, he will have some unconscious appreciation of the physical behaviour of images and these will have been formed by centuries of modification in his own culture and the growing experience of that culture in the unfolding history of world art. Although it is always necessary to consider any major differences, brought about by ethnic factors, in the viewing of a photograph, it is now recognised that a photograph is almost universally understood in terms of visual language by people of vastly different origins and aspirations. Young children, surprisingly, are often incredibly quick in recognising very minimum optical clues in a photograph and seem greatly to appreciate abstract photography. Some African tribes have been shown clear pictures taken on a Polaroid camera and while it was their first experience of photography, they readily grasped the basic concept, particularly when it applied to human forms. Islamic people, for instance, although their own scientists discovered the mathematics of photography, are religiously opposed to the reproduction of human and to some extent animal forms. This is not something forbidden by Koranic law, but as a general guide to conceptual thinking, in communicating with this group, the photographer would need to present ideas which were carried forward by images of objects only, or by deep abstraction of animal forms. The Arabic love of bright pattern and rhythmic form could easily be cultivated to overcome this kind of restriction and naturally would alter concepts.

The creative photographer must learn to create and dissolve all kinds of mysterious structures within his image, if he is to encourage deep participation by his viewer. If he cannot involve the viewer, he has lost the chance of any worthwhile communication.

The first steps the photographer will take to improve this co-operation between himself and the public will be to develop a vocabulary of image techniques which, historically, have some immediate surface meaning in the communication process. That is to say, they will attract the average viewer's attention.

These attention getting devices are all part of the search for optical unity and they control the primary perception of the image and make it more satisfying. This used to be called photo composition but such is the nature of photographs now that they need far more than perceptual techniques for effective communication.

Optical unity is largely a matter of organising the elements of the image in such a manner that the viewer will readily see that which he is intended to see. No matter how interesting the idea is behind the photograph, its meaning will never be known if first the perceptual factors are not clearly understood by the viewer. These factors must of course reproduce well in the final medium which is to carry the image. Some of these physical perceptual factors are outlined below.

Man always demands a measure of security in respect of his surroundings and seeks controllable contact with normal things, yet continuous exposure to familiar objects and situations reduces mental stimulation and creative growth. Seeking out the unfamiliar quite naturally leads to discovery, but if we do not master these unfamiliar experiences, they will master us, inducing anxiety or ambiguity in our minds.

Discovery therefore becomes a constant process of change, a comparison of unfamiliar with familiar, a study of significant similarities and differences between known and unknown things. Creativity is a voyage of discovery, which ends only when truth and reality are revealed.

PHYSICAL VIEWPOINT

This is a basic conceptual control in creating unity; it is usually found that only one viewpoint is the right one. This placement of the lens has a considerable influence over other physical and mental compositional factors and great care must be taken in making the decision. Logistic problems and the space within which the photographer

works often mean a change of lens length, perhaps radically. A looking up or down on the subject can determine what equipment is needed and what structures can be built into the image, even what shape the format will be. Place the lens for maximum visual effect, even if it is difficult, unusual or next to impossible. Only then begin to construct your image. The positioning of the lens creates a unique vision of the object, how it looked at that time and that place, and the optical behaviour of the lens will of course considerably alter the concept. Wide angle lenses tend toward graphic rather than illusionary solutions, tele-photo lenses isolate the subject and strongly increase the communication with main elements of the image. Longer lenses also add weight to slim people and considerably distort aerial dimensions behind the subject by condensing and compressing the space, stacking backgrounds tightly behind the main focus point.

Shy photographers or photographers taking pictures of shy people, even in a formal portrait session, can benefit by using longer lenses for tactical reasons and must consider the effect this will have on the final image.

All of us surround ourselves by a psychological bubble, the outer field of which determines the flight or fight decisions which we all make, unconsciously, in new situations. The size of the bubble is different for all of us and changes according to our changing emotions. Nervous people extend this bubble to an extreme degree, while extroverts retract this space to a point that allows anyone to be physically near them without disturbing effects on their psychology.

Photographers must be very aware of this curious factor and decide camera viewpoints accordingly. Longer lenses are essential for good relaxed portraits of nervous people and can gently intrude, optically, into forbidden areas of the pericorporal space with no ill effect on the subject. Ultra wide angle lenses, often used in advertising, are sometimes placed almost within touching distance of the subject and photographers will do better, when this kind of image is needed, to use professional models who are usually extrovert enough not to be upset by the heavy intrusion into the psychological bubble which contains them.

During a sitting it is better to begin with long lenses and if the subject relaxes, thus shrinking the bubble, wider angle lenses can be used.

PERSPECTIVE

Perspective is a means of making the image of an object look as nearly as possible like the original object, or so to distort that image by deliberate control that it makes normal objects with which we are very familiar look extremely different from the original, thus gaining attention from the viewer. Perspective is altered by looking down on an object when vertical parallel lines will converge at the bottom of the image or by looking up when those same parallel lines converge at the top of the format. If this is to be eliminated and true verticals are to be obtained from high and low viewpoints, a view camera is needed, with swing back movements. This divergence from parallel is greatly exaggerated by the use of wide angle lenses and this is often used to draw attention to an otherwise mundane subject.

PROPORTION

Proportion of objects in relation to other objects within the frame can be controlled by lenses and the space between elements of the image. Nearby objects will be larger than those far away but

Factors upon which values are dependent

Correct optical values	camera viewpoint
	perspective
	proportion
	balance
	form
	edge
	overlapping
	pattern
	space
	tone
	colour
	format
Correct psychological values	research
	pre-visualisation
	quality of the environment
	emotion
	differences
	mental viewpoint
	symbolism
	juxtaposition

distant objects can be made to appear closer to the front object in size and space by the use of long focal length lenses. Wide angle lenses, on the other hand, produce imbalance between near and far objects and this is sometimes carefully used by professionals to draw attention to differences and to create emphasis.

BALANCE
This occurs when all the elements of an image are apparently at rest and their image area is in a state of equilibrium. This pictorial balance produces harmony and holds diverse parts of the image together. When large 'weighty' areas, especially of dark tone, are brought into the centre of the format, balance will be found. Heavy areas in the image to left or right of the centre must be counter balanced by other visually strong elements placed in opposite empty spaces.

FORM
Form is necessary to all perception and the correct placing of strongly structured form is very important in achieving optical unity. Quality of lighting is vital in this and the control of tone within the form. Edges should usually be clearly defined in objects with interesting form and the whole form should separate from its environment. The 'hero' of the picture is essentially a form, well drawn by light and lens and supported by subdued or smaller forms. If this hero is placed above and to the right of centre in the format, that is to say at the optical centre of the picture, absolute emphasis will be found for it. Every property present in the surface structure of such forms should be visible in the final image, using the special characteristics of the photographic process to create interest and attention.

EDGES
Edges are the perimeters which surround the form and separate the form from its background and, by focus and lighting, these edges must be shown. A regularly shaped object such as a sphere may not need such clear delineation all round as the eye will tend to complete such well known shapes even when perception is poor. Silhouettes are forms without any surface structure shown and can be used as suitable screens from which other objects will advance.

OVERLAPPING
Overlapping (Fig. 48) is an extremely important

(a)

(b)

(c)

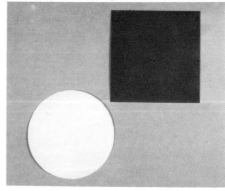

(d)

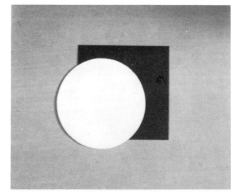

Fig. 48 Overlapping of forms is very important in photography as it helps to generate illusions of three dimensions in a two dimensional medium.
(a) The circle and the square are both at rest and no aerial space exists between them.
(b) Movement is apparent but no dimension or dynamic tension.
(c) Forms are flat, no tension, no movement and no interaction between the two.
(d) Separation and aerial perspective present, good interaction between both, dynamic tension and movement present.

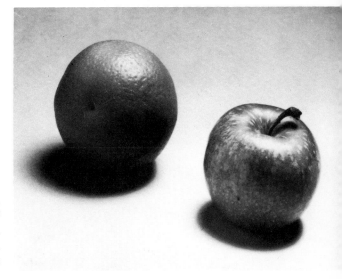

part of organising image construction. Forms should overlap because it assists the rendering of space and perspective and by drawing unrelated items together produces important psychological associations. Objects distributed around a format without any overlapping tend to exist by themselves, producing dilute areas of local interest, creating a flat plane in the composition and destroying optical unity. Overlapping also maintains solidity and gives the impression of quality or weight. Overlapping forms *must* separate from each other and this is done by controlling lighting, colour and texture. Care must be taken to unify the overlapping objects into a carefully structured group so that very often in still life photography there will be seen to be a number of macrocosms, but all controlled absolutely so that the whole image is totally cohesive. Overlapping will always intensify the interaction of one object with another (Fig. 49) and care must be taken in selecting objects which are to overlap. That increased relationship should not appear abnormal unless a deliberate excursion into surrealism is being undertaken. Overlapping also creates a dominant hero, the form in front showing its total value and being supported by any number of receding and lesser forms which are used to amplify the character of the main form.

PATTERN

Pattern is easily developed by the extended use of the overlapping technique. The human mind seems to be highly aware of pattern and in fact seeks it out as part of an attempt to reconstruct meaningful experience from the symbolic image of reality. Pattern is often the first thing we see, quite subconsciously, and there is, as one psychologist says, a tendency 'to grab the whole bag before counting the potatoes'. This is well supported by the Gestalt psychologists who also insist that the

Fig. 49
(a) Separating objects in front of the camera allows for no aerial dimensions between them and forms a pool of action in each isolated world belonging to each object. This is a picture of an orange and an apple.

(b) By placing these two objects together they retain their uniqueness but not to a desolate degree. They now belong to the family of fruit and interact with each other in terms of colour, form and psychological meaning. By creating a single environment of light and shadow, the photographer increases illusion and unity while clearly defining the individuality of each element.

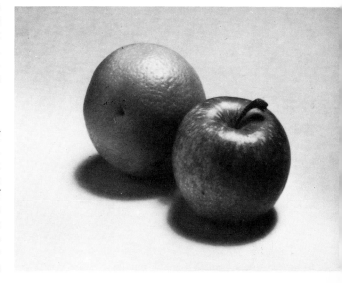

entire image is something more than the sum of its parts. The overall effect of pattern must be carefully noted by the photographer and this can be done more easily by looking at the outline only of the elements of the image and, if necessary, tracing them on the ground glass, so that their distribution over the entire area of the flat plane of the picture can be assessed. Pattern within individual objects themselves can also be used to vary emphasis and develop rhythms within the format.

RHYTHM

Rhythm is something that exists in nature and it is a comforting thing to find within a photograph. Where forms of the same contour appear together they will set up a repetitive pattern and this may be most effective in creating emotions. These alternating rhythms may be given variations by overlapping less emphatic forms of different shape or colour. The whole image can be made structurally strong by interlocking these rhythmic elements into a design plan.

MOVEMENT

Movement or apparent movement will be detected even before colour, and the still camera has two possibilities of utilising this fact. In psychological unity, the blurring of edges by focus or slow shutter speeds tends to evoke memories of life and give the subject vitality, but to some degree this can also be suggested by careful arrangements of main objects and their environment. Small objects placed in the space behind larger objects will 'move'; objects in shadow against bright backgrounds tend to suggest action; when strong forms lie at the top of the frame, in a state of dis-equilibrium and space is created below them, they will tend to 'fall'. Vertical lines are more still than horizontals, sloping lines stop when they are intersected by verticals. Tip the object out of its vertical axis and it will attract more attention because it 'falls'.

SPACE

Space is vital to the structure of any photograph and it will be found that all objects demand an environment of space if they are to produce interesting images and make statements about themselves. Space will exist on two planes in a photograph, firstly surrounding the elements of

the image in the picture's flat frontal plane and also on the three dimensional plane of the illusion itself. Too little space between objects in either of these cases will produce nervousness and disbelief in the viewer and will slow down his participation in the communicative process. Too much space will produce a looseness in the composition, and that concentrates the viewer's attention too intently on the main objects, resulting in rapid identification of them, but diffidence about any subconscious message.

TONE

Tone is a valuable help in establishing unity within an image and is an aspect of photography that is inherent in the process, so it has extra validity. Richly graded tones, both in colour and black and white, are attractive to the eye and quickly gain attention to those areas where they are present. Full scale rendering of the main object, for example, by careful lighting and exposure and then placing it against steeply graded or tonally compressed areas, will create unwavering emphasis on the usual hero, where it is required. Tone producing an overall feeling of lightness is called high key, while that which deals in darker and deeper tones throughout is considered to be low key. These key monotones are very cohesive and will quickly bind compositional elements together.

TENSION

Tension, but not the psychological kind, must exist if there is to be optical unity. It can be helped by apparent movement of inanimate objects, by intensified overlapping, by dis-equilibrium, ambiguity created by opposing lines of the same emphasis, incompleteness of forms where the viewer must make out and complete the whole form and the construction of a dynamic skeleton on which the fleshy parts of the image hang. Totally still objects can be given tension and therefore life, just by having supportive shapes placed in the right position. There is a tendency for individual elements to find their way out of the frame and good image management will encourage this, but will also ensure that there is always total connection to the mainstream of the composition. This binding together of centrifugally mobile elements creates tension and life. Vertical lines tend to move upward rather than down and horizontals tend to be the strongest dynamic elements, producing lateral tension. Circles, however, tend to move more strongly upward than

horizontally. Circular forms have internal dynamics that are seeking their perimeter with equal strength and so can easily be brought to rest by keeping them near the centre of the frame. A triangular shape is at rest along its base but tends to thrust into whatever surrounds the point. The arabesque releases tension and can be used as a background to dynamic composition, or as a relief for the eye to rest upon in busy compositions. Any oblique lines of composition within the frame will usually produce more tensile strength in the image and create attention, as will any obvious deviation from the normally accepted positioning of an object in its environment.

COLOUR

Colour design is a life time study by itself, but at even very basic levels can assist in producing optical unity. The intensity and areas of colours will change the behaviour of many elements within the format and will reveal or conceal to the viewer just whatever the photographer desires. Colour is rarely considered by itself, as it has such subjective meaning, but must work in close interaction with other compositional techniques such as form, balance and perspective. When a bright object of warm colour, strongly lit from the front, along the lens axis and therefore showing no texture, is juxtaposed against a cool textured background with emphasised form, there is vigorous separation between the two, with greatly increased dimension of the space between. If a complementary colour is brought in to overlap behind the main object, tremendous eye attraction will fall on this area while the background is de-emphasised and becomes a screen on which the objects are seen. If it is necessary to create low emphasis in areas containing any strong form, then colours should be harmonised towards a monotone. Bright spots of colour distributed around the frame are distracting and while themselves catch attention, tend to destroy any unity within the picture.

FORMAT

The format itself is part of the structure of the image and its size, shape, proportion and whether vertical or horizontal, will all play important roles in establishing strong structure. In fact, before considering any physical placement of objects in front of the camera, the dimensions and position of the format must be decisively fixed. It is almost impossible to produce strongly unified images, especially with still life, unless this is done.

PRESENTATION

Presentation of the image, the outer physical skin which contains the image, will play an important part in designed images and should be considered along with all the above factors. If the picture will be placed on the left or right side of a magazine, if it is reproduced on glossy or absorbent paper, if it is for display as an original wall print, if it is a book or record cover, all these variables can alter the emphasis needed. The size of the final image is critical, as this can determine to what degree any complexity of the image can clearly be perceived by the average viewer. As far as possible fix this matter of size and shape as an absolute and do not accept that alternatives of size and shape can easily be produced at the same time. Allowance must be made for redesigning the whole image when it changes shape or size. Presentation will also control to some extent the time that a viewer will spend looking at an image and that in turn, will control also how quickly his attention must be caught and what emphasis can be placed on elements of the image. In general, advertising images tend to be dismissed more rapidly, needing cruder emphasis of key areas, while fine art may carry every possible nuance which the photographer cares to create, with greater involvement by the viewer the more slowly those secrets are discovered.

Gustave Moreau is reported as saying that he believed neither in what he saw or touched, but only what he felt – 'subjective emotion alone seems to be eternal and unquestionably certain'.

While it is true that modern photography has a presence that depends on the production of granular spots on a surface, a believable visual statement is far more. Ideas and emotions must be conceived that translate into this physical manifestation and set up both an optical and psychological dialogue with the beholder.

The psychic 'fingerprint' of the photographer must be detectable in the whole work and concepts will depend to a very large degree on the ability to control certain abstract factors that bear relationship to the subconscious participation by those to whom the image is presented.

THE IMAGE

The result of pointing a camera at an object will

not be a record of that object, but will in fact, be an *image* of that object. Photographers are concerned not with surface reality but with images.

Images have three practical existences: the box shaped, three-dimensional illusion of the reality before the camera, the flat, two-dimensional tracing of both the area and edge of the graphic structure of the image, and the thin tactile presence of the medium which actually carries the image. A memorable image will have optical and psychological interaction between all three existences.

RESEARCH AND PRE-VISUALISATION

Research is again necessary to help decide which of these elements should be used and to what degree they must be employed. Deciding upon the techniques to be used to contact the viewer subconsciously, is rather like walking down a long narrow corridor from which open many doors onto large rooms which themselves have many doors. The forceful concept is the only one likely to be quickly understood in visual communication and both force and technique are easily dissipated by wandering in and out of these many rooms which have really nothing to do with making a rapid journey down the corridor.

Research and pre-visualisation on paper will close many of those doors which often only open onto empty useless conjecture. Study the subject, its environment, the purpose of making the image, etc. and set down on paper a guideline brief, even for the most trivial of pictures. Mentally review the physical characteristics of the image and attempt to project this mind image on some imaginary screen. A helpful thing to do is to look at some featureless part of the room, such as a plain door, window blind or the sky through a large window. Do not fix your vision on the surface plane of these objects or attempt to see any details, in fact tend to scan the perimeter of the 'screen' while still being aware of the emptiness that is its special reality. Concentrate deeply for a moment on this technique and then gradually think, piece by piece, about the image you want to achieve. Add and subtract colours, accessories, lighting, etc. and mentally screen the new image as each change is made. When suddenly a combination feels right, sketch this quickly, with no attempt at detailing, in a drawing about 5 cm (2 in) long. With a lot of practice in this method of pre-visualisation, a very reliable visual shorthand can be developed that will guide you to the final starting point for photography. It is helpful if this exercise is done in a quiet room, comfortable in temperature, with subdued lighting. Deep, very slow breathing helps relaxation and usually no other person should be in the room while the mind connects itself to the possible image.

This pre-visualisation, after research has outlined the problem, should never be considered as a finished visual brief. It will merely establish a framework in which the practical work is completed. When a really good thumbnail sketch appears on the paper, deliberately set out to produce another that is from an absolutely opposite point of view. Learn always to see other aspects of *all* problems. Training the mind to co-operate with the intuition in this way not only taps the memory bank and retrieves research information, it connects deep with the subconscious of the photographer and greatly strengthens the image construction. Finally, choose a narrowly defined concept which appears to fit the brief and be wary of making alternative pictures as this will weaken the mental viewpoint.

Armed with these sketched guidelines, practical photography can be started, but only after all equipment, props and environmental controls have been obtained. At this point, it is wise to think very little in detail about the image, but concentrate on putting the picture together in front of camera. Thinking 'off centre', looking as it were, from the corner of the eye, will deepen contact with the essence of the subject. The half glance is far more penetrating in psychological terms than the fixed stare.

Intuition plays a vitally important part in making meaningful images, as does trial and error, or capturing the lucky accident in some kind of unsought happening. These can start a chain reaction that only a camera can capitalise upon. The very nature of the latent image and the camera machine will make it possible to seize these moments, quite without conscious thought. Motor driven cameras can be helpful too in some of these lively situations, or an assistant rapidly reloading the camera, but no photographer should embrace automation of technique to the point where he abdicates from controlling that absolute moment when he presses the shutter, when he, in fact, 'takes' the moment out of time and place and turns it into a picture image.

In trying to establish psychological unity within the photograph, it is important to conduct the actual photography in an intuitive manner but it

helps also to consider some abstract hall marks of this ideal image.

QUALITY
Quality of the environment of the subject and of the practical craftsmanship in the picture itself, will begin important contacts to the viewer, quite unconsciously. Food placed on fine china positions an image at one point, the same food placed on a paper napkin radically alters concept. Jewellery placed on marble, or against bare skin or worn on rough denim will trigger very different responses in the viewer.

LIGHTING
Lighting can construct mood, towards or against quality, it can also emphasise one element in an image and reduce perception somewhere else. Correct lighting will establish time of day, geographic location, etc. and must be considered the primary craft tool in establishing quality.

TONE
Tone can change emphasis, slow down perception and change inner feelings of the viewer. Long scale, beautifully spaced tones promote feelings of luxury, peace and intrinsic quality. Short scale tones, with savage contrasts, promote urgency, life, fear.

EMOTION
Emotion must be clearly seen in the best work and usually it is only captured in a photograph when the emotion is actually present, even for a fleeting moment in time, between photographer and subject. The miracle of photography can catch that moment forever. To hold an open awareness of these emotive happenings, the photographer must be in control of his own environment as well as that of his subject and must feel harmony with both.

Lighting can create emotion by a sensuous revelation of natural forms. Arabesques and feminine contours can promote sexual feelings, beautifully prepared food on crisp tablecloths can produce appetite appeal. Probably the most difficult emotion to create deliberately for the camera is humour. While very successful when caught by alert photographers in a documentary way, when it is controlled and contrived to happen on cue for the camera, such as must be done in editorial or advertising assignments, it can easily be overacted and consequently not be believable.

In this kind of assignment, hire actors and play out the entire scene, shooting selected moments during that period.

Emotion can in fact very often be produced by extremely concentrated direction by the photographer and where a model is concerned, body movements can quickly suggest emotional content in a picture.

MOVEMENT
Movement and the unique freezing and blurring of it that is possible with a camera, brings nearly to life those subjects which have life. Blurring tends to promote a feeling of extended time, dreaminess, a depth below surface reality. At very pronounced levels it needs a great deal of effort for the viewer to resolve the subject and completion only takes place by using the resources of memory. This immediately causes participation. Blurring by low definition, or out of focus areas, which are not in the main subject, will emphasise that primary subject, yet will subtly remind the viewer of subconscious associations that qualify it. Blurred or out of focus parts of the image are highly evocative and must be most carefully managed. They will undoubtedly be understood and decoded by almost any viewer.

SIMILARITY
Similarity between objects can be used to emphasise. Two or three or more very similar shapes establish a repetitive mental rhythm that promotes a pastoral feeling of good taste or classic beauty. Even small changes in similar outlines will be unconsciously scanned for differences and any large discrepancy will bring immediate attention. A quiet repeat of similar shapes can be an excellent background for a subject of great complexity, but these background shapes should also contribute to the main theme of the picture.

MENTAL VIEWPOINT
Mental viewpoint is always obvious in photographs and it must clearly be decided upon by the photographer, preferably well in advance of the picture taking. He must, in all his images, express his own opinion and if he is commissioned by a third party, see that this party's mental viewpoint is conveyed also. Ambiguity of mental viewpoint should be avoided at all costs as it only creates confusion in the mind of the viewer.

SYMBOLISM

Symbolism depends very largely on cultural factors belonging to the society or the individual to which the image is offered. The first scale of reference, long before analysis of any part of the image takes place, will come from general folkloric background feelings which are to be found in all mankind.

Dark pictures are mysterious, light pictures informative, ovals are feminine, circles and squares are peaceful, arabesques are soporific and passive, while zig-zags are active and often create anxiety. Symbols such as these may be found within the image as single objects or as visual patterns made up of several objects.

Besides these collective activators of the unconscious, individuals will be affected by symbols which trigger responses from very deep levels indeed. For each person, there will be a different response and it is helpful if detailed study of the general behaviour of symbolic images can be undertaken.

The books of Jung, E. H. Gombrich and Rudolf Arnheim are most informative, while specialised information about colour symbolism can be obtained from the works of Faber Birren and Max Luscher.

Colours and shapes will recall memories both good and bad, cause anxiety or repose, promote appetite or revulsion, love or fear. They must be managed intelligently if the content of the photograph is to be clearly understood and any reaction is to take place in the mind of the viewer.

Correct placing of symbolic objects can suggest whole environments, rather like the recall effect of hologram plates that have been broken. The fragment can recall the whole image. A well chosen hat can conjure up an entire classification of a social group or even an entire nation and the right chair can evoke a complete roomful of furniture and so, convincingly, indicate time and place with minimum means.

When using symbols to represent much larger happenings outside the frame, careful research must solidly establish that its use is correct in historical terms and will trigger the wanted response.

JUXTAPOSITION

Juxtaposition of unrelated or incongruous objects within one frame has long been a tool of the Surrealist painters and photography has come to use the same techniques as a very basic compositional practice. Unlikely or unrelated backgrounds are frequently used to attract attention to the subject and this is always a primary response to surrealistic undertones within an image.

A second, much deeper one involves the interaction between elements which are often very remote from each other. Jerry Uelsmann is one of the modern photographers working in this way and his pictures often promote a dreamlike uneasiness that at the same time becomes an introspective evaluation of the photographer's own motivations and a reverie of unresolved dreams for the viewer.

Advertising and editorial photographers often use surrealism for cheap dramatic effect but it is a primary tool for modern photography and must be understood if strong images are to be made. Surrealism, by the use of the juxtaposition of incongruous forms, seeks a reconciliation between the narrative content of the message and the soaring unconscious dreams of both the creator and the viewer.

Juxtaposition of two or more images on an open double page spread can create interaction and attention. Frequently this association will create entirely new meaning for the assembly of images, quite separately from that of the individual images, and advance knowledge of how the pictures will be used can help the photographer increase the pictorial value of the total pages.

GROUPING

Grouping and number both interact and assist optical cohesion and psychological unity. An orange and an apple, photographed together but considerably separated by space, retain their individual identity, but grouped near to each other or overlapping, individuality is diminished and the orange and apple become fruit. The separateness of each however is still contained within the larger collective identity. Suggestions of luxury, plenty, or the presence of more than one person outside the format frame, can be implied by adding numbers of the same object together. Objects lacking surface detail and of simple shape do not generally attract the eye for long and if these are to be the subject of a picture, more than two such objects should be shown for emphasis. It is a matter of pictorial folklore that the eye finds more satisfaction in odd numbers in a group and certainly most people dislike the symmetry of equal objects or equal emphasis. A magic three or five grouping will be found to be successful in

The progression of time can create a feeling of life and this can be created in still pictures by showing actions such as pouring, steaming, bubbling, running, hair blowing in the wind, smiling, looking, etc. Time can be arrested by high shutter speeds or fast flash lamps, in which case it is analysed intellectually by viewers, or it can be blurred by slow camera speeds or slow film to create soft edges, thus reducing perception and conscious analysis, but greatly increasing intuitive participation by the beholder who must complete the image from his own memory of similar situations. This involvement intensifies communication. Montage (Fig. 50) is particularly useful in showing different aspects of time and place in one still image. A good montage will give a sensitive dissolve effect from one image to the other and may be assembled in camera by superimposing successive images or by the use of darkroom techniques. To get the true feeling of elapsing time, it is necessary that the scale of one image to the other is most carefully designed and that edges and tones do not end abruptly as the transition is made. Strangely, the best images, even when showing elapsed time, also should have about them a sense of timelessness. This eternal feeling of 'rightness' is reassuring to a viewer and adds an ambience of quality and respectability to the image. Pictures which are sharp from foreground to infinity and edge to edge, often will not carry this illusion of timelessness as convincingly as will a picture which has different degrees and planes of sharpness throughout its three dimensional space.

creating pictorial dynamics and satisfies most people psychologically. The camera has an extraordinary advantage when compared to drawing, in that once the logistics are taken care of, literally hundreds of similar shapes can be collected together and, in one moment, captured on film. This super-numerity of objects is one way of creating undoubted emphasis and the strong attention-getting optical unity is magnified by a tinge of wonder in the mind of the viewer that he can, in one glance, see such a multitude of separate entities. This is particularly useful in suggesting that many people endorse a product or service and is used in advertising to some degree.

TIME
Time is present in all photographs, as the function of the camera is to 'take a picture' of time itself.

SCALE
Scale can create immediate psychological response in the viewer, for example the tiny, isolated object will become precious and important, while the large foreground object placed next to diminutives of the same kind is given connotations of importance and strength. The size of the final picture as it is used, also alters subjective involvement and can determine lens lengths, etc. A wide angle image of a table setting for example, when viewed from the normal 35 to 45 cm (14–18 in), such as usually occurs in magazine reading, can greatly increase involvement, producing a sensation close to real vision. The same picture on a roadside poster viewed from afar will look entirely different, produce unease in many normal viewers and will draw excessive attention to the photographer's presence in the communication.

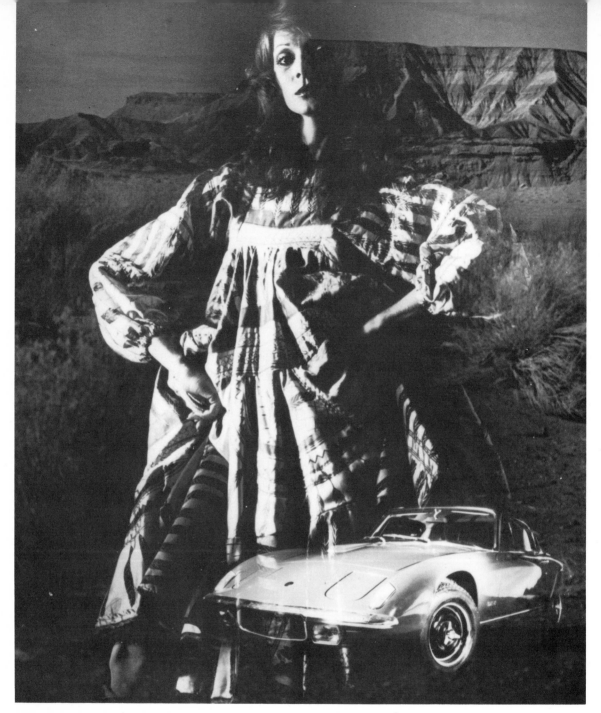

Fig. 50 A true photographic montage integrates a number of unrelated images by overlapping on the same sheet of film. Interaction between objects is greatly increased and this technique opens up many possibilities for surrealist concepts. Montages can be made in camera by successive exposures or by recopying onto duplicating film. See Case History Numbers 9 and 44.

THE CLICHÉ

The cliché should not be overlooked as it is readily understood by the majority of any particular social group and if the image is to communicate quickly with such a group, the well illustrated cliché will do this. Although the concept of a cliché seems to be mundane, it is often based on established habits and truths and seeking a hackneyed mental

concept is not always a bad thing. This ordinary concept, however, must be faultlessly executed, with perfect wit and good optical technique. In fact the cliché concept will support very adventuresome technical execution, creating bold attention-getting visuals for well known, homely beliefs.

ABSTRACTION

Abstraction (Fig. 51) is a valued aid in communicating concepts and is now more understood by ordinary viewers than earlier this century. Black and white photography is itself a simple abstraction and as such the image often becomes stronger than the reality it represents. Lighting can reduce form, soft focus can make abstract shapes and the rigid compression of tonal scale by graphic techniques in the darkroom can call attention to the flat plane of the image. These abstracted, trace elements of real life can be most appealing to the young, and can easily make sweeping generalisations such as must guide concepts in advertisements for institutional clients, for example, in banking, health or insurance. They also neatly augment poetry or music and can be very effective therefore for book illustrations or record covers. They do not give any analytical information to a viewer and are possibly the most strongly subjective images which a camera can produce.

Abstraction has always been an attempt to make the artist's inner, unconscious reality more accessible. This is achieved by the use of hypnotic and mysterious clues which, at first glance, appear to be meaningful only to the artist. Abstraction is, however, a fierce yet unfocused glance at the world which often discloses more of truth and beauty, even to the visually illiterate, than any analytical or figurative image ever could.

MOOD

Mood is, for the photographer, a feeling, beyond analysis or discussion, which will be of paramount importance in making effective images. The camera, quite uniquely, I believe, can capture mood of infinite modulation or intensity and so seductively, that in the presenting of these moods

Fig. 51 Abstraction can be achieved by total suppression of form as in (a) by graphic techniques or (b) by masking ordinary perceptual clues in the image by eliminating information during the original taking session.

and feelings as images there is no better art or craft than photography. The 35 mm camera is especially useful in re-creating mood, as it allows the photographer to maintain undiluted concentration on the essence of his subject. The presence of people quickly creates mood and therefore a strong feeling that humanity is present or has very recently been present, in the picture, will establish believable mood. Muted colours, soft focus backgrounds, cross or back lighting, diffused edges, darkly lit interiors, antique accessories, all assist the viewer in getting some feeling of mood from the image. When 35 mm formats are enlarged to, say, magnifications of 20 times, mood is often greatly increased. The ideal way to photograph mood subjects is to create or control the main elements of the environment in which the subject should find itself and then work quite intuitively. Act on impulse, or ask the subject to act on impulse and exactly when it is felt that the happening in front of the lens is valid, press the shutter. Still life photographers must construct mood by lighting alone and this is a task that can easily take six or seven hours of deeply concentrated activity. Lighting by tungsten light, rather than by flash light, can very often establish mood more successfully in still life, while daylight under strict control surpasses both as a moody light source.

EMPHASIS

Emphasis must be present in any visual theme and therefore there should not be conceptual ambiguity. Optical ambiguity can be useful in causing eye shifts around the image and can aid conceptual emphasis but there must clearly be a dominant element to a well made image, with supporting areas of reduced emphasis to bring this about. In commercial communication such as magazines, advertising and packaging, the dominant, heroic behaviour of the main subject or theme must be in no doubt, as these images must be understood in fractions of seconds, often in poor visual conditions. Book illustration can be much more subtle in the matter of emphasis as these images are in a medium that is kept for a long time, often years. The best of these illustrations will contain some hidden factors and subtleties that are only found after a fairly long association with the image. Fine art images, on the other hand, must be so subjective that a quick reading of the emphasis is totally destructive to any enduring quality. The viewer of these images should, by a clever use of optical ambiguity, delicate shading of concepts and considerable visible introspection, be set a series of codes to unravel. Emphasis there must be, but it should be so carefully manipulated by the photographer that a final solution requires major participation by the viewer.

DESTROYING THE OPTICAL IMAGE

The destruction of the perfectly made optical image, by the use of these subjective modifiers, can produce vitality, believability and acceptance to an amazing degree in visually literate people.

Just as, when the lights are lowered a little in a roomful of people, the hum of conversation rises, visual conversation can be increased by a controlled reduction of perceptual factors. The destruction of form, tone, edge and tactile values in an image, destabilises that image, creating a subjective condition similar to peripheral vision, when the objective's qualities are somewhat distorted, yet still remain as an indication of the basic structure to support any subconscious enquiry by the beholder.

These obscurities and lack of completion, caused deliberately by advanced photographic technique, are a way of coding the elements of the picture and decoding will only come about by the viewer reaching into his memory for some of the pieces which fit the jigsaw puzzle the photographer has presented. Mass audiences in our television dominated world have become adept at unscrambling very minimum clues from a mobile image that is often broken by lines, poor tonal quality and electronic interference. Consequently, visual literacy is found in most modern civilisations. The fleeting images that gather on our screens to present emotional and deeply subjective experiences, are somewhat similar to those which the still photographer can make, quite confidently, in order to achieve deeper communication.

Appreciation of any image which has been made to the limit of its full optical purity is largely an intellectual matter and in the matter of communication is a secondary process. The primary process, one of understanding by induction and intuition, will be the most deeply felt and the one capable of deep retention.

The receptive awareness that is necessary for this desirable condition of communication to be present is easily brought about by masking perception to some degree and slowing down the first impact of the photographer's message. Except for informational reasons, realism is usually not needed and, in fact, the message need not even be

intellectually understood. Surface structure, say in abstracts, could be quite fragmented and without meaning, provided that the picture keeps in touch with the unconscious of both the maker of the image and the beholder.

Ways of destroying the perceptual code are sometimes as basic as using differential focus or diffusion, low intensity light, blurring from camera movement or subject movement, ambiguity in the optical planes, analogous colour harmonies or the use of photographic grain or artificial screens. Compression of tone and abstraction of form can also be used to contact the subjective nature of a viewer, but this is a very demanding and sophisticated technique.

The use of granular patterns in highly diffused images is beneficial, offering something solid and perceptually meaningless for the eye to rest upon, before going back to search out more from the coded structure. This shift in focus also helps to keep intuitive forces alive in the viewer and prevent the fixed, unseeing, blank stare. Deliberately increased grain is quite satisfying in a photograph, as it is intrinsically part of the process and is easily induced by using a fast coarse grain film developed for an extended time in a vigorous developer. In black and white photography, TRI-X developed in May & Baker Suprol, diluted $1 + 10$, gives good grain pattern, while in colour, something like GAF 500 ASA film, under exposed 3 stops and pushed to compensate, will give fascinating, low saturation colour with interesting grain pattern. Grain can be further enhanced by enlarging a small section of this image onto dupe film at high magnifications.

THE HUMAN ELEMENT

Concepts will always be more convincing when evidence of humanity is present, as we always check new sensory data for its relationship with our own physical selves and make translations accordingly. Therefore, try and include a person or part of a person in any concept that needs to get quick attention. The face is especially mysterious and provoking. Because the human form is, perhaps, the most powerful visual symbol to employ in any image, considerable care and thought must be given to, not only how it should appear, but who should appear. Once a concept is fixed and the pre-visualisation phase commences, it will be important to review the character and dress of any one who is to be included. This casting of a suitable actor to support the general theme

may in fact be a matter of going to a location that fits the concept and finding a local person to be part of the photograph, or hiring a professional actor or model to work under direction. In either case, particular notice must be taken of the clothes, characteristics and visual personality and only those whose presence helps the story should be used.

So much emphasis, subconsciously, will arise from an image of the human figure, that every tiny detail must be correct. Old people suggest wisdom and endorsement of the situation, young people indicate life and vitality, children and babies – innocence and purity. Dressed in drab browns, a character can be countrified, without any evidence of location, while those in trend setting clothes bring a breath of transient city life. Workmen's clothes should be work stained, a banker's suit must be spotless. Notice must be taken of local customs, current fashions and normal generalisations, when deciding on identities and wardrobes for all those who are to appear in the final image.

Handling people in a studio or on location demands much of the photographer, who must always treat them with courtesy and good professional behaviour. Plenty of conversation before and during the session, with a minimum of technical fuss, will help get good images. For an important portrait, research the activities of the sitter and meet him once beforehand, if possible. Professional models react well to clear and constant directions and can usually 'act through' a situation many times without any change occurring. This allows the photographer to use a real life shooting technique, tightening up his spoken directions near the point when he must press the shutter and thus getting very natural reactions. The set posing, taught by some model academies, is very old fashioned and a barrier to making believable pictures. If possible, for modern images of people, get them out of the studio and into a comfortable environment that complements the activity which is in the concept and take pictures with existing, natural light.

Remember that whenever photographs of people are published in advertising media, written permission of that person (or their guardian in the case of a child) must go with the photograph to the advertising agency. This must be done for each person appearing in the picture and usually a fee is paid even to amateur models, to strengthen the contract.

93

THE PURPOSE OF THE IMAGE

The way that conceptual images are finally used makes a considerable difference to details of production and a good photographer will make himself aware of general guidelines and progressive changes in various media, as his career unfolds.

At one time, advertising demanded the most from creative photographers, for they were in the business of building the dreams and fantasies of ordinary people and had budgets to make it possible. If a picture of a man cleaning the upper windows of a storm-shrouded lighthouse could sell more detergent, there was a fee to cover this. If an antique aeroplane, an elephant and a band of gypsies were needed in Bermuda as a background to the latest swimsuits, this could be done, with strikingly creative photographs appearing as a result.

Today, with the steady rise of consumerism and tough laws to insist on accurate trade descriptions, both advertising and magazines are looking for much more down to earth, informational pictures. Products must be found in clearly lit, documentary situations, fashion and beauty pictures must be taken with almost snapshot album simplicity. The public no longer finds an excessively obvious studio background very believable and the shrinking of magazine formats, use of cheap paper and a general tendency to forget about decorating editorial pages with lavish double page spreads, mean tiny and uncomplicated photographs in this once lavish medium.

These changing guidelines will alter concepts and in general today, if his motivation is to make deeply committed, complex concepts, the photographer must look elsewhere. Book illustration is also involved with the movement towards simplicity and information, but because of the need for a longer term of interest in this kind of image, creative challenges still await the photographer in this field.

Concepts for record album sleeves and, to some extent, covers for paperback books, continue to involve the visual statement of fantasy and deeply creative photography can be used there to a degree impossible elsewhere. Some calendar clients also ask for these highly motivated images to be used.

A rising potential market, that of audio-visual presentations, where colour slides are cued to music and a subject is presented sequentially in a modified movie technique, is attracting many of the world's most creative photographers and calls for a considerable change of attitudes and concepts. All the elements of control in producing forceful visual statements from still pictures are connected to the complex world of sound and the fact that the photographer has a sheer volume of images to help him. Concepts may be decided upon where the emphasis is built up over many slides and augmented with music, dialogue and special effects. Subjects may be looked at from all angles and provided with elaborate detailing.

Remember, however, that all the basic conceptual practices still apply to this form of photography and it is wise not to weaken the message by a neglect of them. Emotive and well photographed concepts, supported by an intelligent use of the sound track can be a most effective communication and there is considerable growth in the use of this medium.

For some photographers a haven from the intensity and disciplines that are found in making images for advertising and editorial use may seem to exist in the fine art market. It should be said now, that discipline, craftsmanship and motivation must reach incredible peaks in this field. Concepts must be very different from those designed to achieve commercial results, but all the controls are the same. The fine art image is coded to a much greater degree, with more fragmentation the concept is intellectually freer, but metaphysically such images call for an advanced awareness and a trustworthy intuition built up by long, disciplined research and sound photographic experience.

The fine-art photographer must be much more introspective in his conceptual thinking, much more daring also. His images will communicate primarily with himself and his contact to the public will most often be in highly unconventional visual language which perhaps may even be actively disliked by many.

His photographs must acquire a life of their own, a sense of 'being'. A long painstaking search for his true identity will be necessary, a workable philosophy of his own must be found and his craftsmanship must be given a purity of presentation that is difficult for some to acquire in a whole lifetime. The fine art photographer, working with this medium of time, must find concepts that, historically, will stand the test of time itself. To the fine-artist using photography, one final word of warning however: do not disclose your silver dreams, except to other dreamers. Poetry, as has often been said, is only for poets.

94

7 The Life in Still Life

If, from all things we could use, we choose only those, or parts of those, that will suit our purpose and by arrangement and lighting, achieve a result in which the most important feature strikes us first and the secondary interest falls in its rightful place and so on and if the entire picture contains not one thing more than is desirable and the entire creation gives a feeling of completion, we have achieved a perfect composition.

(From an early Dutch book on painting)

To set inanimate objects in front of a mechanical instrument and record the details by an impersonal system of chemistry would seem to provide the ideal ingredients for sterile and soulless images, devoid of any sense of communication. Those photographers who practise this art of still life are following in the footsteps of some very famous artists indeed. For many centuries Western art despised this genre. Real painting seemed to want nothing to do with what appeared to be a dull, inert sub-chapter in art experience. Some decorative examples of still life paintings appeared on the walls of Greek and Roman villas well before Christ was born, but these were not greatly innovative in technique and they and their creators have faded into well deserved oblivion.

Not until the late sixteenth and, in particular, the seventeenth and eighteenth centuries, was 'still life' elevated to a substantial matter worthy of serious painters' attention (Fig. 52). Flower pieces, kitchen interiors, raw and cooked food, household utensils and small accessories to dignified living, all these were rendered in masterly fashion by great painters, whose works are still, today, enduring as shining examples of a deeply concerned art form.

Later in the nineteenth and twentieth centuries Cézanne, Braque, Gris, Matisse and Picasso used still life subjects to advance painting to new and complex peaks in art which still symbolise much of mankind's behaviour in today's world. As John Russell has said 'over the past 70 years, still life has suddenly asserted itself as perhaps the highest form of art'.

Photographers interested in still life should in particular study the work of two, very different painters: Jean-Simeon Chardin, who lived in Paris for the first 79 years of the eighteenth century and died at the age of 80 years and Henri Matisse, another Frenchman whose working life began before the close of the last century and continued, magnificently, for 62 years of this century, until he died at the age of 86.

In the work of Chardin, the photographer will find a subtle structure of soft light, deep humanity and loving witness to the homely experiences of the people of his day. The narrative of human activity, just outside the frame of his canvas, is deeply felt. Here indeed, at its best, is the life in still life. There is an immediacy about his painting, in his casual arrangements of darkly lit kitchen objects, that dignifies the simplest of subject matter with all the force of a major personality.

This then is a good starting point. Choose simple subjects that are relevant to your message, render them as documentary moments in a passing experience, dress them in a soft broad light to look as natural as possible and use the special ability of the camera to record every subtle action that indicates a recent human presence.

This evidence 'in action', that humanity is passing by, the role of the quiet witness of a supreme moment, interrupted in such a manner that the actors have temporarily departed, is something that the still life photographer must be intensely concerned about if he is to make notable communication in this field.

Henri Matisse may seem an impossible mentor from whom the apprentice still life photographer

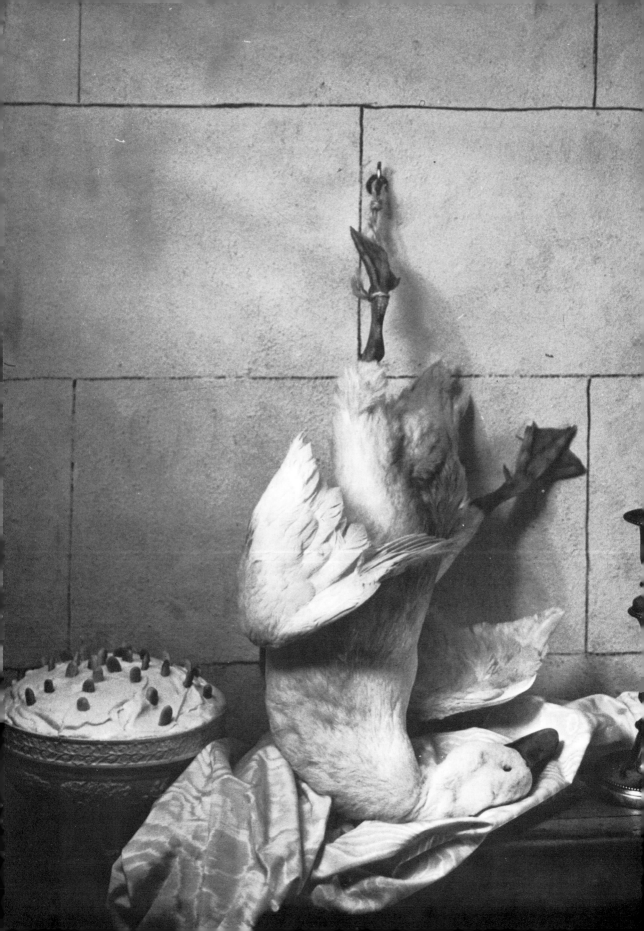

Fig. 52 Recreating old master paintings is an interesting area for photographers' experimentation. See Case History Number 18 for further information.

may obtain guidance. Certainly he departs radically from the work of Chardin in rendering 'life in still life'. Here the artist is not only a sensitive witness to the subject, but brutally controls every tiny facet of the communication until the whole frame erupts with his own individuality. The modern photographer, supported by superb optics and chemistry, can also radically reshape his viewers' emotions and experience by the dramatic use of colour, area and scale.

Study the exotic use of colour and pattern and the rapid changes of brilliant optical planes within the paintings of Matisse. Forget about form. Bring the still life to life by the use of colour alone and the force of your own personality. This kind of photography needs brilliant but soft edged light and maximum saturation of colour.

Every space in the format must perform exactly as the photographer unconsciously visualises it. Colour harmonises, vibrates, recedes or advances, just as the photographer desires.

In this kind of photography comes the ultimate challenge: to overcome the cold and faithful optics of the camera machine and vitalise the subject with the style and personality of the artist photographer.

Remember, you, the photographer, are totally in control of the entire image (Fig. 53). In still life there are no lucky accidents. The position of each object, the character of it and the final overall composite design within the frame is entirely the responsibility of the photographer. The opportunity for failure is deeply inherent in this area of the photographic experience.

Kant has said: 'In painting, sculpture and in all the visual arts ..., to the extent to which they are fine arts, design is essential, for design constitutes the foundation of taste only by what pleases by its shape and not by what it entertains in sensation'.

This may be a typically north European point of view, suggesting that the artist should concern himself only with practically rendering contours and textures and defining the structural nature of the subject, but it is essential for the still life photographer at least to begin in this manner. By using superlative techniques he must give to each object its true surface structure and shape. Glass should be transparent but have glistening surface highlights which disclose its material nature. Fur

should be soft, liquids should flow, wood should have organic structure etc. This is a matter of 'drawing' with the camera and with light itself.

Matisse, the great colourist, also has something to say on this subject. 'If drawing is of the spirit and colour of the senses, you must draw first, to cultivate the spirit and to be able to lead colour into spiritual paths'.

Of course a technical picture will need to give exact and very comprehensive information, so the 'drawing' of its characteristics is taken to an extreme degree, but the more satisfying and expressive picture will leave out unnecessary detail and will show only those characteristics which the photographer believes to be the *essence* of its existence.

The suppression of unwanted detail is of course best done by perceptual factors. Such a still life will have a designed and balanced structure, objects will be grouped logically, shapes and contours will be simplified by proper selection of the object itself and by controlled lighting when it is in front of the camera.

Objects will not stand apart from themselves but will clearly overlap, yet separate spatially away from each other and the environment to which they associate.

The use of lighting and perspective becomes very vital in this illustrative style of photography.

Illustrative still life photography, as different as it is from technical record photography, will be seen to continue to depend heavily on many of the same techniques, but with one important and overriding additional factor: expression.

The illustrative photograph must express the undefined nature of the objects and the subjective viewpoint of the photographer.

This expression can only be conveyed by first establishing a clearly defined perceptual reality. All subjective value of a picture will be lost if its presentation is confusing either in matters of perception or of psychology. This means an effortless technique must support a soundly based concept. Only then will the eloquent, immeasurable plus factor of style show through the work and by establishing an encompassing style for all objects, the photographer can create a total expressive image and environment, in which the position and value of each separate object and their total interaction, each with each, can accurately be defined.

Photography is possibly the most expressive art form in the matter of creating mood images and

here the complete overall detail and feeling of quality become in themselves important elements of composition. Carefully chosen and arranged objects, flooded with soft and revealing light, could quickly establish an impression of a relaxed morning meal. The same objects, arranged dramatically in a harsh, tightly drawn lighting plan could tell a story of fear, nervousness or frantic rush. In expressing emotional content in still life pictures it cannot be emphasised too much that, while many details are suppressed to permit better communication, all *pertinent* details must be clearly seen.

Fig. 53 In building a still life picture, minute attention is needed in every detail. Objects are moved only centimetres to create entirely different images. In (a) the composition is basically completed as far as camera position, lens length and lighting but lacks verticals. In (b) the verticals are added and the lobster cooked to a bright red. In (c) a much more dynamic image has been made by allowing the lobster's claw to break the table edge, turning the lobster clockwise and giving more space between the plate and the left hand table edge. Now look at the colour reproduction of the picture in this book and see how the whole composition changes by the introduction of colour.

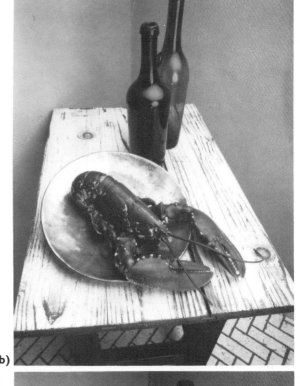

(b)

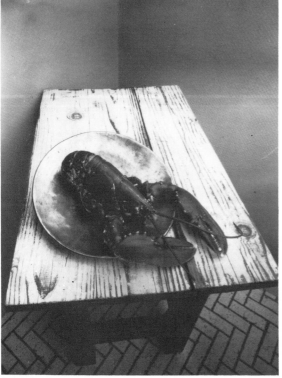

(a)

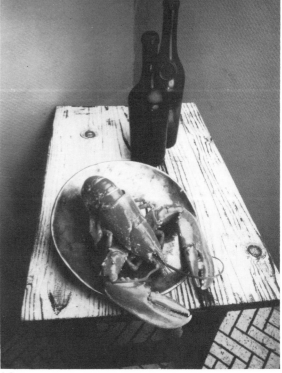

(c)

In still life, where the need is to render line, form and texture as nearly as possible to the tactile realities contained in the original organic objects, it will be wise to use the largest possible format that expenses will allow.

Some leading professionals will use an 18 × 24 cm camera but unless very large magnifications of the photograph will be needed, such as for roadside posters or architectural murals, this size is unnecessary and greatly complicates ancillary equipment. These very big cameras need extremely stable tripods, heavy lenses and, if studio flash lighting is used, tremendous resources of electric power.

For most purposes, a 13 × 18 cm (5 × 7 in) camera, such as the Arca Swiss monorail, will be ideal. This is still a large format but such a camera is extremely light in weight yet exceptionally strong, so supporting equipment can also be much lighter in weight. This makes it more portable and less costly. This particular format, while being enough for very large magnification without loss of quality, also is much less expensive in terms of sheet film and processing than is the 18 × 24 cm (8 × 10 in) camera. The smallest format suitable for most still life purposes is the 9 × 12 cm (4 × 5 in) and this has been the standby of many professionals for half a century. Usually light in weight, equipped with maximum control movements and relatively inexpensive in terms of film and processing, with care, these cameras give excellent results in all areas of still life photography even to extreme degrees of magnification.

The size of these cameras and the costly supporting equipment and film, make it usual that only professionals or photographers with generous private means can aspire to this style of photography.

It is possible to obtain good results in still life by using smaller format cameras with fixed bodies but subjects must be chosen in which perspective control is not vital and where texture and all tactile properties in the subject are less important than colour or mood.

The larger cameras are called view cameras and are always used on a tripod. This tripod needs a rising centre column, preferably on a geared post, a robust tilting head such as the Arca Swiss Mono-ball and very stable, quickly adjustable legs that can lift the camera to a minimum of 2 metres or drop it to at least half a metre (but preferably lower).

Film is carried in double slides which fit the

The order of setting up a large-format camera

- Level the subject.
- Level the camera.
- Angle the camera and select the viewpoint.
- Adjust the camera swing back towards vertical.
- Tilt the lens panel toward the selected plane of focus.
- Angle the lens panel laterally toward the main plane of interest.
- Watch all movements on the ground glass.
- Make each adjustment fractionally.
- If total control is elusive, zero all controls to normal and begin again.
- After the photograph is complete, zero all controls to normal.

back of the camera and at least 10 such slides are advisable, allowing a total of twenty exposures at one loading.

The most distinct advantages of this type of camera, apart from beautifully rendering the physical properties of the subject, is that corrective control may be exercised over parallels, depth of field and perspective.

The front swings control sharp focus on selected planes in the subject, without stopping down unduly. The lens is swung in the direction of the desired plane of focus. This is a very sensitive movement and must be watched carefully on the ground glass by the use of a 5 × magnifier.

The back swings control perspective. This function operates vertically, laterally or a mixture of both and will control parallels and ellipses to give them their expected perspective appearance or, conversely, can be used to exaggerate their appearance to a deformity that is used deliberately to gain attention for the object.

The rising/falling back and front movements will orient the main image within the format, without altering perspective or focus.

All these control movements should be made delicately, watched in the ground glass with the

lens at about f. 8 or f. 11 with a good bright light on the subject and none at all on the ground glass. Inspect all final results with a 5 × magnifier and stop down to a lower aperture for increased sharpness or depth of field, if desired.

Lenses are very important for the still life photographer and he needs several, all of which are highly corrected against aberrations and therefore costly. Such lenses must perform well when they are shifted out of their natural alignment to the film plane and in general will need to be longer in focal length than is usually considered normal with small format cameras.

Lenses such as the Rodenstock range of Apo-Ronars, Sironars and their phenomenal Grandagon wide angles are some of the best ever produced for still life work and can be used with great confidence to produce sharp natural renditions of the subject, even while the most extreme camera movements are being used.

Other extremely good lenses are made by Schneider, while Kodak Ektars and the very effective Voigtlander Apo-Lanthars may still be obtained as second-hand items.

For a 13 × 18 cm (5 × 7 in) format, a still life photographer needs to begin with a 210 mm lens, a 300 mm lens and a 121 mm wide angle. If he can add a 360 mm lens and a 90 mm super wide angle lens, he will have a great deal more flexibility in handling difficult assignments.

Shutters are not necessarily fast, but should have a rapid method of opening the lens without changing speeds and provision for a cable release.

Still life photographers will certainly begin their experience by needing a broad soft source of light with plenty of power and access to a small darkroom for loading film.

Many advanced still life photographers will be operating commercially and this will mean using a powerful set of studio flash lamps to provide the continuity and accuracy of colour in the final photographs that their clients will demand.

Environments must be more closely controlled in still life photography than in any other form of image making (except perhaps medical photography) and inevitably, a studio is required if much of this work is to be attempted.

On small budgets, usually for non-commercial subjects, the photographer can do no better than use daylight as a light source and work with black and white film. Many famous photographers still use no other means than these to produce superb art, many of them with bulky 18 × 24 cm cameras which provide them with a format large enough to display solely as a contact print.

Of all the ways to learn about photography, still life is the best. The technique of the large format forces the photographer to be selective and to meditate carefully before the shutter is pressed. The cost of the film is high and it is impossible physically to keep any large reserve of exposures, especially if working on location. The whole technique of working with large cameras elevates the photographer's craftsmanship to a degree of sophistication not possible in any other way. The advanced photographer will be well advised, if he can, to continue working with still life and large view cameras even if his speciality moves toward small roll film formats.

The careful pre-visualisation, the research into styling, the patient placement of objects and lighting, train the eye to an intuitive editing ability that is the most important capability in any photography *especially* when using small frame, motor wound, automatic cameras.

Still life photographers will usually be working in various distinctive ways and the better ones finally achieve a style that is as personal as a finger print. Some will choose objects that symbolise deeply felt human needs or emotions, some may choose subjects and arrangements that allow a documentary approach, catching momentary glimpses of the passing of contemporary history. Still others will explore only themselves, by choosing objects of great simplicity which are then rendered with maximum virtuosity of technique.

Whichever way is chosen it must begin from the same starting point: research.

In still life, the success of the picture depends finally on the extent of the knowledge which the photographer has about the totality of his subject. He himself must first form a definite opinion of what appears before his camera if he is successfully to communicate to others anything significant about that object. So the photographer must deeply understand everything about the objects he chooses to record, their association with other objects and their meaning to those who will view the finished work. Take notes, ask questions, read, spend as long as possible in close study of the actual objects which will be used.

Once the basic research is completed, it will be necessary to pre-visualise and preferably, sketch some structural plan for the final picture. On such a plan, notes should appear, giving indications of colour, texture and positioning of all relative

objects. Finally, on the same plan, indications of the suggested lens and lighting should be made.

Before anything else is done, once pre-visualisation is completed, a total list must be made of every single item needed for the photography, including film, filters, extra equipment and of course everything which will appear before the camera.

The camera will show every imperfection in an object, particularly if it becomes larger than life size. This means that very often several excellent examples of the main subject must be provided. This is particularly true if the exercise has anything to do with perishable products. Look for the very best qualities in every item upon which sharp focus will fall. Dull or damaged surfaces in new products look alarmingly second rate when caught in good lighting by a competent photographer, yet if the object should amplify human experience by suggesting qualities of age it must *never* appear new. Try in these cases to work with genuinely old items, as the patina of past usage is something which adds immeasurably to the mood of the final picture.

If your still life is to create another era, such as may be needed for advertising, be certain that all objects appearing together should in fact be together, historically speaking. Establish this by research.

This care in beginning the production of still life photographs pays very good dividends in achieving believable pictures which breathe life.

Once the objects are assembled in the studio, their environment is fixed before the camera and the objects placed into this setting according to the sketched plan. The camera is placed in position and with infinite patience, the composition of the final shot begins.

Take time to contemplate in this kind of photography. Be comfortable and relaxed in body and mind. Concentrate deeply on the technical and conceptual problems. Allow the objects to register indelibly in your mind. Form absolute convictions about the way they look best and then present them to the camera in this manner.

Lighting of course is of maximum importance in all still life. First the surfaces and contours of every object must be given their correct appearance by careful lighting. Very often a broad brilliant light source at least 2 metres (6 ft) square will give the best results, but light must establish mood and suggest the time of day as well. Any sense of immediacy will be lost for instance if the scene is supposed to be candle lit but is bathed in a wide white light that could only have come from a source such as a tall window. Shadow areas must still disclose texture, highlights must be sufficiently dense so that surface textures in bright objects are revealed and not 'burnt out'.

Check list on photographing food

- Research the subject and its environment; talk to experts.
- Assemble all props.
- Establish normal viewpoint i.e. as is seen at table.
- High camera angles remove appetite appeal.
- Construct lighting to indicate time and place in which the meal is to be taken.
- Have food prepared by experts from *best* ingredients obtainable.
- The camera *must* await the food, as a guest should.
- Do not indulge in design histrionics with food.
- Do not over enlarge food. Maximum of life size on magazine pages.
- Render, superbly, every texture. This means minimum size of 9 × 12 cm (4 × 5 in) film.
- Create steam, frost, or natural life of any kind in food subjects.
- Cook all meats lightly, otherwise the film will see them as overdone.
- Food should be presented to the camera in a documentary way, ready to eat.
- Beware of excessive eye traps which unwisely selected props will produce.
- Every accessory to food must be fastidiously clean.
- Indicate human action where possible, but without human form.
- Use selective focus to identify main themes.
- Tend always to rich, quality lighting; never over expose food pictures.
- The best food photography has a feeling of immediacy and sensuality.

In still life the arrangement of shapes and forms can be so precisely placed and lit that it is possible to 'draw' with the camera and produce deeply satisfying graphic designs. These can be given overlying colour schemes which will lead the eye around the format in whatever sequence the photographer desires. Communication is heightened tremendously by the total control possible with advanced techniques in this type of photography.

Many professional photographers working in still life will be concerned with the subject of food. This is a natural one for modern photography as the whole characteristics of the camera are particularly suitable for the appetising rendition of food.

Many artists have chosen the sensual associations inherent in uncooked food as an underlying quality which they have emphasised in their still life painting and the photographer, especially working in a fine art technique, would do well to study their success.

With raw food, the environment becomes especially significant and great thought must be given to the manner in which such subjects are presented to camera.

The photography of cooked food is a very specialised area of still life and calls for a sophisticated studio and impeccable logistics. It not only needs large formats, powerful lights and total craftsmanship, but needs a team of experts carefully to prepare the food precisely as the client believes necessary and deliver it to the camera in such a manner that every vestige of appetite appeal is retained.

Of all still life subjects, this one must capture immediacy, life and human experience. Hot food must look hot, cold food must look cold and refreshing, salads must look fresh from the garden, fruit must be firm and ripe.

With this kind of still life the camera angle should rarely be raised or lowered to an abnormal degree. Bird's eye viewpoints of food can easily become design objects, devoid of appetite appeal. Food should never appear over size, as it rapidly becomes a curio of textures and designs which may be fascinating to the photographer but do not communicate any sense of appetising reality.

In fact, until the camera was perfected and supplied with colour film, no artist would present his subject of still life in anything less than the most natural way possible from the most normal viewpoint.

This logic, of working well within the normal experience of the viewer, is still an excellent guide to easy communication. When making a still life, the high angles, super macro close ups and theatrical low angles can be tremendous statements of photographic technique and become legitimate and compelling abstractions of familiar objects, but for wider communication, these techniques must be used sparingly.

The photographer embarking on a career of still life commits himself to one of the most challenging and yet satisfying areas of photography. He must constantly draw attention to life just outside the frame and cope with all the inhibiting factors which this encourages and yet impose his own personal, vital viewpoint in the final picture. It can be a lifetime endeavour.

8 Images Immediately

To the photographer deeply committed to his craft, pursuing every avenue of refinement in the matter of equipment and technique, that part of photography concerned with instant image making would seem deserving of passing, derisory comment. Certainly a large market for this kind of photography has arisen amongst photographically unskilled people and this has brought great joy, and a little magic, into the lives of millions of people who otherwise could never experience the mystical rite of taking a picture of time itself, as it passes us by. But the advanced photographer and certainly those who aspire to professional studios must fully understand the use and potential of instant image making.

It has long been the dream of chemists to give photographers 'dry' processing, away from darkrooms and involved wet chemical routines. Not only would productivity be greatly increased, but the photographer could rightly spend more time on the conceptual part of image making and provide his viewers with far better communication.

Electrostatic processing, where a special photographic paper is dipped mechanically into an activator fluid and then a stabiliser fluid, goes a long way toward this ideal. By reducing processing and drying times to a few minutes, this method assists proofing, editing, trial make-ups, etc. and should be investigated by those photographers working in picture book media, reportage or press. It does not, however, eliminate darkrooms and, initially, does not give permanence to the prints.

Resin coated papers also speed up processing, but only after conventionally enlarging and developing the printed image. Subsequent stages of fixing, washing and drying are accelerated very rapidly, with a great degree of permanence in the final image and excellent control in the matter of quality. Certainly resin coated paper gives vastly improved productivity, but does not provide the photographer with any situation where he can obtain absolutely instant images.

In 1948 the first Polaroid camera went on sale at the Jordan Marsh Company store in Boston, USA, and began a revolution in photography which can bring enormous benefits to the modern professional who understands and fully exploits the amazing characteristics and chemistry of this process.

Kodak and others have also produced recent examples of one step photography but this is largely designed to be absorbed by the vast amateur market and in general, although producing very fine colour images, cannot be said to be of great assistance to the working professional or advanced photographer.

The Polaroid Corporation on the other hand has set out to produce and refine constantly a very large range of professionally interesting equipment and one step chemistry.

The first use a working professional will probably find for Polaroid materials is to check the behaviour of his equipment and this is especially true of the studio photographer. His photography is an end result of intensive planning and expensive production techniques and the more certain he can be that the final image is exactly to his client's brief, the better will be his reputation and continuing business.

When using a view camera he will normally have a conversion of its format to accept 9×12 cm or 4×5 in film. This will allow him also to use the Polaroid Film Holder (Fig. 54) model 545 and no studio should be without one. If the camera back is fitted with a spring loaded 'international' back it will also accept the less expensive and smaller $(8.5 \times 10.5$ cm) model 405 film holder. This holder uses cheaper film and can be a great saving if large quantities of instant images are to be made.

Fig. 54 Polaroid continue to be one of the few photographic manufacturers who constantly edge us toward the era of instant professional images and in keeping with the policy, have recently introduced an instant picture system for the 18 × 24 cm (7 × 9 in) format which is both effective and expensive. On studying the implications of this very advanced system, the professional will find many applications which will help in marketing his skills and speeding up production.

The colour is aesthetically pleasing, fast (80 ASA) and extremely stable, in fact this colour print system is probably the most permanent presently available.

The system is ideal for checking final camera images before transparency material is exposed, very useful for quick lay out prints for discussion purposes and when suitable filters are used in an enlarger to convert the 3200 K of the lamp to the 5–6000 K needed by Polacolor, the system makes a fast, effective proofing medium. When compared with reversal or negative printing systems, costs are very acceptable and of course results are obtained in 60–90 seconds.

For the fine art photographer, the large format Polacolor process offers most interesting possibilities. Because of the considerable stability of the dyes in the finished print it can be displayed in high levels of light with the confidence that the image will remain as the artist intended. The size of the format, when suitably mounted and framed, makes a significant impact on any wall space, especially in domestic environments. Colour prints produced by the technique would seem, for the first time, to make available to the photographic artist an opportunity to prepare signed limited editions at a relatively low cost with total control in the hands of the originator.

The films available for the professional 545 holder include a direct line positive print (Type 51, 125 ASA), a superbly detailed and tonally graded film (Type 52, 400 ASA), an ultra high speed, yet tonally beautiful black and white film (Type 57, ASA 3000), a slow, fine resolution film producing both positive and negative (Type 55, 50 ASA) and a full colour print (Type 58, 75 ASA).

The 405 holder uses the 100 series of films: 105 for prints with a negative, 107 the high speed black and white print film, 108 for full colour.

For professionals using such 6 × 6 cm (2 sq. in) cameras such as the Rollei SL66 and Hasselblad, special backs may be obtained, also taking the 100 series of films.

It has become routine for most professionals, once the final set up in the studio is complete and even progressively during the slow construction of the elements of the image, to assess the result by making a Polaroid test. This test, if the photographer is making his pictures using a 4 × 5 camera, is an absolute check of everything that will be seen in the final frame and shows that all equipment is functioning as it should be.

For all fee paying assignments, I believe it is wise to make a Polaroid test before committing expensive final transparency material to the camera.

In my own case, it is also routine for me to use Polaroid as an exposure test, especially when exposing colour film by electronic flash. Here it is important to use, if possible, a film speed in Polaroid which most nearly matches the taking

Polaroid Land film types

5 × 4 Film Holder (9 × 11.3 cm)	Pack Film Back (3¼ × 4¼ in)	Roll Film Back (3¼ × 4¼ in)	Type	Speed: ASA	Development Time (seconds)	Description
Type 58	Type 108		Colour	75	60	Polacolor II
Type 52			B & W	400	15	Continuous tone, fine grain print
		Type 42	B & W	200	15	
Type 57			B & W	3,000	15	Continuous tone, high speed print
	Type 107C		B & W	3,000	30	
Type 55			B & W	50	20	Simultaneously provides a continuous tone positive print plus a fine grain negative
	Type 105		B & W	75	30	
Type 51			B & W	200	20	Ultra high contrast print
		Type 146-L	B & W	200	30	High contrast line transparency film
		Type 46-L	B & W	800	120	Continuous tone, medium contrast transparency film
		Type 410	B & W	10,000	15	Ultra high speed film producing very contrasty print, specialist film used almost exclusively for high speed oscillography

All pack and roll films come in 8-exposure packages; the 5 × 4 sheet films come in boxes of 20 if black and white or 10 if colour film.

speed of the colour film used. There is no benefit in using colour Polaroid for this task, as this material is very sensitive to minute changes in processing technique and could give results which are difficult to evaluate.

Where a 50 ASA colour film is to be exposed, Polaroid Type 55 is perfect for indicating exposure. It must be stressed that when using Polaroid for evaluating exposure, great care must be taken to time development by *stop watch* and to be sure that film temperature is above 20°C (68°F) at the time of exposure. Only when these factors are controlled can the photographer obtain repeatable results. Some trial and error testing will be needed before it is possible to predict exposure accurately by this method, but once learned there is no need for the use of a flash meter or even an exposure meter in controlled studio conditions. The client also benefits by having an image constructively to criticise before final photography begins.

As far as colour is concerned it may be said that no instant colour image will produce perfect results, but with care many interesting final photographs can be made with Polaroid. My experience is that the 4 × 5, type 58 is the most satisfying but it is critically important that timed development, film temperature, cc filtration and of course colour of light source is taken into account. By varying development by as little as 3 seconds and adding cc filters as mildly corrective as 10 R, very pleasing results are possible. This is a matter of test and the beauty of instant dry processing can really be appreciated in using this technique of trial and error correction. Do remember that to obtain good colour, the film should have been stored at correct temperatures and be used well before the expiry date on the pack. It should be stressed however, that in all professional situations where colour is a primary ingredient of the final picture, it is confusing to use Polaroid colour film as a colour test. Much better to use black and white film which will raise no questionable evaluations of the photographer's choice of subject matter.

With the advent of a fine quality instant positive/negative film from Polaroid, instant images have passed out of the area of merely being a check system and begin an era where dry processing produces final, usable and reproducible images.

Type 55 or 105 Polaroid carry a fine grain, tonally beautiful negative attached to the print image. This negative can be peeled away, washed in a clearing bath of 12% sodium sulphite and provides an excellent enlarging negative of medium contrast and fine resolution.

This film from Polaroid seems particularly good for copying, especially where coloured originals are mixed with line print. It is my normal method to over expose slightly so that a print with highlights too dense for normal viewing is obtained. When this print is peeled away and the negative cleared, a brilliant and well graded film image will be obtained. If the Polaroid is exposed to give the best print result immediately, the negative from that print will usually not carry sufficient density for easy enlarged printing and shadow detail will be lost.

This technique of positive/negative with Polaroid film is of tremendous use if the professional must make black and white prints from 35 mm colour slides. Place the 35 mm slide in an enlarger and fix the 545 holder, face up, into a solid jig, such as can be made from wood. The plane of the 545 film holder must of course be exactly parallel to the film in the enlarger.

Insert the Polaroid film envelope into the holder as normal, sensitive side facing the enlarger lens. Switch off all lights and in complete darkness, pull the protective cover from the film. Expose for an electrically timed interval, of say, 1 second at f. 16 or f. 22. Restore the safety cover of the outer Polaroid envelope and switch on darkroom lights. Process as normal. This can give excellent instant negatives from colour slides and is of great help in providing assistance to clients in arranging final selection of 35 mm transparencies, scaled up to the size of the final usage.

It is possible to use Polacolor film in this manner for colour proofing and editing but care must be taken to filter the enlarger light source to 5500° Kelvin. Remember also that Polacolor film produces pronounced colour changes with changes in development time. Longer development, say 3 to 7 seconds over the optimum 1 minute, will give the picture a bluish cast and give richer blacks with, overall, more saturated colour. If you are over developing for reasons of contrast or saturation but need to avoid the bluish cast, a yellow or red cc filter of appropriate strength should be added, say 10R to 15 R or 10Y.

Under development of the film will lead to a warmer, reddish cast and there will also be desaturation of colour and a lack of contrast. Experimentation with these characteristics of Polaroid film will lead to most interesting results.

Polaroid have also added an 18 × 24 cm (8 ×

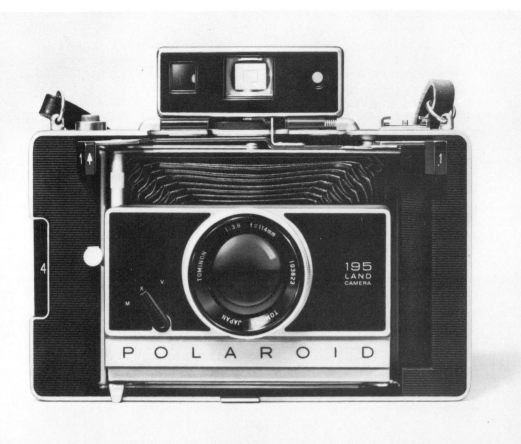

Fig. 55 Polaroid Camera 195 for professional use.

10 in) colour film to their range and this, for the big format photographer, is of great interest. Not only can he carefully check the whole frame before shooting transparency material, but in some cases actually use the colour print for reproduction. This innovation is also extremely useful for proofing colour transparencies by enlargement as described above and, in cost, compares very favourably with reversal colour print proofing.

Sometimes difficult to obtain, but extraordinarily useful, is the Polaroid model 190 or 195 (Fig. 55). This ungainly looking camera, accepting the 100 series of film packs, has the standard flash synchronising socket built into its shutter and can therefore be totally integrated into any studio flash lighting system. Particularly if the photographer is using 35 mm for his originals, this camera may be

Check list of Polaroid uses

- Model reference pictures.
- Location reference pictures.
- Lighting plans.
- Copying coloured originals.
- High speed photography.
- Available low light photography.
- Checking composition.
- Checking equipment behaviour.
- Checking client presentation of 35 mm slides.
- Editing 35 mm slides.
- Telecopier transmission.
- Final art images for exhibition.

used for preliminary checking of a lighting set-up, taking reference pictures of models or props or general 'memo' records. With a very good range finding and lens system it can also produce excellent original negatives and prints from which reproduction photographs can be made.

One of the most amazing and useful Polaroid cameras for the professional is the SX70 (Fig. 56). Very compact and capable of rapid focusing down to macro distances, this camera is an ideal note taking and reference camera. Equipped with a flash bar, or special electronic flash, it is ridiculously easy to use and produces excellent results. Colour is not as good usually as the 4 × 5 Polacolor film, but is certainly acceptable and much cheaper. The high degree of portability and close focus possibility make this a camera for the professional to take on location finding trips, prop selection etc.

For the industrially oriented studio, or where much graphic work is done and anywhere copy work is being extensively used, Polaroid produce an unusually effective systems camera called the MP4 (Fig. 57). This will accept more than a dozen different self-developing films in at least 3 formats and is a tremendous boost to productivity in any area of specialised photography. This camera may be used by relatively unskilled photographers and of course, can produce colour prints in one minute and black and white negatives and prints in half that time.

It is a vertically mounted camera with its own lighting system and is highly efficient in photographing flat copy, small objects, macro and micro photography and in the production of black and white transparencies for projection. The camera is completely demountable and can be converted into a highly efficient condenser enlarger. Most other cameras can be used in the system as well.

An advanced photographer could conceivably

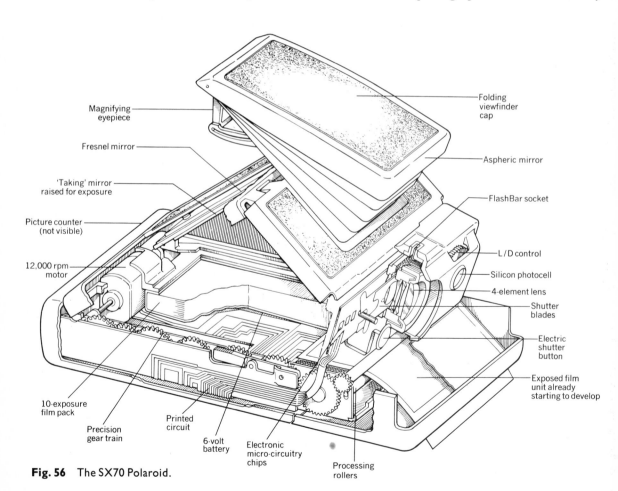

Fig. 56 The SX70 Polaroid.

Magnifying eyepiece

Fresnel mirror

'Taking' mirror raised for exposure

Picture counter (not visible)

12,000 rpm motor

10-exposure film pack

Precision gear train

Printed circuit

6-volt battery

Electronic micro-circuitry chips

Processing rollers

Folding viewfinder cap

Aspheric mirror

FlashBar socket

L/D control

Silicon photocell

4-element lens

Shutter blades

Electric shutter button

Exposed film unit already starting to develop

Fig. 57 The MP4 Polaroid camera system.

automated and highly portable, this process cannot be ignored.

Fascinating images on this film have been produced by such workers as Ansel Adams, Bert Stern, Paul Caponigro, Brett Weston, Howard Zieff, Marie Cosindas and many other famous names in photography.

The degree to which this material permits the artist to forget technical problems and *think*, makes it a prime tool for important conceptual photography. The permanence of its colour process, which is almost as stable as dye transfer, make it archivally interesting and the beautifully modulated black and white originals that arise from careful use of the monochromatic Polaroid films can extend the range of creative solutions available to any artist. Definitely this process has much to contribute to photo art and any serious explorer of these difficult and uncharted areas of photography must be proficient in its use.

Using the Polaroid systems creatively or merely for increased productivity is extremely simple provided certain basic facts are understood:

1. Film must never be subject to excessive heat, colour film *must* be held in a refrigerator until 2 hours before shooting.
2. Film must be used before the expiry date and be bought from a reputable supplier who understands correct storage.
3. Development *must* be strictly timed by stop watch. The films are ultra sensitive to even a few seconds' alteration of processing.
4. Film should not be exposed or developed at less than 20°C (68°F).
5. Equipment rollers must be clinically clean at all times.
6. Although black and white films can give excellent results, the critical colour worker must be prepared to accept less than facsimile reproduction of the original in most cases.

Before leaving the subject of instant images it must be pointed out that another area is very rapidly improving and bears investigation, especially by fine art photographers.

This is the developing technology arising from commercial electrostatic copiers. This too is an instant process and can be linked to the Polaroid system, giving instant multi copy potential that in the near future will produce reproduction quality originals without a darkroom.

Of special interest to artists is the colour copier,

use such equipment as a combined studio and darkroom, obtaining very high quality results from a tiny amount of space and a relatively small investment. Of course he would be constrained to remains within Polaroid's technical limitations.

For the fine artist, the Polaroid system offers huge scope for creativity. With such a range of excellent emulsions and equipment giving extreme degrees of permanence in the final print and all

109

particularly the Xerox machine. This may be used to produce very interesting art originals from photographic sources and has the fascinating capability of supplying subtly changing images which show an evolutionary behaviour of slow abstraction when they come from the machine in quantity.

Another fascinating image making process which is almost instant is the making of photograms (Fig. 58). Man Ray brought this kind of photography to a high art, yet it needs no camera. Photographic paper is laid beneath a simple light source, preferably an enlarger or projector and of course, under suitable safelight conditions. Objects, both opaque and translucent, are laid out in careful designs over the surface, then the light is switched on briefly to fog the paper. It is then developed in a normal way or by the stabiliser process.

Photograms can make tremendous art pieces, particularly if very large sheets of interesting base material, such as water colour paper, wood or fabric are coated by hand with a sensitizer and then exposed to strong light.

If multi copies are required, it is of course easy to substitute a slow lith film instead of paper and obtain a negative. Contact printing this onto film in a subsequent step will then provide a dark field on which the objects stand out, rather like an X-ray.

In working with any rapidly made image making process, the tendency is to minimise technique and lower technical standards, but it must be stressed that quite the reverse is needed if significant results are to be obtained.

Fig. 58 Photograms can be made on the enlarger without a camera and are a valid extension of photography limited only by the artist's imagination.

9 The Fourth Dimension

'Ruffled hair and an eccentric beard do not make a man an artist.' When Honoré Daumier, the master painter, wrote these words in 1862, he had already spent almost a lifetime probing human folly, in satirical paintings, lithographs and caricatures. He still reminds us that external appearances very rarely are indicators of any desirable hidden depths.

The photographer who aspires to a high position in his field, be it art or commerce, must be aware of the need for self presentation as an accessory to his work, but must deeply commit himself to the constant re-sculpturing of those hidden depths. He is fortunate, because one of the primary side benefits of photography is that those who practise it develop a much better understanding of themselves, their environment and other people. With deep involvement in photography, inevitably, a little wisdom will follow. Some subtle change not only brings delight at the role of being a visual communicator, but also increases the understanding of life in general.

The contribution which the photographer himself makes, introspectively, to the image, far outweighs the benefits of a facile technique. Deep commitment to photography, especially as an art form, becomes an autobiography to some extent and the themes chosen for the camera become life itself to the photographer.

The picture must begin in the mind, not in the camera and it should be mentioned, the mind is a notoriously windy place. Good visualisation will come only from deep personal conviction and only then, if imagination and intellect produce some kind of order. Personal conviction will only arise from direct experience and this must be sought at all costs.

Fortunately, the nature of photography increases the frequency of direct experiences far more perhaps than any other art or craft. The photographers and their equipment must stand before the subject, share its environment for a lengthy amount of time and know it well. This gives many golden opportunities to discover a multitude of fascinating elements of life at a level of reality often denied the easel painter, student or even the writer.

Of course image making at an advanced level will demand a high degree of craftsmanship and extensive knowledge of technique, but the experience and discipline of the photographer will, in the final analysis, be shown to contribute far more than mere technique. All the machine made skills must be allied with deep understanding yet the images may still perhaps be de-personalised. They should never be de-humanised, if there is to be effective communication.

There are many virtues to be found in craftsmanship and the dedicated photographer should attempt always to offer his best work at all times, but technology is a seductive thing and photographic hardware has a magnetic attraction for all people. So do not overspend on equipment and in respect of technique, know it perfectly but practise it, as far as possible, unconsciously. A constant battle is needed to overcome the limitations and disciplines of the machinery of photography in order to express more easily those emotions deeply felt. Great tenacity is needed to win this battle but due to the excellence of the new generations of cameras, photographic equipment and chemistry, the conflict is now at a deeper level. Photography has become intensely subjective and the photographer's role has become a celebration of those things that are important to him personally in that time and that place in which he works.

The highest rewards in photographic commerce will go to those who develop an identifiable style, a style which is deeply connected to the fundamental and philosophic nature of the photographer. The

most satisfaction and the most fluent communications will arise for those artist photographers who let their whole breathe conviction into their images.

A person's observations and convictions at a given moment are always influenced – helped or hampered – by what they have seen, thought and learned before. All capacities of the mind should co-operate in the making of a picture, whatever its purpose.

So this then is the continual task for the photographers who want to reach the top: to be aware that they are the fourth dimension, they and only they will contribute that significant spark that elevates a particular image into one of memorable importance and they must therefore always hold themselves open to new experiences, new thoughts and the cosmic power of their own imagination.

Imagination is a soaring attitude of mind involving a preliminary translation of the future, free of all restraint. It cannot be acquired by craft skill, but it can be aroused and exercised by deliberate effort.

Many photographers enter the business without much technical skill and usually even less academic training and even if graduating from photographic college, seem sadly unaware of the beauty and depth of their own creativity. Perhaps the colleges themselves are at fault in this matter. They seem to place undue emphasis on practical matters and seldom have more than a passing thought for teaching creativity. The only significant purpose for photography schools or photography teachers is to nurture the intuitive creative image-making instincts of their students and feed them just sufficient technique to make this ability understood by a wider audience.

First then, the photographer must acquire a

responsible philosophy that fits his own temperament. In general he must fix himself theoretically into the magnitude of the human race, must understand his origins. By reading lucid writers on the subject of archaeology he can be aware, even dimly, of how he reached this point in time. He can, from the same source, obtain objective information on the emotional and intellectual mainstream of his society.

An understanding of the religions of the world is vitally important, even to non believers. Careful reading of simplified accounts of the main philosophic movements will be also helpful.

This exercise is long, perhaps never ending, but it is a necessary step in developing any empathetic links with fellow man and if the intention is to practise photography as an art, this approach is even more important. The imagination will feed on such raw material.

One particular philosophy has an extraordinary compatibility with modern photography and this is Zen. Why it should be so, no one seems certain, but there is a rising tide of world wide opinion, that the photographer, actively seeking to understand Zen, will significantly deepen his creative ability in photography.

Possibly it is the fact that the Zen seeker also seeks destruction of the ego and this is undoubtedly a good beginning to imaginative image making. Perhaps it is the attempt which is made by Zen students intuitively to centre themselves into the very essence of all things animate and inanimate or perhaps it is the humility with which they listen to life and the humour that enriches their observation.

The books of Christmas Humphreys are particularly helpful and also those of Suzuki, Alan Watts and a tiny but vital volume *Zen in the Art of Archery* by Eugen Herrigel.

Zen is not a cult philosophy and is beyond analysis. It is, however, a pragmatic guide to a more meaningful existence and when gently absorbed into the emotional structure of an artist, can immensely deepen his or her creativity.

Psychology is a natural subject for the photographer to study but care must be exercised. When properly explained it becomes very appealing to the intellect, with consequent and deadly effect on a free running imagination. Much of the writings of Jung however are highly relevant to photography and his books are generally presented at a layman's level of understanding.

The works of Konrad Lorenz are also very accessible to informally trained people and worthy of close attention as are the writings of Ivar Lisner and Bronowski on archaeology.

Philosophy and religion is an enormous tandem of vital subjects but a photographer's image making capabilities are improved by a slow search for understanding in these matters. A balancing input of information of both Western and Eastern philosophies and creeds should be attempted and an individual attitude, free of influence from any third party, should be defined. Do not hesitate to change opinions about these very complex subjects as they unfold. In fact change in all things must actively be encouraged if the imagination is to stay free.

A very readable book, pertinent to this search for self improvement, is *Irrational Man* by Professor William Barrett. In it he lucidly discusses existential philosophy and its meaning to modern man and modern art.

A photographer who feels he needs to enlarge his visual repertoire must of course study the works of art, artists and art styles as they have arisen in past and present time. Care is needed or the photographer will fall in love with the styles of easel painting and either attempt to cudgel the photographic image into some kind of copy of a noted painter or become disillusioned with photography altogether. Photography is far removed from easel art, but can, without dispute, be fine art.

There are artists whose work is of special interest to photographers and whose work bears very close study: Leonardo, who became the world master of the technique of 'sfumato', a veiling and softening of outline that is very close to the camera's soft focus effects. The Zen painters' swift and solitary brush strokes also produced evocative images that conjured up reality from the barest of clues. As the brush strokes indelibly marked the soft paper, there was no going back, no repair, and in this way they join the artist photographers whose latent image for ever marks the film and is also a product of an instant in time itself.

The still life paintings of Northern Europe in the seventeenth and eighteenth centuries, particularly the momentous work of Chardin and Oudry, are highly relevant to photographers and once the deep compassion for humanity is discovered in their art, it can lead modern photographers into more significant work.

The Impressionists of course must be studied, particularly the late work of William Turner who

poetically translated ethereal themes into shimmering images, Monet who painted light itself and Seurat whose granular images remind us now of the grain structure of photographic films and who made beautiful black and white drawings resolve with the utmost conviction from the most delicate of clues.

Surrealism is most important to photographers particularly the work of Magritte and Dali, in fact the whole movement should be deeply studied for its relationship to photography.

Matisse must be understood for his exemplary use of colour and exotic pattern, two attributes of images which modern colour film can render so well.

Henry Moore should be studied, not only for his sculpture but also for the philosophy which appears in his book *Henry Moore on Sculpture* edited by Philip James. Braque, Gris and Picasso (especially his early paintings) also give the photographer inspiring images to study.

Of course photographers should follow their tastes for photography and become aware how other fine photographers have resolved problems that in some cases will parallel their own. It must be emphasised that it is pointless to copy technique or styles from other photographers, as weak imitations of past masters are an abject admission of defeat and are usually not saleable in any well informed market place.

The art of photography of course has a contemporary history and the young photographer will do well to absorb the most that these modern images provide. Names like Ansel Adams, Atget, Richard Avedon, Ruth Bernhard, Blumenfeld, Cartier-Bresson, Wynn Bullock, Bill Brandt, Harry Callahan, Paul Caponigro, Imogen Cunningham, Alfred Eisenstadt, Ralph Gibson, Ernst Haas, David Hamilton, Sam Haskins, Hiro, Karsh, Art Kane, André Kersatz, Dorothea Lange, Henri Latigue, Man Ray, Duane Michaels, Sarah Moon, Moholy Nagy, Arnold Newman, Helmut Newton, Irving Penn, W. Eugene Smith, Edward Steichen, Stigleitz, Paul Strand, Jerry Uelsmann, Edward Weston, Minor White, are credits on some of the world's outstanding photographic images, which should be sought out for study.

We all have a unique chance to know these pictures at first hand and, as many are still at work today, to hear their creators at lectures and workshops.

Although of great interest to commercial photo-graphers, it is the fine artist in photography who must lean most heavily on this short history of his art. Modern photography seems to have received a tremendous impetus from the artists of the Bauhaus, so the writings and images of this time contain much that is relevant.

The fine art photographer will also, particularly if he works in the British Isles, sometimes have to defend his work from critics (some of whom, surprisingly, are also photographers) who deny the medium any status in the art world. No lengthy justification is needed however to offset this very negative thinking and all those who work with photography should be confident in the knowledge that while all photography is not art, there is much that is, at both the level of a folk art and a fine art.

As history unfolds in this century the instant graphic image, *because* of its inherent mechanics and not in spite of them, is becoming recognised as possibly the art form *most* suited to recording and interpreting much that is happening in the rapidly changing and complex world in which we now live.

The machine-made nature of these images, their capability of unlimited copies and the absence of any motor traces attributable to a human arm are all cited by critics as reasons for exclusion from the art movement. But in my opinion, this democratisation of collectable images is an excellent thing and itself one of the justifications of photography as art media.

Moholy Nagy, famous from the beginning of the Bauhaus days and himself one of the founding fathers of modern photography, says on this point, in his book *Painting, Photography Film*: 'People believe that they should demand hand execution as an inseparable part of the genesis of a work of art. In fact, in comparison with the inventive mental process of the genesis of the work, the question of its execution is important only in so far as it must be *mastered* to the limits'.

Antagonism to machine images is heightened by loyalty to past art forms, even though most people are now drawn to photography because of the present day statements it makes.

Perhaps indeed, the most functional way today of communicating the urgent and necessary needs of mankind *is* photography. Advertising, journalism and television, if freed from their politics and almost god-like superiority, could quickly reach millions of ordinary people at a level most likely to cause consolidation of responsible public opinion. Possibly, though it is as fine art, photography could more easily present honest know-

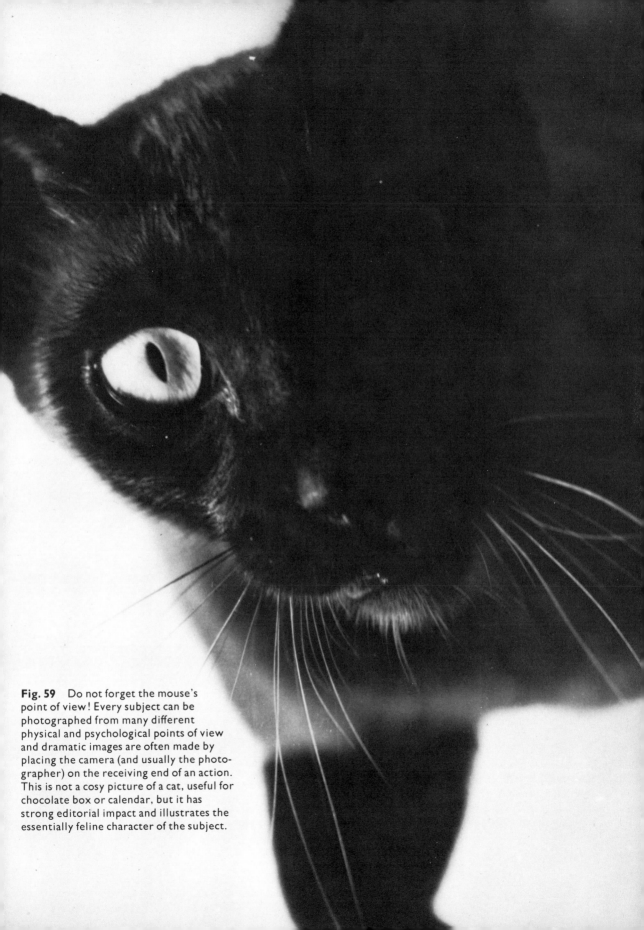

Fig. 59 Do not forget the mouse's point of view! Every subject can be photographed from many different physical and psychological points of view and dramatic images are often made by placing the camera (and usually the photographer) on the receiving end of an action. This is not a cosy picture of a cat, useful for chocolate box or calendar, but it has strong editorial impact and illustrates the essentially feline character of the subject.

trospection and meditation of the photographer, however well they are conceived, will only be as clear cut as the technique used to bring it to public attention. All the pertinent qualities must be brought out by precise perceptive features, devoid of any ambiguity.

This means of course that while searching for an inner contact and seeking answers to external questions, the responsible photographer must continually advance his photographic technique. There is a need for spending time and money on published technical material, attending lectures, workshops, etc. which are devoted to technical matters and keeping eyes open for new technology.

There is a tremendous pace in the technical innovations being made available today and these can be very vital to the methods of communication the photographer must use. A wide technical reading list is advantageous, membership of a lively photographic association is helpful (even though it is hard for individual egos to function with desirable humility in some of these groups) and contact with practising individual photographers can give reassurance and an exchange of recent technical innovation.

A particular source of information on matters of technique is the growing number of consumer type photographic magazines. Under commercial pressure from the market place these carry the most recent reviews of equipment and chemistry and many tips of many icebergs may be found from their pages. Three important American magazines are especially worthy of note, even though professionals often consider them undignified and amateur. These are *Popular Photography*, *Modern Photography* and *Petersen's Photographic Magazine*. In Britain *Photo Technique* is fast entering the mainstream of this kind of publishing and its pages provide sound information for the advanced photographer.

A balanced mixture of philosophic exploration and self-sculpturing, plus the acquisition of sound technical skills can become very therapeutic. Some extraordinary metamorphoses have occurred amongst abnormally shy or neurotic photographers as they have deepened their association

ledge and honest art, honestly distributed. The artists in photography are usually very socially aware people and may foster an unshakeable understanding of the deadly philosophical prospects facing all men today and help protect, on a massive scale, the long, complex and wonderful evolution of our race.

Steichen has said 'The mission of photography is to explain man to man and each man to himself. And that is no mean function.'

The expressive attributes of photographic images which are vastly improved by the in-

Fig. 60 Commonplace actions often give remarkable opportunities for good illustrations when they are isolated by careful techniques and pre-visualisation. This type of photograph is not usual in advertising but is highly regarded for magazine editorials.

with photography. Much more assurance in handling people is one benefit which is soon to be seen in good photographers and of course to anyone professionally involved as a business, this confident, but not abrasive, social contact with people can be essential to a successful commercial or art life.

Advanced professional photography will always depend on meeting people in a relaxed manner, especially those who become fee paying clients. The photographer will be called to executive meetings in board rooms or fast moving briefing sessions at editorial or advertising offices and it can be disastrous if any unease is felt by either party.

This means that care should be taken with the appearance, personal hygiene and general attitude of mind. The photographer will do better in his business if he appears perfectly to fit the environment in which he is expected to perform. The industrial photographer will benefit by dressing a different way from the fashion photographer and the artist will project a different, perhaps highly individual style. In no way, however, should a photographer maintain any very obvious eccentricity, especially if he is beginning his contact with the professional world.

Peace of mind is essential if a relaxed and intuitive approach to image making is to be maintained and this means that in his studio he needs to wear comfortable clothes and shoes and maintain good working conditions around him.

He will also need to schedule his pre-production activities, and make the best use of his time when shooting. He must keep his mind open to new ideas and opportunities. Talking to one client may easily lead to other, quite unrelated matters that can be beneficial, creatively or financially.

Do not hold ideas to yourself, help your client solve his problem. If you are searching for new business, the time to do it is when you are busy, but do not neglect old clients. Do not be afraid to mix on equal terms with your client socially and demand dignity and responsible attitudes from all concerned with your photography. Pay your bills on time and collect what money is due to you with the same businesslike and courteous approach you would expect to receive.

Photography in any advanced way is emphatically a big, fast moving and expensive operation and survival will depend on cultivating sound business techniques. If this is not in your nature, be sure to hire an agent or accountant to do this for you.

The fine art photographer will be faced with as many, but different problems. Because of the much longer time scale between briefing, production and payment (it can be as long as a year) he must act defensively from the beginning. He must keep his overheads artificially low, hire equipment if it is only occasionally used and *always* seek at least a 50% deposit on all commissioned work.

This work in fine art will often require lucid, verbal presentation of ideas not only at a briefing, but as the work progresses. It is a considerable handicap for such an artist if he cannot do this, as he must then use an agent or gallery representative to intervene, with consequently great risk of misinterpretation of the brief.

Photography as an art or craft is very young, comparatively speaking. The miniature camera is only 50 or so years old, it was not until 1935 that colour film became widely available and it is not often realised what a thoroughly complex and difficult subject it is for those concerned with it in depth.

To succeed, at such a level, it will be necessary to cultivate patiently every facet of the photographer's personality, blending reason with intuition, science with unfathomable feelings, until the images that are made reflect a total commitment to both the client's brief and to the photographer's own decisive point of view.

10 Targets

Realistically, advanced photography can only be possible when it is considered as a business venture. Even the most ascetic worker, in the pursuit of the purist ideals of image making and who restricts technical matters to the bare essential, will usually spend £500 ($1000) at the outset of a career. A beginning professional, renting a studio, will easily commit £5000 on fixed assets and supportive activities. Targets must be set in order that fees can be obtained at a level of certainty so that creative work may deepen and grow and so that the photographer does not burden those near to him with hazardous financial behaviour.

It is something of a myth, born of the poetic notion of the story book Bohemian, that creativity somehow is inhibited by an understanding or practising of good business habits. The legendary Bohemian equipped with pad and pencil and perhaps a glass of wine, bears no resemblance to the modern photographer who creates with miraculous and expensive technology his expressive images. Creative photographers must face the business facts of life and if they cannot protect their own interests successfully in this area, *must* find someone who can do the job for them.

This could be a bank manager, accountant, expert friend, close relative or professional agent. Once found, be open with them, discuss your errors and ignorance in business matters and trust them, unless eventually they demonstrate beyond doubt that they cannot help you efficiently.

The creative photographer, with his mind overflowing with unformed ideas, benefits enormously by taking an interest in his own future and planning the steps that will achieve a balanced and successful creative life.

His first concern will be to set attainable targets in the areas relating to finance, creativity, production and marketing and, in his mind, allot a reasonable time scale for their attainment.

FINANCIAL TARGETS

Financial targets tend to set themselves to some degree and are closely interlocked with the market acceptance of the photographer's style and the structure of his fees. However, there are certain financial matters that need mandatory attention in order to protect the creative worker and allow him to continue working at top pressure.

He must arrange a proper banking service, preferably with a bank near to his studio. Be frank with the manager, show him a portfolio, tell him crisply of business plans. If credit is obtained, repayment of that credit, precisely under the negotiated terms, is vital, however hard this may be. Photography can be a remarkably difficult business in respect of cash flow and a wise and experienced bank manager will be a useful friend, provided that agreements are kept by the photographer.

As business progresses, an accountant will be found to be well worth his fees. His estimation of your business potential can be essential to bank loans, overdrafts, etc., and his negotiations on your behalf with income tax representatives and credit organisations can often mean the difference between success or failure. Find an accountant who is understanding of the special characteristics of the business of photography, allow him to see how you work and in general help him to get closer to the creative side of your business.

Insurance is also a vital matter. Your bank can guide you or there is a world wide company, Bayly Martin & Fay who have special experience with photographers and can be very helpful on all classes of insurance needs.

All risks coverage will of course be needed on *all*

equipment. Market value of this equipment should be re-assessed each year and up graded where necessary. Satisfactory guarantees should be obtained about the precise time in which a claim is handled. A professional cannot afford to be without equipment for more than a few days at a time especially if he is involved with any of the high fee sectors of the business.

A suitable third party insurance is necessary to cover loss or damage to clients' products, and to cover the photographer in case of injury to models, employees or visitors to the studio. Do not neglect these life savers.

Expenditure of money is mostly at its peak during growth years, but because of the most unpredictable behaviour of a photographer's earnings if he is self-employed, he must take note of the future and plan a strict time table for saving. Creative people are notorious for something of a Micawber philosophy to this side of their business, but if creativity is to continue for a long period in the photographer's life he must have the peace of mind which arises from having some financial assets for emergencies.

A necessary part of growth and creative life will be the investment in new hardware and its maintenance. Spend *very* reluctantly on new equipment. It is a beguiling and amusing fact of a photographer's life that must be carefully controlled. Buy only when a positive need arises and then only when the pressure caused by the lack of the item is becoming unbearable. Investigate thoroughly all alternatives and discuss major purchases with experts.

Whatever hardware is under your care, maintain it diligently. Cameras must be stored in cases, lenses capped, darkroom equipment cleaned and drained, floors wiped, waste bins emptied. This normal attention to routine maintenance does not impede creativity, in fact will be found to clear the mind of annoying details before work begins.

Taxation is an important matter and failure to make adequate provision for tax or pay it promptly has often meant the creative demise of very talented photographers. This is a matter to be aware of and to discuss with your accountant. It will not go away.

The fine art photographer, because his markets are very insecure even today, must be especially active in protecting his creative life from the cool financial winds which blow through this increasingly interesting market. He must set up very defensive overheads, rent instead of buy equip-ment, borrow lenses, share studios and darkrooms or, in many cases, have a stable income from part time employment quite unrelated to photography. He must spend the absolute minimum on film and equipment and if he has dependants, it is very unlikely that he can make a reliable living for all, unless he has a supremely gifted talent.

PRODUCTION TARGETS

Production targets must be set so that the expensive investment of time, energy and money is well used. Planning is essential, first the way the studio and darkroom will operate at peak. Then how the day can be balanced to complete a client's work efficiently. A day that begins late will rarely be the most productive and photographers should cultivate the habit of operating largely within normal business hours.

Creative people sometimes perform well at eccentric times of day but if the photography concerns others as well, care must be taken to think of their needs. Should photography continue as it sometimes does, into the small hours, proper rest periods and refreshment are necessary if the imagination is to be usefully alert. It must be stressed again, however, that pre-planning and an energetic beginning to the early part of the shooting day will usually eliminate late work and this is greatly to be desired.

A part of production often overlooked is presentation to the client of final work. This, if well done, will always create a favourable impression and can lead to further work because of that impression.

Prints should be spotted and trimmed, transparencies framed and masked (in a temporary way), layouts and briefing material returned with finished work. As far as possible the photographer should deliver these to his client personally so that the whole job may be frankly assessed and discussed. This is a particular need for the beginning photographer as it is part of the learning process in professional photography.

Productivity in photography is something of a neglected subject by those who create in the medium but with such enormous financial investment and in such a labour intensive activity, it must be closely studied.

By finding improved chemistry for the dry or semi-dry processes, the extensive use of Polaroid and the practical exploitation of studio space to control traffic flow at peak moments, the photographer can make his day easier and his full

Check list of the assistant's ideal precepts

- Go to a good photography school: learn everything.
- Keep academic studies at high level, especially art subjects.
- Work part time in a good studio.
- Always carry a note book.
- Become a full time assistant.
- Work only for a photographer you admire.
- When applying for an assistant's job, take your portfolio.
- Do not work in a studio that is disorganised or non-professional.
- Be willing to work overtime every day and the weekend.
- When you make mistakes, tell the photographer *immediately* and learn by those mistakes.
- Ask questions, but choose the right time to do so.
- Take orders gracefully, be eager to learn, be thorough, but be fast, cultivate a sense of organisation, check all equipment before and during the session. Check exposure settings, lighting, etc. and monitor these constantly during the photography. Tell the photographer at once if you think something is wrong.
- Follow up each session by looking at the finished work. Ask the photographer questions. This is part of the learning process.
- Do not leave the protection of the studio to freelance until you have basic equipment and at least enough money to live for six months without getting work.

creativity more attainable. Automated cameras and processors help, as does the careful selection of staff who must receive key instructions for any project. Pre-planning every possible activity which is related to the elusive variables that are present at every turn, will be vital.

CREATIVE TARGETS

In most professional photography, the photographer becomes part of a strange committee, who must agree a consensus. Client, art director, production supervisor, stylist, all constitute fierce individuality, but in the end, whoever is elected chairman, even if it is the photographer, must subdue his creative ego and reflect the majority view. Visually, it is rarely the most ideal solution, but practically it is often the only way to go.

Attaining creative targets will mean, usually, that a distinctive style appears and this is highly desirable from both the satisfaction that it brings

and the marketing impetus it gives. To elevate early work through the long learning processes needed in such a complex subject, demands the highest concentration from the photographer. Experiments must be made constantly, new equipment and chemistry tried, other photographers' work studied. The whole aspect of photographic education must never stop.

It is wise to begin a small library on technical matters and which may be used for identifying key factors which will then be a guide during research. It has been my practice to avoid memorising the routine technical side of photography as it is safer to check this information direct from text books whenever the need is relevant.

Most manufacturers are extremely understanding of their own product and are usually especially helpful to professionals. Make a habit of discussing problems with the service division and ask for written answers on very complex questions. Keep

fully understands how his picture will be used, how the client sees the image at its ideal best. Information about size and shape of format is of tremendous help as is positioning to left or right within a printed page, which can greatly change the nature of the final photograph.

Any discrepancies in the photographer's knowledge about the subject of the brief must be filled in by further research, preferably from expert sources. By the time photography commences, the photographer should be capable of discussing finer points relating to the subject with anyone, even the client. This greatly accelerates the enthusiasm of all concerned and rapidly develops a unique point of view from which memorable images will come.

Very often, briefing will demand the utmost of concentration, especially if the subject is unfamiliar and particularly as frequently there is only 48 hours notice before final photography. This time consuming element in advanced photography is, in any fee-paying situation, the subject of a further fee outside the negotiated one for actual photography and usually is about 25% of the day rate plus expenses, provided no experimental photography is included in the research.

MARKETING TARGETS

Marketing targets are very hard to define in photography, particularly as this is a rapidly changing and somewhat esoteric world. Many photographers have handed this responsibility to an agent or representative who will probe for new business and present portfolios of the photographer's work. Of course this is very desirable and helpful *provided* the agent or company chosen is competent and wholly to be trusted. Many are not.

The agent/representative becomes very close to the photographer and in many ways totally controls the creative emphasis of the photographer's work. This is a distinct danger and agents who are hungry for turnover can force the photographer into more and more creatively distracting work simply to improve profits.

Financially this is fine but, in the long run, the successful agent will need to understand deeply

a file of all data sheets from every manufacturer whose products are in regular use in the studio and refresh your memory from these frequently.

In a quest for style, undertake a reading of the history of photography. Go to the public libraries and galleries and visit any photographic events where pictures are displayed. Keep a clipping book in which photographs which appeal personally to you are kept. Know who the photographer was, compare his way of dealing with a subject with the way another has presented it and, of course, compare their concepts with your own.

This image research will greatly help the imagination but care must be taken to avoid any tendency to copy a style that is attractive to you. Be original, as nothing but originality has any lasting value in photography.

Creativity is greatly aided by pre-production research and briefing from the client. Pre-production discussions with all those concerned with the final shooting will pay handsome dividends. Points of view can be discovered which greatly increase the chances of a successful job, accessories to styling the picture can be finalised, locations suggested. Incidentally, if possible, always check locations personally and take a Polaroid camera along to make visual notes.

Creative briefing is quite vital to the success of a photograph. It does not matter whether the subject is a portrait, a can of beans or an entire nation, it will be necessary to obtain a brief from the client or his authorised representative. *Take notes. Listen. Ask questions. Propose tentative solutions.* It is important that the photographer

Fig. 61 This is an extension of still life, much more difficult because of the need to direct people into precise positions. It is often a very good idea to introduce a hand to achieve a sense of scale with small objects, such as is done here with the tiny Minox camera.

122

the motivations behind his photographer's work and try and slot it into the most suitable market.

The agent can be a good buffer to protect the photographer from stress and can negotiate the creative environment needed for a top professional to deliver confidently, day after day, work of superior quality.

It would seem wise to look for an agent only when you are already earning enough to support all the overheads and your personal needs. It is not axiomatic that an agent, once associated with the photographer, will get work for him. Any new or untried agent must be taken on as a temporary business partner and then only after a simple but tight contract is signed, setting out the period of trial, the financial considerations and what happens in the event of non-renewal.

Most agents will seek 25% of the photographer's fee, excluding of course, income from expenses. The agent's overheads of office and publicity are found by the agent himself, unless much international travel is involved, in which case costs are split 50–50 with the photographer.

Most agents publicise their photographers by direct mail and sometimes receive subsidies from the photographer for this work also.

An agent working on a trial basis should only receive commission on business attributable to these new efforts and the photographer must guard his existing business from tactless or unskilled handling by the agent on trial.

Agents should not generally handle the photographer's accounts and billing. This puts all the creative work and total livelihood of the photographer at risk. Far better that money matters are handled centrally by a trusted accountant and the agent's commission is paid from these incomes by an agreed formula.

Many photographers are better than agents at marketing their own work and today more and more clients refuse to deal with agents, on the grounds that a third party will dilute the briefing and obstruct the photographer's natural empathy for the job by too much emphasis on fees. This can be a valid comment.

If the photographer represents himself he will have to learn to talk about very abstract visual matters and clearly present himself and his

u: die Holländische Soße, die Ihnen immer gelingt.

Servieren Sie doch mal Holländische Soße zu Spargel.

Spargel Hollandaise

1 kg Stangenspargel. 1 Schächtelchen Holländische Soße von MAGGI, Schinken, neue Kartoffeln. Den geschälten Spargel mit Bast oder Baumwollfaden umwickeln. Leicht gesalzenes Wasser zum Kochen bringen und den Spargel co. 30 Min. darin garziehen. Die Bündel abtropfen lassen, auf vorgewärmten Tellern anrichten und die Fäden aufschneiden. Besonders gut dazu schmecken neue Kartoffeln, Schinken, grüner Salat und ein leichter Weißwein. **Die neue Holländische Soße ist im Nu fertig.** Damit nichts von dem guten Spargel-

geschmack verlorengeht, wird ¼ l von dem Spargelwasser abgemessen und dorin die Holländische Soße von MAGGI zubereitet. Einmal aufkochen, fertig ist die Soße. Erlesene Zutaten, wie Eigelb, Milch, Butter und Muskat geben ihr den sahnigen und feinwürzigen Geschmack. Die fertige Soße über den angerichteten Spargel geben. 24 MAGGI Soßen für abwechslungsreiche Gerichte. Weitere Rezepte in der Fernseh-Serie „Soßentag im Maggi Kochstudio" oder direkt vom Maggi Kochstudio, 6 Frankfurt am Main, Postfach 710404.

MAGGI KOCH STUDIO

Fig. 62 Remember that when working in advertising, care must be taken that the whole image will carry the information decided upon. Clear space must usually be made for a headline, for a product, a logo and a quantity of associated copy. This means total control often passes to an art director who will then draw a layout to scale for the camera format which is followed by the photographer.

creativity as a professional, competent and enthusiastic operation. This will mean exceptional preparation, with close study of possible markets which might accept the style of work offered. He must, of course, also understand basic business matters and financial affairs.

Directories listing advertising agencies, their business and their creative employees, will be useful and these should be updated half-yearly. Magazine mastheads will carry names of the art section and usually the art director is the person to see. Book publishers will sometimes deal creatively from their editorial staff and sometimes from an art department. Each will have an established routine for viewing new portfolios and usually are eager to see well presented professional work and student work.

The portfolio is possibly the most important item in the photographer's marketing equipment.

It will record past successes, contain unrepeatable images, suggest new techniques for future work and generally be a most valuable item. It must be insured, especially if carrying a lot of colour print material. It should be contained neatly in an easily handled protective case with the photographer's name *and* telephone number clearly and permanently fixed inside. It is also a good idea to indicate on this name tag that a reward will be paid for safe return, as a lost portfolio can do the photographer untold damage.

The best way of presenting a collection of images is a very difficult matter to define. Using magazines of slides and projection equipment certainly carries significant advantages, especially in establishing the range of a photographer's work, but on the other hand art directors rarely have a darkened room nearby and few have time to set up special meetings in projection theatres.

The most acceptable and flexible way that I have found is to laminate each item separately in thin plastic film. This looks well, keeps the print perfectly and allows the photographer to alter the content of the portfolio for each presentation and this last facility is frequently a useful aid to getting the job successfully. Sometimes, even while an interview progresses, it is possible to lead with different items of the portfolio, as the occasion seems to indicate, quite out of the planned sequence of presentation.

The portfolio is, of course, the photographer's signature in the market place. It must disclose as much as possible about the knowledge, understanding and performance of the photographer, relative to the market he is approaching. It must, of course, be striking and easily recalled. This means that clever and original work is highly desirable, yet if solely this was shown, the prospective client may think that the photographer cannot work to a brief calling for fairly routine but important images. Some indication of problem solving is useful and this is ably demonstrated by including work done on a very common subject presented with new vision.

The portfolio should not be a snapshot scrap-

125

Fig. 63 Working for editorial pages has a little more freedom but the photographer still must bear in mind that his image will be associated with type and, in this case, other smaller images.

book showing a multi-image record of all the photographer's work over five years. Rather, it should be highly selective and aimed at precisely the needs of the person who is making the assessment of the photographer. This means that, again, research is necessary to find out what that potential client's requirements in photography may be. A good idea is to put into such a presentation a stunning image quite outside the other subjects covered. This encourages the buyer to consider the totality of the photographer's work and suggests all round skills and adaptability.

New work must be regularly added to the portfolio and if possible this should be a mixture of recently printed work plus experimental images from the photographer's own collection. Magazine editorial work is often attractive in a portfolio as it is usually free from very stringent conceptual boundaries and excites any new client with the potential for interesting new photography of his own product.

As well as the laminated print material it is useful to present a small selection of original transparencies mounted in carefully masked black frames. This will demonstrate emphatically the original quality which the photographer can achieve without any retouching or mechanical aids and, in the case of a group of 35 mm transparencies from one job, could demonstrate the flow of an actual photographic assignment and how it has been handled.

The old days of uninhibited creativity by 'star' type photographers do not seem to be with us now. Budgets are much tighter and the brief is usually a little more exact. The advent of strong consumer protection laws has meant a switch to more factual and documentary styles in advertising where the major emphasis is placed on information. This does not preclude creativity, merely makes the attainment of it more dependent on supreme concentration, research and technical skill.

Those whose work is less disciplined should look to less exacting markets than advertising, even if these do not attract top fees.

Publishing also has been hit by economies and magazines now often run smaller editorial pictures, while illustrated books have heavy reductions in the usage of pictures. Fortunately book covers and record covers are still very important

creative areas, strongly alive to new work and the self published photographic book, against almost insuperable odds, is making slow progress.

Fine art photography, as long as it is tied to the commercial gallery, will always be dependent on carefully orchestrated exhibitions of established names, but in a few notable cases, photographic galleries are now selling work at respectable prices purely on the appeal of the image. This is especially true of the North American market but it is certain that growth will continue in this area all over the world.

This kind of image, more than any other, requires superlative craftsmanship and a deep imprint of the photographer's own personality on every one of the pictures offered.

Company reports, public relations releases and sales aids are also valid areas for the photographer to market his work. Here he must usually seek

Fig. 64 The world of art offers the photographer limitless opportunities without many constraints. A visit to this location in Kuwait produced material for the following picture abstracted by solarisation and wide angle view points which allowed a mural to be made 2 × 3 metres (6 ft 6 in × 10 ft) for an entrance lobby in London.

Check list on achieving targets

- Set attainable goals.
- If you are uncertain, seek expert help.
- Insure, soundly, all hardware.
- Set up defensive overheads.
- Anticipate tax needs well in advance.
- Publish a fee scale and demand prompt payment from clients.
- Prepare the working day, the day before.
- Start early, allow adequate time on working days.
- Maintain equipment impeccably.
- Always provide a back up item for every major piece of hardware in use.
- Take infinite care of the portfolio.
- Research new techniques constantly.

primary contact with the commercial company concerned and they will appreciate a highly professional and crisp contact rather than a loosely controlled 'creative' approach.

Arising out of the extended use by commercial organisations of creative photography a new market is growing which develops the use of photography as decor in commercial premises. Because the image usually is closely associated with the company view point and is not unduly disturbing to people using the buildings, it can be highly successful and very decorative. Be warned that it is very expensive in production terms, because of the giant scale images demanded and requires of the photographer a larger measure of research and conceptual skill than almost any other kind of photography.

New technology is still being improved to be of use in this area and in general it must be treated as a very serious market for the creative photographer of the future. Laser light shows, holography, photo sculpture, computerised printing on fabric, tele projection and hand coating of ceramic surfaces with sensitisers are just some of the techniques already waiting for the designer-photographer working in this field.

The establishment of targets will also begin to define for the photographer an outline of the worth of his work on the open market and this in turn

somewhat controls his whole attitude to photography. Advertising has traditionally paid the highest fees, offered the most inhibitions and been the most creatively frustrating and this is still possibly true. Record companies demand highly expert work and pay accordingly, as do multi national corporations who understand the importance of good image making on their marketing strategies.

Financially well down the list but sometimes creatively inspiring are the glossy magazines and frequently the photographer actually loses money on such assignments for these organisations. The public relations value to the photographer of working in this manner has become very doubtful now that good images of editorial interest are less and less capable of transition to the higher priced advertising market.

The fine art market is very unpredictable and still to a large extent depends on signatures on limited editions, elaborate written guarantees about the exclusivity of the work and a public relations exercise to build up the artist. A free market for the thousands of beautiful images produced by anonymous photographers is growing slowly, but should be looked at most cautiously as a source of steady income by any advanced photographer who has any established overheads and regular commitments.

In any kind of creative work, a point is reached where our power of free choice comes to an end. The work assumes a life of its own ... a mysterious 'presence' reveals itself which gives the work a living personality of its own.

... as we penetrate into deeper levels of awareness, into the dream, reveries, subliminal imagery and the dreamlike visions of the creative state, our perception becomes more fluid and flexible. These different levels interact constantly.

The creative process can be divided into three stages : an initial stage of projecting fragmented parts of the self into the work. . . . The second phase initiates unconscious scanning that integrates art's sub-structure, but may not necessarily heal the fragmentation of the surface. . . . In the third stage, . . . part of the work's hidden sub-structure is taken back into the artist's ego on a higher mental level. . . . The artist feels at one with his work in a mystic oceanic union.

(From *The Hidden Order of Art* by Anton Ehrenzweig published by Weidenfeld and Nicholson, 1967)

Case Histories

These case histories have all been drawn from my actual professional assignments and the photographs made under the usual stress that surrounds these activities. The range of work covers a number of subjects in different fields and taken over a number of years of my working life in various parts of the world. Pictures for this book have been chosen to demonstrate points arising from the text, rather than to be a portfolio of exhibition images.

It should be noted that although 95% of this work is in the form of colour transparencies, it was felt equally important to keep the price of this book at a reasonable level. The use of black and white for reproduction is therefore regretted, but in fact the abstraction of colour tones does encourage a careful study of the image structure, which otherwise would not be easily achieved. It is important to bear in mind that the quality in monochrome reprints from colour originals does not indicate a great deal of the original design control of either tone or colour value.

CASE HISTORY NUMBER I

Date: 1960

Location: Australia

Briefing: In touring Australia, I was looking for a number of fine art images which could be used in small interiors and which would be very representative of the Australian scene.

Camera: Linhof Technica 6 × 7, 150 mm Schneider lens.

Film: Ilford FP 3.

Exposure: 1/100 second at f. 16.

Lighting Notes: Late afternoon, almost sunset, subjects riding towards a very light sky, with strong side light from a dying sun.

Production Notes: In several of these pictures I was experimenting with making small images and enlarging them via intermediate positives on Kodak Gravure film. This altered their character remarkably and by tilting the enlarger or using convex mirrors, elongated forms were produced which seemed to satisfy many viewers and also spoke somewhat of the immensity of space in that country. The almost mirage effect, with just enough dust at the horses' heels to indicate the arid landscape, conjures up something of the mystery of Australia and its endless time. The differences of space between the horses is nicely out of symmetry and the whole image has life. The original was 20 mm in height.

CASE HISTORY NUMBER 2

Date: 1969

Location: Frankfurt

Briefing: Make a clear photograph of a cigarette pack for use as an image 5 metres long on a roadside poster.

Camera: Sinar 18 × 24 cm, 360 Symar lens.

Film: Ektachrome daylight.

Exposure: Rollei Flash System E5000.

Lighting Notes: Very broad source of diffused light from top right of camera. Small reflectors to fill each area.

Production Notes: Many fine images are made of small familiar objects which when enlarged totally out of scale make excellent visual structures on which copy is carried. This kind of photography may seem easy and a little boring, but in fact calls for a maximum technique in lighting and camera management. One great difficulty with this particular subject was the need to reproduce the cellophane wrap yet not desaturate the type face unduly on the package. Very precise angling of the broad reflector, watched constantly in camera, gave the required result.

CASE HISTORY NUMBER 3

Date: 1969

Location: London

Briefing: Produce a one page image of an omelette actually cooking for use in an internationally famous cookery book.

Camera: 4 × 5 Arca Swiss, Apolanthar 210 mm lens.

Film: Ektachrome Type B.

Exposure: 1/5 second at f. 11.

Lighting Notes: Single spot, from the top back, undiffused.

Production Notes: A fairly prosaic activity can be given great beauty by the careful construction of a documentary image. The props of course had to be carefully chosen as the author would discuss them in the book and the omelette was actually to be cooked. This meant about five minutes for actual photography, so careful setting up was necessary beforehand. The pan was anchored in place and the action began, completely as it naturally would. Heavy diffusion and a wide lens aperture gave a misty heat-filled atmosphere and soft ambiguous edges. The blue gas flame was vital to the whole composition.

132

CASE HISTORY NUMBER 4

Date: 1969

Location: London

Briefing: Produce a suitable cover for a picture book on the life of a particular Burmese cat.

Camera: Arca Swiss monorail 4 × 5 with Voigtlander Apolanthar 210 mm lens.

Film: Ektachrome Type B.

Exposure: 1/10 second at f. 8.

Lighting Notes: Daylight and one strong tungsten spotlight.

Production Notes: The camera was set up facing a large scoop of white paper and strong daylight flooded onto it from a skylight. Exposure was set so this would record at about half normal strength. The spot was aimed low across the set to catch the cat's eyes. An assistant placed the animal at a prefocused and marked spot and the exposure made as the first striding movement was made. The beautiful feline form and the glowing greenish yellow eyes all contained by a dusky blue light made a striking cover. Only one sheet of film was used.

CASE HISTORY NUMBER 5

Date: 1969

Location: London

Briefing: Produce a monochromatic image of a
nude, but without surface form, to be used to
support a magazine article on female sexual
characteristics. The magazine was a large
circulation family magazine.

Camera: Arca Swiss 4 × 5 monorail fitted with
6 × 9 cm reducing back.

Film: Ilford FP4.

Exposure: $\frac{1}{2}$ second at f. 16.

Lighting Notes: Very powerful spotlights on
either side of the figure to produce a rim of
light on the body. Absolutely no fill on the
front of the figure.

Production Notes: Because this was to be
used in a family magazine, the image had to be
female but not sexual in any way. Abstraction
by solarisation was the ideal solution as it
retained a sensuous line without revealing any
surface form. The fine and beautiful line
wanders around the void of the black page and
is typical of what may be achieved by the use of
lith film and the solarisation technique.

CASE HISTORY NUMBER 6

Date: 1969

Location: London

Briefing: Illustrate an expensive cookery book for a large publishing house, following a pre-arrangement of subjects and formats.

Camera: Arca Swiss 4 × 5 monorail with 90 mm Angulon lens.

Film: Kodak Ektachrome Type B.

Exposure: 15 seconds at f. 16.

Lighting Notes: Single reflector spot from above, diffused with pale gold tissue. White card for fill from near front of camera.

Production Notes: A small set was built to include the table top and items on a no longer used cooking stove at the back. At the moment of shooting paper was flamed in the grate to give the fire effect. The pie was pre-cooked as it was not necessary that it be opened. Colours were chosen to give a country and home effect as was the earthenware jar of castor sugar coming in from the left. The large green cooking apple, while extending the logic of the story, also clearly identifies what is hidden in the pie. A wide angle lens was used to increase the panoramic effect of the double page spread but care was taken that verticals were largely parallel.

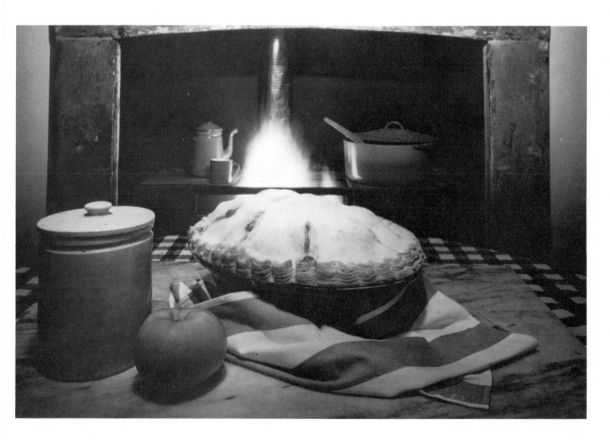

CASE HISTORY NUMBER 7

Date: 1969

Location: London

Briefing: Produce an example of lighting control to illustrate a feature on lighting in photography. The object used should not have any character in its own right.

Camera: Arca Swiss 4 × 5 with Apolanthar 210 mm lens.

Film: FP4 developed in Promicrol 1 + 3.

Exposure: ½ second at f. 16.

Lighting Notes: Tungsten lighting, a 2000 W spot light placed on the right side of the camera and a considerable distance from the subject. A matt white card was placed very near to the subject on the left of camera and a very diffuse light placed on a very distant background to achieve the transition of light to dark.

Production Notes: As this was a lighting example great care was taken to establish the principal clues to good studio lighting. There was an incident highlight within the main highlight, a lighting core where light became darker, a shadow side which showed a range of greys and a cast shadow which was solid black. The full texture of the highlight side of the subject showed conspicuously, but tonally fitted to the scale of the whole picture. The photograph was printed without any shading or dodging.

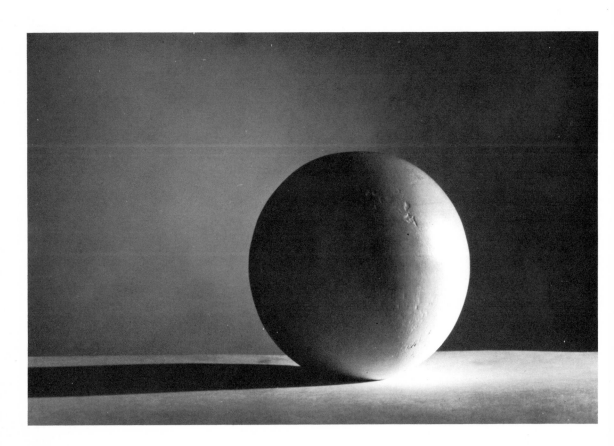

CASE HISTORY NUMBER 8

Date: 1969

Location: London

Briefing: Produce a generic picture of an apple for an experimental advertising campaign discussing agricultural aids for orchardists.

Camera: Arca Swiss 4 × 5 monorail, 210 Apolanthar lens.

Film: Ektachrome daylight.

Exposure: 5 seconds at f. 16.

Lighting Notes: Daylight from a bright overcast sky, coming into the studio from two large windows on each side of the subject. White reflector at camera, directed along the lens axis.

Production Notes: First it was necessary to reach a concept that discussed fine quality food stuffs that might be expected to arise from using the product. After many unsuccessful attempts to use various fruits in baskets and in large quantity, I made a decision to use just a solitary but perfect apple. The dark blue tissue in which it was wrapped became a perfect foil to the symmetry of the main form and also was a logical extension of the subject's natural environment. A rather short depth of field helped to achieve a soft pastel effect at the edges of the apple and a low viewpoint was taken to accelerate the heroic solitude of the subject.

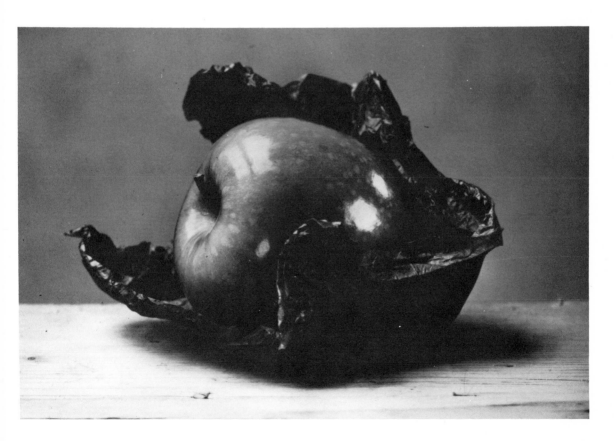

CASE HISTORY NUMBER 9

Date: 1970

Location: London

Briefing: Make an experimental image for use in a fiction magazine to support a story about a romantic dream.

Camera: Nikon F2, 43–85 mm zoom Nikkor.

Film: Kodachrome.

Exposure: I second at f. 16.

Lighting Notes: Daylight on main set and blue spot on girl's face.

Production Notes: A partially wrecked building was found and the girl posed against a black velvet cloth. The young man was asked to walk from the lighted area to this darkened foreground. The camera, mounted on a friction free pan head, was swung from this advancing figure to the close up of the girl during the I second exposure. Further colour was added by fogging each frame with a secondary colour image after the main shooting had finished. Grain was added by shooting dupes through a grain pattern screen.

CASE HISTORY NUMBER 10

Date: 1970

Location: Japan

Briefing: Visit Japan and photograph widely the life of the country.

Camera: Nikon F2, Nikkor 28 mm lens.

Film: Kodachrome, 25 ASA.

Exposure: 1/30 second at f. 3.5.

Lighting Notes: Daylight from tall windows, bright sun outside.

Production Notes: During a visit to a school gymnasium, instruction was being given to advanced students in various martial arts by world authorities on the subject and the action was very fast indeed. From observation it seemed that this could best be illustrated by a great deal of blurring, but some static point of reference was thought desirable. By careful timing, a moment was chosen when body contact stabilised only a tiny part of the action while the rest of the image was almost destroyed by sweeping movements. This type of image needs a very slow film for best results.

CASE HISTORY NUMBER 11

Date: 1970

Location: London

Briefing: Go to a well known restaurant and photograph a special dish related to fish and rosé wine. These were to be used in a book about wines and this was to be for the chapter on rosé.

Camera: Arca Swiss 4 × 5, 90 mm Angulon lens.

Film: Ektachrome Type B.

Exposure: 1 second at f. 22.

Lighting Notes: Daylight, as a back light, one small tungsten spot on wallpaper behind the chair, one strong tungsten flood on table and main dish, from above.

Production Notes: The decision to use a mixture of tungsten and daylight, but to use a tungsten type film, gave marvellous opportunities for colour mixtures of blue and red. The overall atmosphere had to be rosé and red, but the beautiful blues and purples creeping in from the out of balance daylight gave added emphasis to the main colour. Using a wide angle lens on food is usually not recommended but in this case has produced a wholly satisfying graphic picture. The nature of the food lent itself to this slightly more ascetic approach.

CASE HISTORY NUMBER 12

Date: 1970

Location: London

Briefing: Produce a romantic picture of an untypical girl for a sophisticated French perfume. It must reproduce in newsprint, in monochrome, as well as in glossy colour magazines. The colours must be variations of blue only.

Camera: Nikon F2, Nikkor lens 43–85 mm zoom.

Film: Ektachrome EHB.

Exposure: 1/10 second at F.8.

Lighting notes: Daylight, from a tall window facing north.

Production Notes: Using tungsten film and daylight achieves a subtle range of blues such as can be obtained no other way. The glowing greens in the giant tropical butterfly fell away a little, but held basically to true colour. The whole picture was shot through a grain pattern screen to help it resolve in newsprint and give the eye something to rest upon. A gentle zoom while the shutter opened gave a subtle, soft edge to the face and the model was encouraged to look very directly and slightly down to camera to increase a mood of unattainable mystery.

CASE HISTORY NUMBER 13

Date: 1970

Location: London

Briefing: Produce a calendar page, on the subject of English food. Food should be identifiable but fairly generic and the period should be Edwardian.

Camera: Hasselblad 6 × 6 cm, 150 mm Zeiss Sonnar lens.

Film: Ektachrome EP120.

Exposure: 1/125 second at f. 5.6.

Lighting Notes: Daylight, hazy sun.

Production Notes: Meticulous attention to the costuming of the models and a spotless arrangement of food on a flowing white cloth give the shot appetite appeal, even though the image structure is deliberately formalised, old fashioned and edges are unsharp.

The use of a heavy plastic diffusion filter over the lens aided the illusion of a backward look at history, as did the muted colour scheme of pastels. Energy in this basically static image was enhanced by the drifting table cloth which leads into the picture from right to left.

CASE HISTORY NUMBER 14

Date: 1970

Location: London

Briefing: Devise an advertising campaign for designer/jeweller in top of market and with international clientele. 90% of purchases of product made by men of high income for gifts to women and as investment commodity. Campaign to run in glossy fashion magazine, 6 different visuals needed of the same model, jewellery must be obvious and have scale shown to human figure.

Camera: Nikon F2, with 55 mm Micro-Nikkor lens on tripod.

Film: Kodachrome.

Exposure: $\frac{1}{2}$ second at f. 8.

Lighting Notes: Natural light from large window on right of camera, white reflector on left, heavily snooted projector with blue filter to bring the colour of light to the film balance.

Production Notes: It was decided to choose a model with natural beauty but of unspecified ethnic origin with international style. She was to be dark skinned to allow an increase of light on the jewel and to reduce the figure in perception to a minimum. She was to be as natural as possible and no clothing was to be shown in the picture to simplify the story and reduce competition with the product. The model selected was a ballet dancer as poses had to be held in difficult positions for long periods. The hands displayed the jewel to camera and one hand shielded it from the key light so that a dark shadow inside the hand would give clear separation. Space between the hand and the body added delicacy of touch to help the illusion of elegant design.

CASE HISTORY NUMBER 15

Date: 1970

Location: Mexico City

Briefing: Photograph Mexico for a travel feature in a leading fashion magazine.

Camera: Nikon F2 with 135 mm Nikkor lens on tripod.

Film: Kodachrome.

Exposure: 1/125 second at f. 11.

Lighting Notes: Bright hazy sun, subject was copper sheeting and highly reflective. Back lighting was chosen to bring out contours and allow tiny figures of men to separate.

Production Notes: The fascinating building by Felix Candela, constructed in the form of a hemisphere, was faceted like a jewel with huge sheets of copper hung from an outer sphere of cables. A locating shot of the entire structure was made on a wide angle lens then a detail was taken with the longer lens. The men were swinging across the surface on safety lines and it was difficult to shoot a dynamic grouping. The repetitive tents of copper make a magnificent screen for the tiny human forms to advance from, thus increasing the perceptive involvement and underlining the scale of the work.

144

CASE HISTORY NUMBER 16

Date: 1970

Location: Parma, Italy

Briefing: To include in a general picture story on Tuscany, photographs of the oldest coffee house in Parma. Because Parma is noted for the intriguing clothes which local people wear, include an indication of this and also of their occupation.

Camera: Nikon F2, 28 mm Nikkor lens on tripod.

Film: Kodachrome.

Exposure: 1/5 second at f. 8.

Lighting Notes: Daylight from window only.

Production Notes: The camera was set up in a fixed position on a tripod facing a table by the window and any patron thought to be interesting was asked to be seated there. This was done so that as many as 10 pictures could be used across the page showing the same camera angle and the same environment. This greatly exaggerated attention on the differences about each individual, what they were doing and what they were carrying. The wide angle lens tended to minimise the figure a little and show the old fashioned environment. Care was taken to include one balanced horizontal (the table top) in order to keep the image at rest.

CASE HISTORY NUMBER 17

Date: 1970

Location: Italy

Briefing: General travel pictures of a journey from Rome to Parma in Italy, for a magazine. Strong images needed for full page lead pictures and many smaller images for general distribution through the text.

Camera: Nikon F2, 200 mm lens, hand held.

Film: Ektachrome Ex.

Exposure: 1/25 second at f. 4.

Lighting Notes: End of daylight, strong blue overcast but a cloudless sky.

Production Notes: In one picture, I wanted to illustrate the many faceted group of people to be found on any Roman street in the blue evening hours. A position was taken high above a suitably lit street and exposures made over a period of 2 hours. This was almost at the end of shooting. Notice how each person is representative of an age group and wears distinctive clothing. The considerable separation between each group did not destroy the feeling of a flowing street scene, but heavily identified the individual. Notice also that traffic is entering and leaving the frame from different directions and this gives considerable life to an otherwise still picture.

CASE HISTORY NUMBER 18

Date: 1970

Location: London

Briefing: Illustrate a high quality cookery book with an image which was reminiscent of a well known painting by Oudry, a French painter of food subjects in the eighteenth century.

Camera: Arca Swiss 4 × 5, Apolanthar 210 mm lens.

Film: Kodak Ektachrome Type B.

Exposure: 10 seconds at f. 22.

Lighting Notes: Single spot lamp diffused by large silk reflector, from right of camera, second less powerful diffused flood to fill from left of camera.

Production Notes: Considerable research was needed to come up with the correct props for this picture. Ducks were not in the shops, but one suitable one was found and rushed to London. The almond meringue was made to an original old French recipe, the bowl was discovered in a film property house, pewter candlesticks and wooden chest from the period were obtained by rental from antique dealers and expensive damask bought. The lighting in the original painting was analysed and a similar style planned. Time on this picture was, for the photography alone, seven hours.

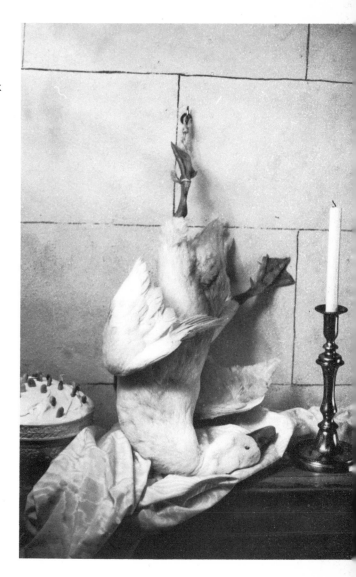

CASE HISTORY NUMBER 19

Date: 1970

Location: Bedford

Briefing: Recreate early twentieth century country feeling, using only two people in tightly cropped location scene. Suggest early attempts at colour photography.

Camera: Hasselblad 6 × 6, 250 mm Sonnar lens.

Film: Ektachrome EP120.

Exposure: 1/30 second at f.8.

Lighting Notes: Misting rain, occasional high points in the overcast light.

Production Notes: Great care was taken with the casting of the two actors and their period wardrobe. A mixture of greens and greys was used to de-saturate the image. Further destruction of any hard colour was made by using two partial filters of green and red held about 7.5 cm (3 in) in advance of the lens. The muted colour accent of the yellow gingham cloth in the food basket gave the eye a strong point to begin exploring the image and further extended the country theme.

CASE HISTORY NUMBER 20

Date: 1970

Location: London

Briefing: Illustrate, in a very general way, the subject of eggs, for use as a leading double page introduction to a selection of recipes.

Camera: 4 × 5 Arca Xwiss monorail, Apolanthar lens.

Film: Ektachrome Daylight.

Exposure: ½ second at f. 16.

Lighting Notes: Daylight, sunbeam controlled by flags to give spot effect.

Production Notes: A feeling of the country, freshness and earthy texture give this picture a strong psychological structure to qualify the main story. The colours are muted browns and blues, but the dust cloth is in soft orange to complete an appetising harmony of the country.

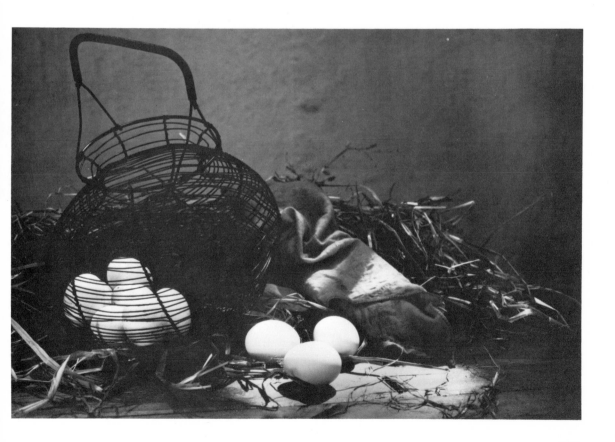

CASE HISTORY NUMBER 21

Date: 1970

Location: London

Briefing: Recreate a headshot of Nefertiti, but impart a documentary feeling of that time. Pay attention to make up and the ethnic origin of the model.

Camera: Nikon with 135 mm Nikkor lens.

Film: Kodachrome daylight.

Exposure: 1/5 second at f. 8.

Lighting Notes: Daylight plus broad source tungsten light.

Production Notes: A model was chosen with a particularly exciting profile and beautiful skin colour and although daylight balanced film was used, the main exposure came from a tungsten source. This gave a sensational bronze glow to the skin, while the dark blue and blacks in the eye make up held true. Very selective focus was used. Note the fascinating shape of the shoulder as the model, under the photographer's direction, uses body movement to create feeling.

CASE HISTORY NUMBER 22

Date: 1970

Location: London

Briefing: Produce a photograph of sardines which will be used to lead an editorial and fairly intellectual discussion of the fish.

Camera: 4 × 5 Arca Swiss monorail, Apolanthar lens.

Film: Kodak Ektachrome daylight.

Exposure: $\frac{1}{2}$ second at f. 22.

Lighting Notes: Diffuse daylight from a north facing window about 4 by 3 metres (13 by 10 ft).

Production Notes: A really antique plate was found and, for a very rare occasion in food photography, a high, almost bird's-eye viewpoint for the camera. This moved the subject into an intellectual and design area, but left the opportunity to use vivid contour lighting to play up the surface structure of the whole subject.

CASE HISTORY NUMBER 23

Date: 1971

Location: London

Briefing: Photograph a Burmese female cat and her young for an editorial publication about maternal instinct.

Camera: Nikon F2, 55 mm Micro Nikkor lens.

Film: Ilford HP4.

Exposure: 1/15 second at f. 5–6.

Lighting Notes: Existing daylight, falling into the room from a long window.

Production Notes: A long series of pictures of a very remarkable cat produced a rapport between us that was almost mystical. At the time of the birth of the litter, my presence was not only permitted, but sought and the slight intrusion of the camera accepted with increasing anticipation. The extraordinary felinity of the subject is brought out in this picture, together with the unwavering protective courage of maternal love. Many, many pictures were needed to achieve the final result.

CASE HISTORY NUMBER 24

Date: 1971

Location: St Tropez, France

Briefing: General pictures to illustrate a magazine article on the food of France. Beside close ups of dishes, regional pictures were needed to illustrate the degree of concern which the French feel about even the simplest food.

Camera: Nikon F2, 55 mm Micro Nikkor lens.

Film: Ektachrome Ex.

Exposure: 1/60 second at f. 11.

Lighting Notes: Slightly overcast in shaded street. Early morning.

Production Notes: Moving quietly around the old part of St Tropez well clear of the tourists who were sleeping anyway, I found this moving picture of an elderly lady going home with her daily bread. Some environment was needed in the picture so the full figure was included. Notice the dynamic action in the walking stick and the feet. The intrusion of the subject (bread) well into the dark figure quickly separates it, and its yellowish colour amidst all the blues and greys give it further quick perception. The subtlety of tone and light and the fact that no face is seen make it even more interesting.

CASE HISTORY NUMBER 25

Date: 1971

Location: Tuscany

Briefing: Produce a series of pictures on Tuscany for a travel feature in a mass circulation consumer magazine.

Camera: Nikon with 28 mm lens.

Film: Kodachrome.

Exposure: 1/125 second at f. 8.

Lighting Notes: Afternoon sunlight.

Production Notes: Two fine white oxen drawing a country cart through the olive groves in Tuscany seemed to me to be the essence of the country. A mixture of extraordinary drab browns and greens surrounded the pure white of the animals and the long, slanting light of an afternoon sun gave rich texture to the dry land. This image is magnified many times by duping, from an original section of a 35 mm slide measuring one centimetre ($\frac{3}{8}$ in) square.

CASE HISTORY NUMBER 26

Date: 1972

Location: London

Briefing: Produce a suitable image for a magazine cover to be circulated to two million people. The image could be decorative only, but should have associations with the subject of beauty. Colours should be blue and orange to reinforce the magazine logo.

Camera: Nikon F2, 43–85 mm Zoom Nikkor.

Film: Ektachrome EHB.

Exposure: I second at f. 16.

Lighting Notes: Daylight plus one small tungsten spot on fruit, plus one electronic flash on background.

Production Notes: As this image had to be a very general one, a model was chosen without any specific ethnic origins but representative of an international style of beauty. The fascinating softening of the edges added much of the half tone value to the image and this was achieved by rapidly zooming the lens during the exposure. Daylight and tungsten exposures were blurred while the flash exposure recorded sharp and clear. Flowing lines in the image were obtained by careful direction of the model, a well known ballet dancer, who could therefore visualise and produce directed movement precisely on cue.

CASE HISTORY NUMBER 27

Date: 1972

Location: London

Briefing: Produce a book cover for a publisher of books for young readers, on various science fiction subjects.

Camera: Arca Swiss 4 × 5 monorail, Apolanthar 210 mm lens.

Film: FP4.

Exposure: Various.

Lighting Notes: Daylight on figure, plus enlarging light.

Production Notes: The real need in this image was to produce a feeling of elapsed but encapsulated time which could suggest unreality within easily imagined real situations. The picture is a combination of an original photographic negative superimposed across the photogram of a piece of string and a glass plate. The assembled image was then abstracted by the use of Kodalith and partly solarised positive separations produced which were given arbitrary colours. The whole was then printed on Agfa colour print paper.

CASE HISTORY NUMBER 28

Date: 1972

Location: London

Briefing: Re-shoot of earlier work for publisher, with my own modifications, theme of 'The Lovers', for an experimental portfolio piece.

Camera: Nikon F.2, 28 mm Nikkor lens.

Film: Kodachrome 25 ASA.

Exposure: ½ second at f. 16.

Lighting Notes: Daylight, bright overcast.

Production Notes: Earlier in the year, I had completed a magazine assignment in which I illustrated a story about young love. The session resulted in quite interesting work but I always felt more could have been done. For my own portfolio I returned to the scene with two models and remade the series. In this picture we have all the tenderness, anonymity and over-sentimentality of the boy-girl cliché. The warm mood, despite the minimum of sharp focus, comes through inescapably. The dramatic sweep of the blurring red cape lifts any tendency to sombreness and the image of hopeful young love communicates its whole message absolutely. Note the use of a coarse grain pattern to rest the eye, and to prevent visual boredom arising from the extremely soft structure of the photograph.

CASE HISTORY NUMBER 29

Date: 1972

Location: Alderney

Briefing: Visit the island of Alderney and make a series of fine art pictures which would fit the theme of *The Yesterday Place*.

Camera: Nikon with 135 mm Nikkor lens.

Film: Ektachrome X.

Exposure: 1/60 second at f. 8.

Lighting Notes: Morning shade from an open sunlit sky.

Production Notes: The island of Alderney retains courtesies and customs from soft past passages in time. There is a slow pace and a reverence for the humanities. My intention was to capture some of this for a suite of pictures to be reproduced in litho as limited edition prints. A deliberate breaking up of the image by photographing through a grain pattern screen added a sense of both immediacy and decay while the homely milk jug stood as an optimistic symbol of the continuing human presence.

CASE HISTORY NUMBER 30

Date: 1972

Location: London

Briefing: To produce a poster and book cover image for a well known war book about the 1914 to 1918 war. As the book was a classic re-appraisal of the futility of war, this had to carry into the image. A particular closing paragraph of the book was chosen to illustrate.

Camera: Hasselblad 6 × 6 with 150 Planar lens.

Film: Kodak Ektachrome Type B.

Exposure: Bowens flash lighting plus tungsten film ½ second at f. 16.

Lighting Notes: A soft light with coloured gelatins on the background, side light of flash, bounced from a silver umbrella inside a parachute diffuser. Snooted spotlight (150 W) on butterfly only.

Production Notes: This grim picture would not have been a good working image if it had been any less painful to look at. This was the climax of the story and it had to have sadness, finality, horror and peace all wrapped together. The low camera angle dramatises the hand and the grey mud adds to the hopeless feeling. A hole was cut in the table top so that the hand would protrude and very careful direction was needed to get the shape of the fingers exactly right, otherwise they looked so grotesque that the viewer would become altogether too disturbed about the final image.

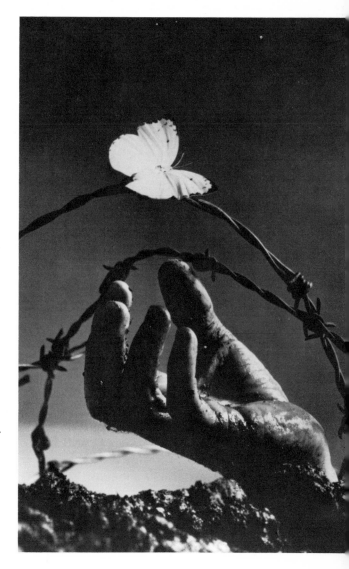

CASE HISTORY NUMBER 31

Date: 1972

Location: Australia

Briefing: General travel and PR pictures for use in Department of Immigration brochures for Australia. A feeling of sun should be present in all pictures.

Camera: Nikon F2, 28 mm lens, hand held.

Film: Kodachrome.

Exposure: 2 seconds at f. 16 with N.D. 0.5 filter.

Lighting Notes: Bright afternoon daylight, back lighted subject to give airy sunny mood and to give incident highlights on water.

Production Notes: In a strong wind, yachts were moving rapidly and I had hired a fast hydrofoil capable of at least 40 knots. We moved at top speed toward any subject that looked promising and on signal the camera boat was turned parallel to the yacht and the engine immediately stopped. The camera boat was therefore stationary but dipping up and down and the yacht was moving at about 15 knots laterally past the camera. While this contrary moving of subject and camera platform was going on, I swung the camera in an arc to follow that of the bridge, thus registering it sharp enough for perception and, at the same time, beautifully blurring the wave highlights.

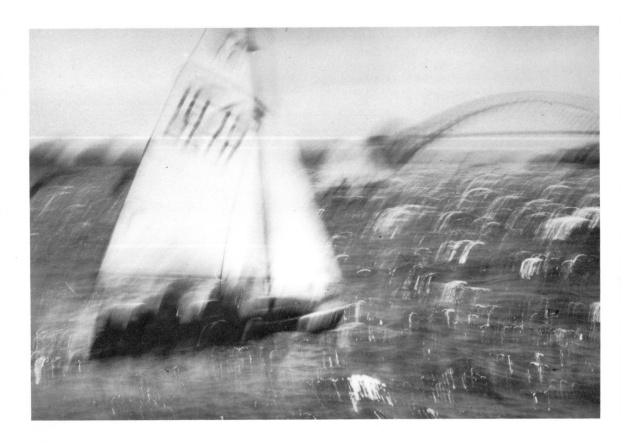

CASE HISTORY NUMBER 32

Date: 1972

Location: London

Briefing: Photograph Maestro Jephtas, a young conductor from Zurich, in a less than usual style, so that the image could be used for in-house posters. It should not be used for newsprint or magazine reproduction.

Camera: Nikon F2, 135 mm Nikkor lens, hand held.

Film: Kodak Recording Film 2374.

Exposure: 1/250 second at f. 8.

Lighting Notes: Very low level natural light from two frosted windows. No other lighting aid.

Production Notes: This picture set out to be grainy with a minimum of sharpness yet recognisable as the subject. Deliberately designed to elevate life and mood in the mind of the viewer and suggest overtones of black and white charcoal sketches, together with a classic feeling of music.

 The subject was asked to walk about while the pictures were taken and the film was developed at 3 times normal time in DK50 to enhance grain.

CASE HISTORY NUMBER 33

Date: 1972

Location: London

Briefing: Produce still life pictures of a highly respected brand of Scotch whisky, showing the product to be old fashioned, distinguished and expensive. Suggest this by a series of 1920 recreations of simple homely scenes.

Camera: Arca Swiss 4 × 5 monorail, 210 Apolanthar lens.

Film: Ektachrome Type B.

Exposure: 15 seconds at f. 22.

Lighting Notes: Outside late afternoon light coming through a lead light window, wide flood reflector beamed at subject through silk, white fill in reflector to left and beneath lens axis.

Production Notes: A careful research was made for genuine untouched 1920 to 1930 interiors and finally one selected with a suitable window and cabinet ledge. The rich blue of the skylight arose from the use of Type B film and the delicate gradation of tone greatly qualified the product. An emotional feeling of nostalgia gave a sense of historic value to the modern product, and by the use of tiny silver reflectors behind the glasses of whisky, the extraordinary rich gold of the product received instant recognition.

CASE HISTORY NUMBER 34

Date: 1972

Location: London

Briefing: Produce a book cover for a paper back written for mass release. Illustrate, using symbols, some of the actual happenings in the story.

Camera: Arca Swiss 4 × 5 monorail, Apolanthar lens.

Film: Kodak Ektachrome Type B.

Exposure: 1 second at f. 22.

Lighting Notes: Strong but soft cross light, plus a very strong spot light with barn doors, playing on the glass.

Production Notes: The correct gun was important as this featured so much in the story and after a lot of research a similar type was found. The black rose is significant also and the other elements were added to magnify, in a considerable way, the textures. This still life is a constant interaction of textures, of a kind that the camera records so well. Note also that in colour, the harmony was almost a green monochromatic harmony, giving a deep psychological bias to the whole image.

CASE HISTORY NUMBER 35

Date: 1973

Location: London

Briefing: To photograph a series of spoof situations, with a character actor to represent the British business man, to introduce Post Office facilities. Not intended for reproduction but for display on individual panels approx. 3 metres (10 ft) in height.

Camera: 4 × 5 Arca Swiss, 210 mm Apolanthar lens, f. 22.

Film: Ilford FP4 developed in Promicrol 1 : 3.

Exposure: By Rollei Studio Flash System.

Lighting Notes: Large diffuse light source 2 m (6 ft 6 in) high by 1 m (3 ft) wide on right of camera. Smaller diffuse lamp on boom on left of camera aimed at background to give a transitional highlight at back of figure and so increase separation. Top light in tight reflector on foreground only.

Production Notes: As these photographs were to be used on exhibition stands at a very large size and were to be carefully made enlargements on photographic paper, greater subtlety of tone could be attempted in the negative. The very soft broad light effectively gave good tone in both the dark suit and the white paper aeroplanes. It was felt that the character should be somewhat unbelievable but should maintain a faint link with a gereralised cliché about the British business man which could be taken in good humoured fashion by all members of the public.

CASE HISTORY NUMBER 36

Date: 1973

Location: Frankfurt

Briefing: Photograph, for a leading coffee wholesaler, instant coffee granules. Show the shape of the crystals and get a feeling of immediacy into the subject.

Camera: 18 × 24 Sinar, 360 mm Rodenstock Apo Ronar lens.

Film: Ektachrome Daylight.

Exposure: Rollei Flash System.

Lighting Notes: A top back light to show structure and form, from a 2 × 3 metre (6 ft 6 in × 10 ft) reflector. Fill light from a 1 metre (3 ft) square white reflector.

Production Notes: It was necessary to show a lack of formality and casual immediacy in this picture, so grains were allowed to accumulate on the far edges of the glass. The shape of the grain of coffee was shown precisely, as this had a primary part in the descriptive copy. Note the documentary feeling which is increased by the oblique angle of the plunging spoon.

CASE HISTORY NUMBER 37

Date: 1974

Location: Ibiza

Briefing: Photograph a maximum number of different fish which are to be found in the Mediterranean, to be used full page in a cookery book as both a decorative and informational image.

Camera: Arca Swiss 4 × 5 monorail with 6 × 9 cm roll film back and Sironar 150 mm lens.

Film: Ektachrome EP 120.

Exposure: 1/15 second at f. 22.

Lighting Notes: Bright overcast, slight rain falling.

Production Notes: Because of the need to make this picture a clear source of information, every fish had to be seen but the chance to make a gigantic still life of such a volatile subject was too tempting to miss. A visit to several fishing villages in the early morning produced the fish (some still flapping vigorously) and the odd pieces of net and fish boxes etc. These were carried 20 kilometres back along the coast to a pre-selected place and patient setting up began on the spot where the waterline was expected to be in 3 hours' time. When the arrangement was finalised, gentle waves were washing around both camera and subject. The softer fish streamed gently across the picture as water swept by and this was when the exposure was made. Two assistants, knee deep in the water, caught smaller fish that were washed out of the set. Fortunately a slight mist was falling, although bright light was also present and this gave a fresh slickness and a cool blue to the highlights which made the whole subject fresh and appetising. The photograph took seven hours to prepare and shoot with one additional day spent on research.

CASE HISTORY NUMBER 38

Date: 1974

Location: Spain

Briefing: Produce a single page illustration for an Italian cookery book, on location in the Mediterranean. Present the food in a documentary way, with maximum appetite appeal and in a kitchen.

Camera: Arca Swiss 4 × 5 monorail with 120 roll film back, Sironar 210 mm lens.

Film: Ektachrome EP 120.

Exposure: 1/10 second at f. 22.

Lighting Notes: Bright sunshine, diffused by nearby white walls and archway. Direct light was brought into the image to give added form to the dominant subject matter, by way of concave mirrors placed well outside the set.

Production Notes: This dish, famous in some parts of Italy, is the flower of the zucchini, dipped into a batter of cheese and anchovies and very quickly fried in olive oil. It takes only a few seconds and must be photographed absolutely at once if it is still to look appetising. This means that all setting up must be done on 'stand-in' material and then the photographer awaits the arrival of the real dish. This was to be a right hand page so that fact greatly controlled the design of the image. This documentary way of photographing food needs maximum speed and very knowledgeable technique, but does produce phenomenal, appetising results.

CASE HISTORY NUMBER 39

Date: 1974

Location: Germany

Briefing: Photograph a very small camera to show its actual size in relation to the human hand. Emphasise the craftsmanship in the production of the camera; give a jewel-like effect. Leave space for fine line copy to drift down the descending chain.

Camera: Rolleiflex SL 66. Sounar 150 mm.

Film: Ilford FP4.

Exposure: Rollei Flash System.

Lighting Notes: Soft but very broad and very bright top back light, slightly to right of camera. Fill from 2 metre (6 ft 6 in) square white cardboard reflectors.

Production Notes: Type design was to play a very important part in this photograph and a strong accent was needed on texture. The biggest technical problem was to reproduce the grained leather case and the brushed chrome camera casing. This was helped by processing in Promicrol developer from May & Baker, diluted 1 : 5 and exposure was increased by 25%, with compensating decrease in development times. Notice how the main subject is held tightly into *the optical dead centre* of the format, so that added type could not attract greater attention.

CASE HISTORY NUMBER 40

Date: 1974

Location: London

Briefing: Photograph a champagne substitute, in a long narrow format for black and white insertion in a poorly reproduced magazine. Design it to carry type within the image area and to be noticed by young people.

Camera: Nikon F2, Micro Nikkor lens.

Film: Ilford FP4.

Exposure: Approx. 1/30,000 of a second.

Lighting Notes: Close up use of a Rollei 36 RE flash.

Production Notes: Because the creative solution seemed to lie in an analysis of the refreshing moment when the wine was pouring into the glass, some graphic investigation of the action was indicated. The Rollei high speed flash could do this effortlessly and the half tone result was reproduced on Kodalith line film processed in a vigorous lith developer. Elegant design was the special characteristic of this image and such design acted as a screen to carry a witty narrative about the product.

CASE HISTORY NUMBER 41

Date: 1974

Location: London

Briefing: Produce public relations pictures which would interest glossy magazines, showing diamond and silver jewellery for a glamorous yet practical target market. Pictures should not be in colour.

Camera: Rolleiflex SL66, Planar 80 mm lens.

Film: Ilford FP4.

Exposure: Rollei Studio Flash.

Lighting Notes: Very diffuse but strong light across the subject with a polished mirror vinyl reflector at camera lens, angled to catch a reflection from the key light.

Production Notes: Because it was essential to produce superb tonal qualities and great detail, this film was over exposed by 25% and under developed by a similar compensating factor. Cross lighting brought out all textures but it was necessary to construct a partial tent of white paper to prevent unseemly dark shadows in the jewellery. Reflected light to fill in against the cross light came from a highly polished vinyl mirror foil. The element of sensuality indicated by the bare skin was felt to be complementary to the jewellery, but for obvious reasons in general release pictures, was not over emphasised. A play of texture between skin and suede helped the design.

CASE HISTORY NUMBER 42

Date: 1974

Location: London

Briefing: An advertising agency requested experimental graphics for a tie manufacturer, to suggest modern styles, avant garde marketing and their interest in fashion conscious younger men. Surrealism was permitted and animal forms were agreed upon by arrangement after research.

Camera: Area Swiss 4 × 5, Hasselblad 6 × 6, Sinar 8 × 10. Various lenses and focal lengths.

Film: Masters on Kodak Ektachrome, duping on Agfa Duplichrome.

Exposure: Rollei Studio Flash System.

Lighting Notes: More or less straight lighting to reveal texture and form by using diffused cross lights and a secondary light on the background.

Production Notes: This was extremely advanced photography, ending up with a most unusual piece of surrealism. The person wearing the suit and tie was photographed in colour and black and white, the cock's head, which had been made out of papier mâché, was taken separately and the whole combined as a black and white positive on Kodalith film. The tie had been masked by a negative mask and therefore unexposed, so that finally the colour transparency of the tie, isolated also by negative masks, was projected onto colour dupe film and the Kodalith positive of the cock, covered in red and green gelatin filters, added to the picture in a secondary exposure.

CASE HISTORY NUMBER 43

Date: 1974

Location: London

Briefing: Photograph, in the studio, various items of American Zuni Indian jewellery for editorial use in a weekly magazine colour supplement to a newspaper.

Camera: Nikon 28 mm Nikkor.

Film: Kodachrome.

Exposure: Rollei Studio Flash System.

Lighting Notes: Strong top back light, plus a very large mirror reflector along the lens axis. Background lit by flash with an orange cinemoid filter over the tube.

Production Notes: A feeling of the natural Arizona environment had to be introduced and this was done solely by the use of colour. The turquoise and coral jewellery was beautifully off-set by allowing everything else to fall into warm reds and browns which also complemented the buckskin worn by the model. To display the jewellery, the model was asked to execute a very simple human gesture, but the lighting of this action took 1½ hours.

CASE HISTORY NUMBER 44

Date: 1975

Location: London

Briefing: Produce a long horizontal image to act as an exhibition invitation for a jewellery salon and also a double page monochrome spread in high fashion magazines. Suggest the sea, a model who was distinctly from a dark skinned race but without specifying any particular ethnic origins. Show the pearls dramatically.

Camera: Rolleiflex SL66, Planar 80 mm lens.

Film: Ilford FP4.

Exposure: Rollei Flash System.

Lighting Notes: Strong cross light plus top back light from a broad source, I metre (3 ft) square. Fill was from a large area diffused flood reflector.

Production Notes: Because of pre-established requirements from the layout, a long flowing line had to develop in the image, together with a suitable montage of the sea. Note how the body has been lightly oiled, then sprayed with a glycerin and water mixture to get the effect of a spray splashed skin. The montage of the seascape was allowed to destroy part of the body structure and this erosion increased the dreamlike environment of the whole image.

CASE HISTORY NUMBER 45

Date: 1975

Location: Ibiza

Briefing: Photograph new season swimsuits for a weekly colour magazine supplement to a national newspaper. Show the designs but also use imagination in respect of location and technique.

Camera: Nikon F2, 200 mm lens.

Film: Kodachrome 25 ASA.

Exposure: 1/60 second at f. 8.

Lighting Notes: Bright noon sunlight plus remotely controlled Rollei Studio Flash, 3000 watt seconds, directed at figure.

Production Notes: The 'white isle' of Ibiza was a very suitable location for the romantic swimsuits of that year. My idea was that the pink bikini could be harmonised with the white walls of a villa and the sky could be rendered absolutely black by the use of a strong polariser. Because this would drastically reduce the exposure overall, additional lighting from a radio synchronised Rollei flash system, was directed at the figure and the wall. Notice how the chiffon scarf, blowing in a gentle wind, has cast a shadow which repeats the rhythmic form of the nearby roof tile.

CASE HISTORY NUMBER 46

Date: 1975

Location: Bordeaux

Briefing: Go to Bordeaux and photograph various regional recipes and fresh food for use in a cookery book on French food.

Camera: Arca Swiss 4 × 5 monorail, 90 mm Angular lens.

Film: Ektachrome 6115.

Exposure: ½ second at f. 22.

Lighting Notes: Daylight, through a tall frosted window. Tungsten light, bounced from a 1000 watt flood aimed at the white ceiling, augmented the light and added warmth to the colour in general.

Production Notes: The chateau had stood almost unchanged for a hundred years and belonged to a very fine family. The scullery had never been modernised so this still life was in fact quite documentary. The giant fish were diminished in scale by the use of the wide angle lens and in fact merely became a food symbol. The colours were a modulation of whites and ambers, all kept to a very high key. This is a still life which lacks appetite appeal but does speak historically of the sensual nature of food. It fascinated me that it existed and could be made without any pre-fabrication.

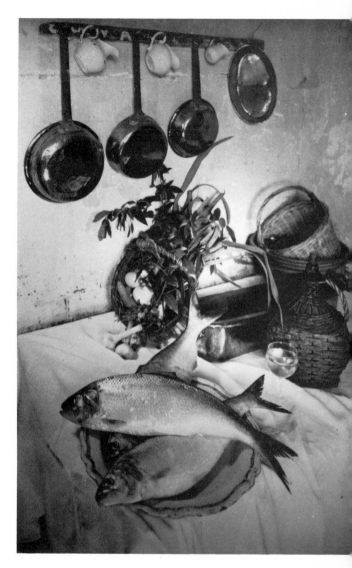

CASE HISTORY NUMBER 47

Date: 1975

Location: London

Briefing: Produce a suitable image for a large scale print for use in an interior decor identified with music. Must be capable of enlargement to 1.5 metres (5 ft).

Camera: Arca Swiss monorail 4 × 5, Sironar 210 mm lens.

Film: Ilford FP4 developed in Promicrol.

Exposure: 1/10 second at f. 22.

Lighting Notes: Two snooted spots and one unguarded 150 lamp in camera view.

Production Notes: A guitarist was posed against a dark background and the camera movements used to produce successive images on the same sheet of film. This was developed and dried then a film positive made of the result, solarising it during development.

 The accidental re-arrangement of the line and half tones in the image greatly enhanced the flowing arabesques of the guitar profile and gave a most satisfying music oriented mood. I called this picture Jazz.

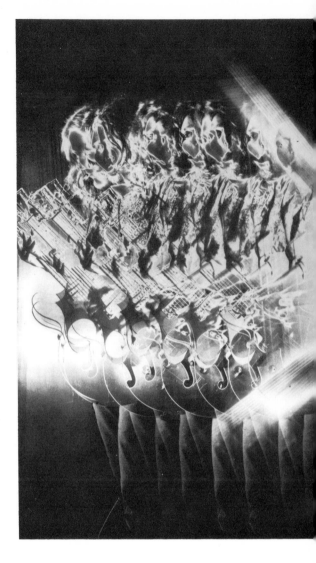

CASE HISTORY NUMBER 48

Date: 1975

Location: London

Briefing: Photograph experimentally, to illustrate a copy headline talking about free enterprise in Britain and how the self-employed and managerial classes were being limited by bureaucratic legislation.

Camera: Rollei SL66, Planar, 150 mm lens.

Film: Ilford FP4.

Exposure: Rollei Studio Flash System.

Lighting Notes: Strong cross lighting from a circular, lightly diffused reflector. A heavily snooted reflector was used to skid light down the model's skin towards camera to increase form and texture and produce added dimension.

Production Notes: This picture, quite incidentally, won a professional photographic prize, much in excess of the commissioning fee and proved that the popular cliché of government bureaucracy infringing on individual business enterprise could be well illustrated. The model was chosen for his ability to take very explicit directions and act them effectively to the camera. As a representative of the British business man, the model dressed in clothes which, although they clearly represent a well known social class, in fact have long since disappeared from general use.

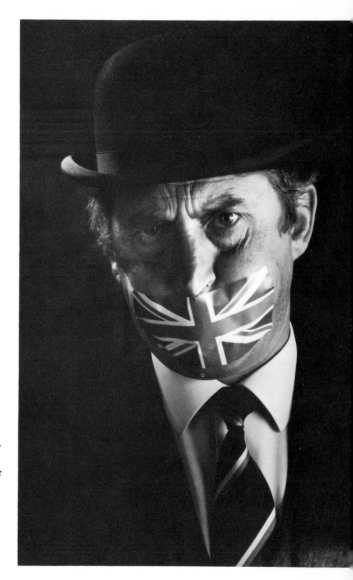

CASE HISTORY NUMBER 49

Date: 1975

Location: London

Briefing: To photograph man sneering, to fit outspoken copy headlines about an alcoholic beverage. Character should not be of identifiable ethnic origin, but should not be Nordic.

Camera: Rolleiflex SL66, 150 mm lens f. 22.

Film: Ilford FP4 developed in Promicrol 1+7.

Exposure: Rollei Studio Flash System.

Lighting Notes: Main key light in soft reflector 1 metre (3 ft) square, on right of camera, white card 1 metre (3 ft) square on left of camera, *working* on chin. Back light in tight reflector to highlight hat textures and surface skin.

Production Notes: Very close cropping of this image helped the impact and heightens the effect of the sneering face. The difficulty in directing this type of photograph is that the expression must not advance too far into absurdity. The sunglasses are used to mask the eyes, which otherwise would be the strongest element in the image. A hint of life behind them adds to the humanity of the picture. Working in black and white materials, full use was made of every available texture.

CASE HISTORY NUMBER 50

Date: 1975

Location: Bordeaux

Briefing: Go to Bordeaux and illustrate agreed subjects for a book on French regional cooking.

Camera: Area Swiss monorail filter with 6 × 7 film back and Rodenstock Sironar 150 mm lens.

Film: Kodak Ektachrome Daylight.

Exposure: $\frac{1}{25}$ at f. 32.

Lighting Notes: Daylight, early morning, with a 800 watt floodlight with blue filter on the brioche.

Production Notes: The breakfast tray was prepared so that it conformed to normality for that part of France and laid in a beam of sunlight streaming across an antique table. The doves were encouraged to fly to the owner of the chateau to be rewarded with corn and a slow shutter speed was chosen to get blurred wing movement in the birds. A beautiful idyllic moment, redolent of Bordelaise love of food was the result.

CASE HISTORY NUMBER 51

Date: 1975

Location: London

Briefing: Produce for a wall poster, a striking picture of the setting sun. Because of time and low budget, it must be done in the studio.

Camera: Arca Swiss 4 × 5 monorail camera, 360 mm Rodenstock lens.

Film: Ektachrome Type B.

Exposure: 5 seconds at f. 16.

Lighting Notes: Projection lamp toward camera with soft broad source flood in top back position.

Production Notes: The projector lens itself became the sun and an impression of distant landscape was made by a black velvet drape. The rippling sea was made from several layers of mounting tissue and the effect overall became a rich analogous colour harmony in reds, yellows and browns. Many thousands of miles of location travel would be needed before achieving anything more convincing than this image, which had by definition to be timeless, exciting, yet harmonise with a pre-determined interior environment.

CASE HISTORY NUMBER 52

Date: 1975

Location: Frankfurt

Briefing: Produce a full page advertisement with pre-determined copy and product. Appetite appeal, product usage and a feeling of immediacy should heighten the story of a market leader in the convenience food field.

Camera: Arca Swiss 4 × 5 monorail with Rodenstock 150 mm lens.

Film: Ektachrome Daylight.

Exposure: Rollei Flash System.

Lighting Notes: Very broad reflector diffused by silk 2 metres (6 ft 6 in) square from the top front. Diffuse fill light from a strong light source left of the camera axis.

Production Notes: The sharp fall off of light was essential to carry the copy headline and to surround the recipe card with sufficient darkness to draw immediate attention to it. Very close attention was paid to co-ordinating the ceramics, food and table cloth by both the photographer and the stylist. The action of pouring heightens the sense of immediacy and shows the product in action. The package was incorporated in the picture more closely to identify it with the food and to suggest scale. Very precise timing was needed to catch the peak of the action and many pictures were taken.

CASE HISTORY NUMBER 53

Date: 1976

Location: London

Briefing: Produce a graphic image, capable of use for wall decor up to 2 metres (6 ft 6 in) in length.

Camera: Rolleiflex 6 × 6.

Film: FP4, then Kodak duplicating film.

Exposure: Various.

Lighting Notes: Very strong cross light from right side of camera, no fill.

Production Notes: The negative of this picture was made by sandwiching the mirror image of the same shot and thus required a large area of clear film so that it would read. This black and white image was then made into a positive image in Kodalith and solarised in Dektol 1+4 by exposure to a 15 watt lamp 1 m (3 ft) from the film 30 seconds after development began. This image was then abstracted into two further positives of highlight and shadow and each given colour by the use of colour gels in the enlarger. The whole was then combined in register by the use of a Kodak register board and printed on Kodak duplicating film.

CASE HISTORY NUMBER 54

Date: 1976

Location: Frankfurt

Briefing: Photograph for the Maggi Gmbh division of Nestlé, an arrangement of escalopes of veal, spaghetti and their product, Italian tomato sauce. The need was stressed that the image should appeal to younger people who were identified as the target group.

Camera: Area Swiss 7 × 5 camera, Rodenstock Grandagon lens, 90 mm.

Film: Kodak Ektachrome.

Exposure: Rollei Studio Flash System.

Lighting Notes: One single diffused lamp at top and slightly to the right of the subject. Note the incident highlight in the tray near the plate which picks up the texture of the paint.

Production Notes: Using ultra wide angle lenses is always a matter of slowly choosing the right viewpoint when all the unnatural distortion is working in a pleasing manner to aid the eye movement throughout the image. The interesting distortion of the breadsticks is arrested by the strong check pattern of the cloth and the main dish is more or less naturally drawn even though the lens was only 30 cm (1 ft) from it. The Rodenstock Grandagon lens performs magnificently in these still life situations.

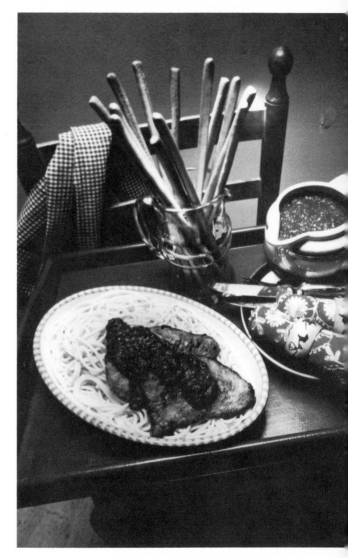

CASE HISTORY NUMBER 55

Date: 1976

Location: Reims, France

Briefing: To cover activities in the region of Champagne in France, for editorial use.

Camera: Nikon F2, 135 mm Nikor lens, hand held.

Film: Kodax Tri X.

Exposure: 1/30 second at f. 4.

Lighting Notes: Room lighting only.

Production Notes: Film was rated at 1000 ASA and developed to compensate in Promicrol, diluted 1 + 4, for an extended time. Notice the finely graded tones and soft highlights. The moment is a supreme one for the two subjects as they discuss the merit of champagne. The mood comes through very strongly as a classic one, full of joy and loving knowledge and projects the feeling of immediacy to a very high degree by the use of slightly blurred outlines.

CASE HISTORY NUMBER 56

Date: 1977

Location: London

Briefing: Photograph a non specific food item for inclusion in a portfolio for world wide publication.

Camera: 7 × 5 Arca Swiss monorail. Rodenstock Grandagon 90 mm lens at f. 32.

Film: Ektachrome, daylight.

Exposure: Rollei Studio Flash.

Lighting Notes: Very broad, bright, but diffuse light from top right and highly controlled diffuse, but narrow, fill light from left of the lens axis and near the subject.

Production Notes: This picture was more intended to show design rather than appetite appeal, yet it had to be recognised as a food oriented item. Because it was to circulate internationally, a lobster was chosen as a symbol, easily recognised by most people and of such a shape and colour to help the design. The bottles were hand blown antiques and their free shape worked beautifully with the natural distortion arising from the use of a super-wide angle lens. Note how the brilliant lobster colour has been placed on a neutral screen of warm greys to isolate it further, and strong form has been shown throughout the whole picture. The dynamic tension is heightened by the breaking of the edges of both table and dish by the very active shape of the main subject.

CASE HISTORY NUMBER 57

Date: 1977

Location: London

Briefing: Produce a still life which although undeniably photographic, had overtones of a painting. It must be capable of working effectively at a size of about 1 × 0.75 m (3 × 2 ft) for use as a decorative wall hanging.

Camera: Arca Swiss 13 × 18 cm monorail. Sironar 210 mm, f. 32.

Film: Ektachrome 6115.

Exposure: Rollei Flash System.

Lighting Notes: Broad source above and to the right, small snooted flood on background.

Production Notes: A very difficult picture to make and the use of a curved horizon was one of the problems to integrate into the general design. Fruit was chosen because of the harmonising colours needed to support the image, but as this kind of subject lacks many dynamic qualities the structure was destabilised by the use of the plunging knife, the stray leaf under the plate and the mysteriously graphic shapes of wheat stalks in the empty space at the bottom right. Props were most carefully chosen and the whole image given the most sensuous connotations possible for such an inanimate subject.

CASE HISTORY NUMBER 58

Date: 1977

Location: Kuwait

Briefing: Design wall decorations of various sizes, using various photographic media, for the Kuwait Embassy, London. Pictures to be ultra modern and of specified subjects.

Camera: Contax R.T.S., Distagon 25 mm lens.

Film: Kodak Tri X.

Exposure: 1/500 second at f. 16.

Lighting Notes: Daylight, late afternoon sun – ultra violet filter to counteract considerable haze.

Production Notes: It was necessary to fly to Kuwait in the winter time, in order to avoid the unendurable heat and haze of the summer. The Towers of Kuwait, standing on the shore, are exotic and fascinating pieces of functional architecture. The feeling of the twenty-first century was absolutely dominant in my mind as I stood beneath these extraordinary turquoise structures. Cosmic ideas of space and a glimpse of our incredible future all had to be built into the final image. This very much solarised and abstracted picture was finally printed on sensitised brass about 3 × 3 metres (10 × 10 ft).

CASE HISTORY NUMBER 59

Date: 1977
Location: Kuwait

Briefing: Go to Kuwait and photograph suitable subjects for wall decoration in the Government's London Embassy.

Camera: Contax R.T.S., Zeiss Planar 50 mm lens.

Film: High Speed Ektachrome, Type B.

Exposure: 1/250 second at f. 16.

Lighting Notes: High noon, full sunlight.

Production Notes: The dhow is a most emotive symbol for the State of Kuwait and, in small numbers, is still hand built in tiny shipyards along the coast. It was necessary to obtain an original that could be abstracted in monochrome or colour and be reproduced photographically 1 × 1.2 metres (3 × 4 ft) for the Embassy walls. By solarising both negative and positive from the 35 mm transparency, using IL4 Ilford film and May & Baker Suprol developer at 1 + 30, extraordinary beauty appeared in the final graphic assembly, producing a feeling of eternity and the sea. Very tight cropping helped to increase local image tension.

CASE HISTORY NUMBER 60

Date: 1977

Location: Kuwait

Briefing: Produce monochrome originals of important public buildings in Kuwait for interior decorative panels in the Kuwait Embassy, London.

Camera: Contax R.T.S., 25 mm Zeiss Distagon lens.

Film: Tri X developed in Promicrol 1+5.

Exposure: 1/30 second at f. 11.

Lighting Notes: Sunset, the mosque outlined almost as a silhouette against a brightly lit sky.

Production Notes: The silhouette condition was a good point to begin chemical abstraction, separating both positive and negative images on to Kodalith film and developing them in HC110, normal dilution. Solarising was done with a 15 watt lamp 1 m (3 ft) above a black developing tray with an exposure of 5 seconds.

 The romantic arabesques in this image brought an oriental feeling to a modern but timeless subject. the Kuwaiti clients fully approved of the extremely abstract and novel image which was finally rendered in a series of arbitrary but subtle colours.

Glossary

Abstract Photograph which is optically simplified by use of tonal, chemical or focus controls.

Acutance Ability of developer to render edge sharpness between tones.

Agitation Planned movement of film or paper during processing in liquids.

Aperture Control on camera lens, in f. stops to permit more or less light to strike film.

Boom stand Right-angled lighting stand.

Brief Outline of professional planning of future photographic action.

B & W Black and white.

Cable release Long flexible mechanical shutter release.

Clip test Test development of few frames of film.

Compensating developer Solution which acts to improve shadow detail while retaining quality in highlights.

Contacts Prints made same size to negative without use of enlarger.

Cropping Isolation of relevant image area by masking out extraneous detail.

Differential focus Use of unsharpness to pinpoint critically focused areas.

Format Physical perimeter of film or paper used to make photograph.

Incident highlight Small sharp highlight, within main highlight.

Latent image Image retained by film as it is exposed to light and before processing.

Macro image Close-up camera image, 1;1 or larger.

Monochrome Single colour.

Monorail Camera, usually large, running on a single rail.

Montage Mixture of several images, blended together on a single negative or print.

Negative colour Film designed to produce colours in opposites or complementaries as an interim printing negative.

ND Filter Neutral Density Filter.

Orthochromatic Film insensitive to red.

Panchromatic Film sensitive to all colours.

Parallax Lack of co-ordination between images when viewed through one optical system and photographed through another.

R.C. Print Resin coated print on plasticised base.

Scanner Optical, electronic machine used to make engravings from photographs.

Separation Clear division between forms and tones.

Set Physical area to be photographed.

Sheet film Single negative on plastic film base for use in large cameras.

Shutter Mechanical speed control on camera.

Skid light Accent light which skims surface of subject.

SLR Single lens reflex.

Specular light Light emitting from a narrow or point source.

Still bath Water bath used to soften effect of developer.

Stop bath Neutralising bath to stop developing action.

System camera Camera with planned range of optics and accessories.

Tent lighting Special shadowless lighting for shiny objects.

Tungsten light Constant emission light source of 3200 degrees Kelvin.

Universal developer Developing solution effective for wide range of both film and paper.

Index